Art and Revolution in Modern China

This volume is sponsored by the
Center for Chinese Studies,
University of California, Berkeley

Ralph Croizier

Art and Revolution in Modern China

The Lingnan (Cantonese) School of Painting, 1906–1951

University of California Press
Berkeley · Los Angeles · London

University of California Press
Berkeley and Los Angeles, California

University of California Press, Ltd.
London, England

Library of Congress Cataloging-in-Publication Data

Croizier, Ralph C.
 Art and revolution in modern China.

 Bibliography: p.
 Includes index.
 1. Ling-nan school of painting. 2. Painting,
Chinese—20th century. 3. Painting—Political
aspects—China. I. Title.
ND1043.53.L55C7 1988 759.951′27 86-31783
ISBN 0-520-05909-3 (alk. paper)

Printed in the United States of America

1 2 3 4 5 6 7 8 9

Ah, but a man's reach should exceed his grasp,
Or what's a heaven for?

Robert Browning, *Andrea del Sarto*

Contents

Illustrations

Color Plates

Acknowledgments

As a historian moving into the previously unfamiliar terrain of art history, I have incurred an uncommonly long list of debts of gratitude. Where to start in acknowledging them?

Should I first thank the American Council of Learned Societies who in the academic year 1973–74 provided me with a "retooling grant" to go back to my alma mater in order to pick up the basic skills and approach of an art historian? Or is it appropriate to recall the personal moment of sudden enlightenment when I saw that art could be a way to deepen my understanding of modern Chinese intellectual history? It occurred six years after my Ph.D., four years after my first book, in the midst of a prolonged meditation over what direction my future research should take. But the moment itself was truly Zen-like and unexpected as I sat on the sun-drenched patio of the Berkeley Student Union with my teaching assistant and the best student from my summer class of 1972. For helping trigger a moment that sent me on such a long journey, thank you, Jonathan and Vera.

Yet no acolyte reaches enlightenment without the helpful guidance of a master. I have known two. James Cahill, Professor of Art History, University of California, welcomed me to his graduate seminar in that retooling year of 1973–74, and over the years he has helped me with his insights, wisdom, counsel, and friendship. I am deeply grateful.

The teacher to whom I owe the deepest debt, intellectually and emotionally, cannot read this belated tribute to his guidance and inspiration. Joseph Levenson died three years before that moment on the sunny patio at Berkeley. It has now been almost two decades, but the insights and approach to history in this book still owe far more to him than to any other source. In fact, his own brilliant essay into integrating history and art history, "The Amateur Ideal in Ming China," provided the original stimu-

lus for my efforts in twentieth-century art history.* Beyond that, his life's work and his personal example have been a lasting inspiration for all my efforts to try to find meaning in history.

In my search for meaning in the specific history of the Lingnan School, the process of researching and writing this book, many individuals and organizations have come to my assistance. To begin with, I am grateful to several fine art historians for their special kindness. During my ACLS year at Berkeley, Michael Sullivan graciously allowed me to audit his lectures at Stanford and to use his rare photographic collection from wartime China. Subsequently, Ellen Johnson Laing, one of the few senior Chinese art historians to share my belief in the potential value of serious work on modern Chinese art, gave my initial manuscript the kind of thorough art historical criticism that it so badly needed. Other art historians read and commented on parts of the manuscript—Jerome Silbergeld, Calvin French, Stephen Addis, and William Rathbun. The Japan chapter, in particular—where I was a double interloper as a non–art historian and a non–Japan specialist—benefited from their advice.

As for my own discipline of intellectual history, an old friend and classmate, Laurence Schneider, applied the critical scrutiny of a modern Chinese intellectual historian to the initial manuscript. I could not do everything he wished with this subject, but the book is better for his suggestions. The same can be said for the advice and criticism given me by Roxane Witke, Edgar Wickberg, and Leo Lee. And, finally, I am grateful to Paul Cohen for the tough, but fair-minded and insightful, review he gave to a later version of the manuscript.

In doing the actual research—tracking down paintings, writings by the painters, reviews, reproduction volumes, friends and disciples of the founders of the Lingnan School—I have been fortunate to encounter so many people who were so generous with their time and efforts. First, I thank members of the Gao and Chen families who helped me so much with research on Gao Jianfu and Chen Shuren. The children of Gao Jianfu, Professor Diana Kao (Gao Lihua) in New York and Kao Li-chieh (Gao Lijie) in Hong Kong, were extraordinarily helpful in so many ways that without them this book could not have assumed its present form. Similarly, Chen Shuren's son, Chen Shi, and his grandson, Dickie Chen, who now live in Toronto were very generous in allowing me to examine and photograph a large number of paintings and sketchbooks.

* First in John Fairbank, ed., *Chinese Thought and Institutions* (University of Chicago Press, 1957), 320–44, and subsequently as chap. 2, *Confucian China and Its Modern Fate* (University of California Press, 1958).

Among living artists who have also been invaluable in making paintings and information available to me, I single out Professor Chao Shaoang (Zhao Shaoang) and Yang Shan-sum (Yang Shanshen) in Hong Kong whose own considerable artistic achievements receive only brief treatment in a book focused on the earlier history of the Lingnan School. In Taiwan the Venerable Xiao Yun (You Yunshan) was also very generous with her assistance, while in China itself Li Xiongcai and Guan Shanyue shared helpful reminiscences with me.

Of private collectors who knew Lingnan painters, I should mention Paul Lau (Liu Yongxiao) who allowed me to view and photograph his valuable collection of Gao Qifeng and Zhang Kunyi paintings in New York. Peter Chou (Zhou Jingrong) showed me hospitality and his fine collection of modern Chinese art during several visits to Hong Kong. And, finally, the late Jen Yu-wen (Jian Youwen—historian and authority on Guangdong culture and history, friend and artistic executor of Gao Jianfu) deserves more than a passing reference. Careful readers will note how much information he has provided me through his writings, reminiscences, and art collection. It is a source of sadness that I did not finish this book in time for him to read it.

As for public institutions where paintings and literary sources were made available to me, the list is long: the Hong Kong Museum of Art, the Art Gallery of the Chinese University of Hong Kong (repository of most of the Jen Yu-wen collection), the Guangdong Provincial Museum, the Canton City Art Gallery, the Shanghai Museum, the Shanghai City Library, Hong Kong University Library, the Library of the Central Academy of Fine Arts in Peking, the National Library in Peking, the Library of Congress, Washington, D.C., the Hoover East Asian Library, Stanford, the Berkeley East Asiatic Library, Columbia University East Asian Library, the Harvard-Yenching Library, the University of Washington East Asian Library, and the Asian Library of the University of British Columbia.

Too many people in these institutions have been of too much assistance for me to name them individually. However, I should mention several Chinese friends who went out of their way to ease the difficulties of doing research in China. These are Professor Chi Ke of the Guangzhou Academy of Fine Arts, Professor Shao Dazhen of the Central Academy of Fine Arts, and Professor Zhu Boxiong of the Zhejiang Academy of Fine Arts. Help when most needed is longest remembered.

At the University of California Press several people have touched or handled this manuscript: Barbara Metcalf, Phyllis Killen, Sheila Levine, Nancy Blumenstock, Mark Ong (responsible for artistic design), and Susan Stone, who saw a messy manuscript through to a finished book.

And finally I come to the institutions that smoothed the way financially. The American Council of Learned Societies' role has already been mentioned. Later much appreciated financial assistance came from the Social Sciences and Humanities Research Council of Canada and the University of Victoria Committee on Faculty Research and Travel.

Canadian financing for a project started in the United States and researched mainly in China and Hong Kong—it seems a suitable mixture for a study of an art movement with such international and cosmopolitan characteristics.

ROOTS AND BRANCHES OF THE LINGNAN SCHOOL

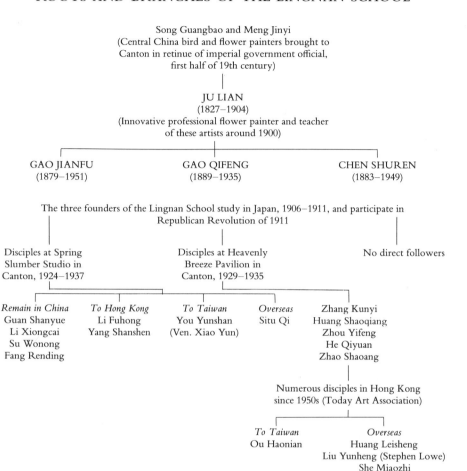

Song Guangbao and Meng Jinyi
(Central China bird and flower painters brought to
Canton in retinue of imperial government official,
first half of 19th century)

JU LIAN
(1827–1904)
(Innovative professional flower painter and teacher
of these artists around 1900)

GAO JIANFU GAO QIFENG CHEN SHUREN
(1879–1951) (1889–1935) (1883–1949)

The three founders of the Lingnan School study in Japan, 1906–1911, and participate in
Republican Revolution of 1911

Disciples at Spring Disciples at Heavenly No direct followers
Slumber Studio in Breeze Pavilion in
Canton, 1924–1937 Canton, 1929–1935

Remain in China *To Hong Kong* *To Taiwan* *Overseas* Zhang Kunyi
Guan Shanyue Li Fuhong You Yunshan Situ Qi Huang Shaoqiang
Li Xiongcai Yang Shanshen (Ven. Xiao Yun) Zhou Yifeng
Su Wonong He Qiyuan
Fang Rending Zhao Shaoang

Numerous disciples in Hong Kong
since 1950s (Today Art Association)

To Taiwan *Overseas*
Ou Haonian Huang Leisheng
 Liu Yunheng (Stephen Lowe)
 She Miaozhi

Portraits of the Artists

1. Gao Jianfu in the uniform of the revolutionary army, 1911. (above, left)
2. Gao Jianfu with Cai Yuanpei at the artist's individual exhibition, Shanghai, 1936. (above right)
3. Gao Jianfu in his last years, Macao or Hong Kong, ca. 1950. (left)

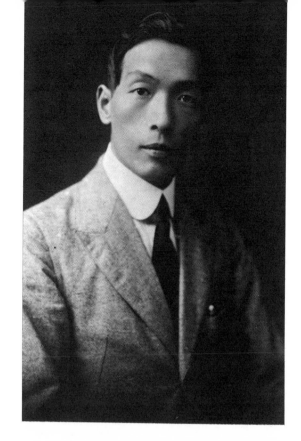

4. Gao Qifeng in his mature years, probably during the 1920s.

5. Gao Qifeng in summer-weight scholar's robe, ca. 1930.

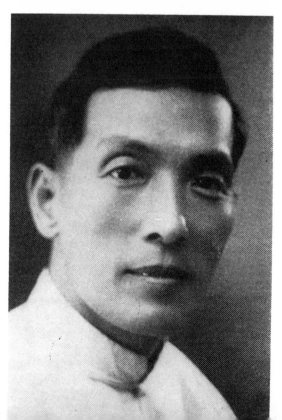

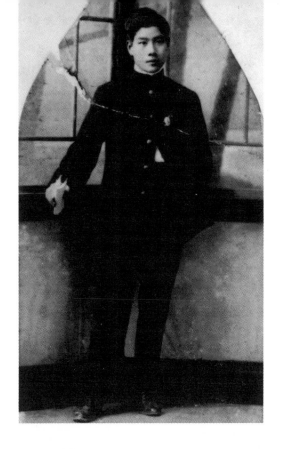

6. Chen Shuren in school uniform, ca. 1905.

7. Chen Shuren at work in h[...] studio, ca. 1935.

Introduction: History and Art History

This is a book about art, but not just about art. The subject is an art movement with specific regional origins that achieved national significance in the context of the political and cultural revolutions of early twentieth-century China. It is about a group of painters who attempted to produce a new national art that would be modern and still distinctively Chinese. It is about the interplay between art and politics in a period of cultural crisis and social change.

The name most commonly used for this group of artists, *Lingnan pai*, literally means the "South of the Mountains School." Lingnan is the ancient name for the part of China south of the Wuling mountain range, which now comprises the provinces of Guangdong and Guangxi, centered on the Pearl and West River drainage basin. It is common in Chinese art history to use geographic names for sometimes loosely related groups or styles. In the case of the *Lingnan pai*, they were a real "school" in the sense of showing a distinctive style, developing an articulated philosophy of art and its social functions, and passing these on through an organized body of students.

Gao Jianfu, Gao Qifeng, and Chen Shuren—the three founders of the Lingnan School—all came from the same district near Canton and learned the fundamentals of Chinese painting from the same Guangdong master. Then all three studied art in Japan in the first decade of this century where they joined Sun Yat-sen's revolutionary movement and participated in the Revolution of 1911. Out of this shared experience came a common approach to art as a means to national rejuvenation and a distinctively syncretic style that sought to combine the best features of modern Western and traditional Chinese painting. Their efforts to establish this new art as what they called "New National Painting" (*Xin guohua*) is the main theme of this book.

This means that our concerns as scholars go beyond art history, nar-

rowly defined. It is, of course, necessary to understand what they were trying to do as artists; for this, stylistic analysis is as important as literary sources. We must examine the Lingnan School's affinities with specific traditions in Chinese painting; the sources of foreign influence, Western and Japanese; and the technical problems of creating a new vocabulary for ink painting. Style is the language of art. To understand the artists' meaning, you must understand their language. Therefore, stylistic analysis is not a digression from these artists' place in the larger history of the era, but a way of clarifying it. The history and the art history come together in their lives. Both are needed to assess the Lingnan School's historical significance.

It may seem like a commonplace to stress the integration of history and art history. All artists are part of the history of their times, although few have been so directly involved in public events as the founders of the Lingnan School. Similarly, art historians cannot work without a thorough understanding of the larger historical milieu, and historians must understand the value of art as a broadly illuminating part of the record for any historical era.

Unfortunately, this has not usually been the case, especially for modern China, and, until recently, for history in general. Writing in 1973, Theodore Rabb, editor of the *Journal of Interdisciplinary History*, lamented the distance between historians and art historians, especially the historians' reluctance to venture past the written record and look at artistic artifacts as part of total history.[1] Eleven years later, finding the situation changing in European history with the appearance of works like *The Building of Renaissance Florence* by the historian Richard Goldthwaite and *Images and Ideas in Seventeenth-Century Spanish Painting* by the art historian Jonathan Brown, Rabb optimistically forecast "a great surge of a new form of interdisciplinary research."[2] This surge has not yet reached China, although, in earlier Chinese studies, a few waves are lapping at the shore.[3]

This might seem strange, given the interdisciplinary background to so much of China studies in the West and the important role that art, particularly painting, played in China's high culture. However, in the study of modern China disciplinary specialization has eroded most of the old sinological tradition with its holistic approach to the field. More serious, a chronological as well as a disciplinary gap has opened between historians and art historians. Most of the latter have confined their serious scholarship to the high periods of Chinese art in the past, when it was unsullied by foreign influences or modern political pressures, while in China the political sensitivity of the recent past has inhibited serious research.[4]

As for the much larger number of Western historians and social scientists who study modern China, most have not had much taste for the more

abstruse parts of China's cultural tradition. Modern Chinese literature, mostly fiction, has achieved recognition for its relevance to the dynamics of modern social, political, and intellectual change.[5] But art, apparently one step further removed from social and political issues, has not received the same attention. The art historians are in Ming; the historians are into Mao. Meanwhile, modern Chinese art—the art of the twentieth-century revolution and of the period of East-West cultural confrontation—has awaited serious and integrated historical study.

This is not to claim priority for art in the study of modern Chinese history or to pretend that it has been in the forefront of the cultural and intellectual revolution. Generally speaking, it has not. In the assimilation of Western influences, painting, in particular, lagged well behind political thought, social philosophy, serious literature, or urban popular culture. Why this has been so is only partly our problem, because in its early stages the Lingnan School was a notable exception to this rule.

But, even where art has been conservative in the general cultural milieu, it still illuminates the tensions, problems, and atmosphere of its time.

The general reputation for conservatism, for repetition or stagnation, is one of the main reasons that Qing and post-Qing art have been relatively little studied by art or cultural historians in China. Actually, Qing-period painting was probably neither so repetitive nor so devoid of innovation as many modern critics charge. It has received a bad press from modern Chinese nationalists and Western-centered historians of China. In fact, the late seventeenth century saw an explosion of creative talent that still echoes in the twentieth-century Chinese art world.[6] However, according to its modern critics, that has been the problem for the long and complex tradition of Chinese painting—too many echoes of previous periods, too much "after the manner of" earlier masters, too many subtle nuances within an accepted cultural tradition, and too few stimuli for change, a fresh look at the world, and new ways to express it.

Opportunities to absorb new techniques and a new approach to art were not entirely lacking. In the late Ming and early Qing, Jesuit missionaries brought illustrated books, engravings, oil paintings, and even oil painters to China. This exposure to post–Renaissance European art, with its illusionistic techniques of fixed perspective, chiaroscuro, and shaded coloring, may have influenced some of the individualistic masters of the seventeenth century more than Chinese artists admitted or, until recently, later scholars recognized.[7] But, even if this earlier chapter of East-West contact produced something of greater artistic significance than the hybrid Chinese-Western style of the Jesuit court painter Giussepe Castiglione (also known by his Chinese name, Lang Shining) and his followers, it did not seriously deflect

the mainstream of Chinese art history. Without changes in the social system and the world view of China's scholarly elite, purely artistic or intellectual influences did not make a lasting impression on the well-established great tradition of "literati painting" or even on court and commercial artists who emulated the scholar-painter taste. It was not until the Western political and commercial intrusion started substantial social and intellectual change in such places as Shanghai and Canton that the Western presence began to influence Chinese art in a fundamental way. And even then, in the rise of the most creative movement in nineteenth-century Chinese art—the Shanghai School—Western art played no direct role. The West indirectly laid the economic foundations for that school by helping to create a prosperous and concentrated urban bourgeoisie as a base for patronage, but the painting itself shows no direct Western influence.

Such direct Western influence did not appear in Chinese art until the twentieth century. By then, Shanghai had long since become the focal point for every kind of change in China. However, for the earliest systematic attempt to create a new style of Chinese painting—one that would incorporate elements from both traditional Chinese painting and modern Western art—we have to look to that other major treaty port and window on the outside world, Canton.

Canton's role in modern Chinese history has been extraordinary. It had long been the major southern outpost of Chinese civilization and a maritime gateway to South China, but only when that gateway became important to the whole empire did Canton achieve real national importance. Before the Opium War, it was China's sole entrepôt. After 1842 it was one of the first treaty ports, although its leading position in foreign trade was soon surpassed by Shanghai. But, with its close connection to Hong Kong and openness to foreign stimuli of all kinds, Canton assumed a leading position in the political revolution by the beginning of the twentieth century, a position it would hold at least intermittently up until 1927.

The birth and florescence of the *Lingnan pai*, or "Cantonese School" of painting, were coterminous with Canton's period at the center of Chinese politics. That is one reason why the history of this group, rather than that of more famous artists and schools in modern Chinese art, has been especially interesting for a historian accustomed to seeing cultural change in relation to the political environment. But it is only one reason. More than any Peking or Shanghai artists, the Lingnan School shows the interaction between two of the central themes in modern Chinese history. One is the obvious clash between revolution and tradition, often seen culturally as a struggle between Westernization and Chineseness, although it is much more complicated than that. The second theme, not always so obvious in

cultural and intellectual history, is the more subtle tension between nation and region.

Revolution versus tradition, nation versus region—in a sense these are the warp and woof of all modern history as the juggernaut of technological and social change rolls over ancient empires, traditional societies, and local communities everywhere. But there are several reasons why the interplay between these two themes has been particularly complex and particularly important for modern China.

To begin with, although the vast extent of the Chinese empire made for wide differences among its nation-sized constituent provinces, a literate high culture of unparalleled antiquity and continuity transcended those regional differences and helped hold China together. When that culture and the gentry-mandarin class that embodied it came under assault by modern revolutionaries, there was the danger that China would fall apart along regional lines. During the warlord years of the early twentieth century, that nearly happened as modern political and social revolutionaries struggled desperately to create new forces of national unity to replace the old ones they had helped destroy. In essence, creating a modern nation required overcoming both cultural conservatism and regional particularism—overcoming, but not obliterating, because even the most radical revolutionaries found that traditional cultural and regional characteristics did not simply fade away when faced with the imperatives of modernization. Instead, reshaped by modern nationalist ideology and a new social consciousness, these old elements were essential ingredients for building the new nation. From Sun Yat-sen to Mao Zedong and beyond, modern Chinese leaders have grappled with these issues in the cultural and intellectual as well as the political sphere. One purpose of this book is to show how the interaction between tradition and revolution, region and nation, has also manifested itself in modern Chinese art.

And for that purpose the Lingnan School is particularly relevant precisely because of its regional character. These are artists who were political and artistic revolutionaries, yet felt strong ties to the traditional culture and sought to preserve the best of it in a new creative synthesis. They are provincials who, with new Western ideas and artistic techniques, sought to take the lead in remaking the national culture. Their story is an important part of the history of modern China's efforts to establish a new political, artistic, and cultural identity.

1

South of the Mountains:
Guangdong and China

In 228 B.C. the all-conquering First Emperor of Qin brought the Pearl
River delta into the boundaries of the Chinese Empire. Since then,
Guangdong has been an integral part of China. The Pearl and West river
system provided the fertile flatland for Chinese-style agriculture and
the transportation network to make Canton a natural commercial and
administrative center for the region, as well as the most important ocean
port for South China. In the Tang dynasty (A.D. 618–905), Guangdong
was still regarded as a remote and exotic place, but, unlike the temporarily
conquered Red River valley immediately to the south, it was indisputably
a Chinese province. Chinese farmers had pushed the aboriginal peoples
out of the best irrigable rice lands, imperially appointed officials ruled
Guangdong as a regular part of the empire, and Canton had become a
major center for foreign trade. It still was a thousand years later when, in
the second half of the eighteenth century, the Qing government made it

the sole port for legal trade with overseas foreigners. By this time, the environs of China's southern maritime gateway were much more developed than during earlier dynasties, as Guangdong, with a population of 16 million, became one of China's more prosperous agricultural and commercial centers.

Guangdong, the Permanent Frontier

Yet, for all this, Guangdong has in some important ways remained peripheral to China—a permanent frontier. The reasons are only partly geographical. There is no insurmountable geographic or climatic obstacle to the further extension of Chinese agriculture such as exists on the northern frontier. But the tenacious resistance of the Vietnamese inhabitants of the next major river valley, the Red, thwarted permanent southward expansion of the boundaries of the empire and any large-scale emigration of Chinese farmers beyond Guangdong. To the west, mountains and jungle kept the adjoining provinces of Guangxi and Guizhou relatively sparsely populated, leaving Guangdong as the major center of Chinese population, government, and culture in the south. It was also—with the largest navigable river system south of the Yangtze and a good harbor at Canton—the natural entrepôt for maritime trade with Southeast Asia and beyond. But geography also limited Guangdong's usefulness as a gateway to the central portions of China, for its rivers run in an east-west direction and ranges of fairly low mountains divide it from the Yangtze basin.

Thus, distance, terrain, and drainage patterns separate the area "south of the mountains" from central China, although none of those barriers has been formidable enough seriously to impede commercial relations and political control. For centuries the low passes of the Wuling Mountains have been traversed by coolies carrying teas and silks southward and returning with foreign goods from Canton. For over two millenia, no separate political power has been able to use Guangdong's isolation to defy the imperial masters of the north for long.

This firm but attenuated relationship with the rest of China has been a central part of Guangdong's history and an important factor in molding Guangdong or "Cantonese" culture. It has made the province indissolubly a part of China, but distant from the centers of politics, economics, and culture. It has left the Cantonese exposed to foreign influences through the seatrade at Canton, but not threatened by foreign conquest as were the northern border regions. They have been frontier provincials, conscious of a long history as the southernmost bastion of pure Chinese culture, but with distance and foreign contacts always threatening their claims to pure

Chineseness. From all this, the inhabitants of Guangdong developed a culture and a consciousness both conservative and receptive to change, both local and intensely concerned with belonging to the Chinese ecumene, both strongly assertive and plagued with feelings of inferiority vis-à-vis "the north." In a word, geography and the usually restrictive imperial policy on maritime expansion combined to keep Guangdong a permanent frontier—always distant from the center, always provincial, always as much a frontier bulwark of Chinese culture as a gateway for foreign influences.

If the essence of "Chineseness" was more cultural than political or racial, in some ways the Cantonese have been ultra Chinese. For example, nowhere in China was kinship organization, the clan or common descent group, more developed than in this southern border province. Nowhere was there more pride in ethnic purity uncontaminated by the blood and customs of the barbarian conquerors of the north. Nowhere did older linguistic patterns hold on longer than in the Cantonese dialect, which is much closer to the spoken Chinese of the Tang dynasty than to modern Mandarin.

Such provincial cultural conservatism is not unusual. Innovations often start from the center and spread outward, reaching the most remote provinces last. Similarly, although a frontier position can lead to absorption of foreign cultural influences, it also can intensify cultural conservatism by generating feelings of insecurity about belonging to the ecumene. In the case of Guangdong, it probably has done both. Restrained from outward maritime expansion by the political and social control from the center, at least until modern times Guangdong was also inhibited in borrowing the foreign cultural elements that might have created a syncretic Guangdong culture no longer provincial in the larger Chinese scene. The cultural pull and political control of the center was too strong for that. Thus, the large Arab settlements in the Tang dynasty made no significant dent in the wall of Chinese culture; in the mid-nineteenth century, Cantonese stubbornly resisted the entry of foreigners into their city after the Opium War. Up until the middle of the nineteenth century, imperial policy, cultural pride to the point of xenophobia, the self-interests and conceits of gentry society—all combined to keep Guangdong very much a province of China and, in the traditional Chinese world, very provincial.

Provincial Culture and Cantonese Painting

In the high culture that was so important to traditional China and its upper classes, Guangdong, despite its long heritage, definitely remained more an

emulator and consumer of fashions established elsewhere than a trendsetter in its own right. There were famous scholars and artists in Guangdong, but few made a mark nationally.[1] There were clan- and gentry-supported Confucian academies, but their influence was localized. One general indicator of Confucian cultural levels was the number of metropolitan degreeholders (*jinshi*) produced by a region; during the Qing dynasty, Guangdong, ranking eleventh among the nineteen provinces in population, was thirteenth in the number of *jinshi*.[2] One does not expect a frontier, even an old and stabilized one, to be permeated with the fragrance of scholarship.

Although Guangdong was far from being an artistic wasteland, this general cultural provincialism was manifested in the arts, including painting. The local gentry and, later, the prosperous merchants of Canton practiced and patronized painting as one of the highest forms of literati cultural achievement, but only one Guangdong artist, Lin Liang, court painter in the early Ming dynasty, can be said to have achieved a major national reputation and significant influence in the northern cultural centers of China. His forceful and realistic pictures of great birds of prey (eagles and hawks) gave Cantonese painting a reputation for this genre that persisted down to modern times. However, his was not the style or genre that would become most esteemed by the lower Yangtze arbiters of Chinese taste by the end of the Ming dynasty. Lin Liang acquired a secure, but not preeminent, niche in the history of Chinese painting; Guangdong painting remained in a status peripheral to such places as Songjiang, Nanjing, or Yangzhou. The "Southern School" most extolled by literati cognoscenti did not refer to painting south of the mountains. Insofar as the northern-southern school classification had any geographical meaning at all, the southern locus was the gentry-dominated society of Jiangnan, the lower Yangtze valley.

One indication of this northern, or central, Chinese disregard for Guangdong painters is the late Qing scholar Dou Zhen's compilation of famous Qing dynasty artists. Out of 1,733 named, only 10 are from Guangdong.[3] Another statistical ranking of leading painters from all dynasties ranks Guangdong twelfth among the provinces with only 2.2 percent of the total number.[4]

Within Guangdong, painting continued to develop throughout the Ming-Qing period, with the greatest concentration of artists and collectors lying in the prosperous Pearl River delta region around, but not directly in, the city of Canton.[5] Although scholars in northern and central China took little notice of them, the number of provincially famous artists indicates an active local cultural environment, even if much of it was derived from the north. That derived taste, provincial variations of national trends, can be seen in the later Guangdong collectors' preference for the southern

style as defined by the doyen of late Ming literati culture, Dong Qichang.[6] It can also be seen in the work of early nineteenth-century Guangdong painters, such as Li Jian and Xie Lansheng, who drew heavily on Song and Yuan period works in local collections.

By this time, a more contemporary style from central China, the controlled eccentricity of the Yangzhou School, was also influential in Guangdong, but with an interesting difference from its acceptance farther north. Cantonese collectors and artists took to the Fujian-born members of the Yangzhou School, Hua Yan and Huang Shen, while ignoring other leading figures, such as Jin Nong and Zheng Banqiao. The reasons for this selective enthusiasm for the major movement in eighteenth-century Chinese painting are partly fortuitous: the posting to Canton in the 1760s of an influential scholar-official art connoisseur who disliked Jin Nong. The opinions of this erudite northerner carried great weight with Guangdong tastemakers.[7] The geographic proximity of Fujian and possibly the migration of rich merchants from Quanzhou to Canton once it became the sole port for foreign trade, may also have contributed to the availability and popularity of works by Hua Yan and Huang Shen. The latter would exert a strong influence on the eccentric late nineteenth-century Cantonese figure painter Su Liupeng.[8]

Behind these immediate reasons for the acceptance of some Yangzhou eccentrics and the rejection of others lies the fact that, according to prevalent artistic opinion, Hua Yan and Huang Shen represented a safer, more easily appreciated form of eccentricity. It also may have been a form easier for professional artists (and most of the late nineteenth-century Guangdong masters were professionals) to emulate. It probably was more acceptable to a provincial gentry anxious not to have the depth of their cultural sophistication called into question. In any event, Cantonese tastes continued to reflect trends established elsewhere. The flow of cultural influence was from north to south, from the center to the province.

This flow continued into the nineteenth century, facilitated by the wealth of Guangdong collectors who might patronize provincial artists but got more prestige from buying works by nationally famous painters from Jiangnan. Northern influences also reached the far south through Cantonese scholars and merchants returning from sojourns in the capital or the commercial centers of the lower Yangtze. And, perhaps even more important, the political ties with the center brought scholar-officials to Guangdong who sometimes included artists in their retinues.

The most important instance of this came in the Daoguang reign period (1821–1851) when an official native to Jiangxi Province, Li Bingshou, brought two accomplished central Chinese painters with him during his tour

of duty in Guangdong. These two had a marked influence on the genre of flower and bird painting, which was already popular in the Pearl River delta.[9] Their styles differed somewhat, but both represented major trends in central Chinese painting during the Qing dynasty. Song Guangbao was an exponent of the meticulous yet lively "boneless" (no outline) style of the most famous bird and flower painter of the Qing, Yun Shouping (1633–1690). The careful draftsmanship and intricate coloring techniques made works in this style fine examples of what Chinese connoisseurs called *xiesheng* (painting the form of an object),* as close as Chinese high art would come to a tradition of realism or naturalism. But the insistence on capturing the inner essence makes them much more than botanical studies. Nevertheless, it is a style that requires care, precision, and technical mastery and therefore is perhaps better suited to professional artists than casual amateurs.

The other painter, Meng Jinyi, was much freer and more powerful in his flower and plant paintings, closer to the style of the late Ming "madman" Xu Wei or some of the Yangzhou eccentrics. He was more in the *xieyi* tradition (painting the idea behind the external reality) and, as such, nicely complemented Song Guangbao. Song represented sophisticated technique, polish and control; Meng represented literati ideals of expressiveness and spontaneity. They created a considerable impression in provincial Guangdong. Between them they stimulated the particular local school of flower and bird painting that was the source of twentieth-century China's first revolutionary art movement. All the founding members of the Lingnan School took their initial discipleship under a Guangdong painter who referred to himself as a follower, "halfway between Song and Meng."[10] He was the scholarly, but thoroughly professional, artist from Panyu district Ju Lian.

Local Roots: The Ju Lian School

The local roots of the Lingnan School are important. Its founders—Gao Jianfu, Gao Qifeng, and Chen Shuren—were not just Guangdong artists. They were all from the same district and studied under the same painting teacher. The district was Panyu in the heart of the Pearl River delta within the fifty-mile radius of Canton that produced over 95 percent of

* Literally, the term means "painting life" but, although that did lead to some emphasis on directly studying the object to be painted, it did not always mean "painting from life" or "from nature."

Guangdong's famous artists.[11] Panyu itself was well known as a center of Guangdong painting, ranking second only to Shunde in the number of famous painters produced during the Ming-Qing period. A prosperous district with a long scholarly tradition, it was close enough to Canton to have connections with the political, commercial, and cultural life of the provincial metropolis yet rural enough to preserve a scholar-gentry millieu.[12]

Although influence from the new northern styles of flower and bird painting radiated throughout the Pearl River delta, its most significant development occurred within one family of artists in Panyu. No less than six members of the Ju family achieved a measure of fame in Guangdong art circles, but the two leaders of this local movement were the cousins Ju Chao (1811–1865) and Ju Lian (1827–1904). The Ju family had a scholarly background and, although they did not hold official position, the elder served as personal advisor (*muyou*) in an official's retinue. Moreover, both fought on the Qing dynasty's side in the civil war against the Taipings.[13]

Ju Chao followed the style of Song Guangbao rather closely. The most distinctive aspects of this style were the techniques of "sprinkled powder" (*zhuangfen*) and "splashed water" (*zhuangshui*). The sprinkling of white powder on colored areas, especially flower petals, produced a bright, somewhat glossy surface, which when handled with restraint could give freshness and vivacity without becoming vulgarly colorful. Although there had been some precursors in this innovation, it is generally accepted that Song Guangbao popularized the technique in Guangdong, and Ju Chao perfected it.[14] He also adapted the Jiangsu artist's "boneless" (no exterior outlining of shapes) painting of leaves by using his "splashed water" technique in which, before the colors dry, water is splashed or dripped on the surface and then forms the borders with its own carefully controlled flow. One interesting feature of this technique is that it requires a hard sized paper or silk, so that the water will not be too quickly absorbed. Combined with the bright colors of the powdered petals, this means that the finished work depends on color and surface appeal somewhat more than the traditional literati painting values of brushwork and tonal gradations of black ink (plate 1).

Both Ju Chao and the younger Ju Lian mastered and popularized these techniques. It would be interesting to know how much these coloristic innovations, plus a fondness for "common touch" subject matter (bean sprouts, moon cakes, salted eggs, dried cooking ducks) and the usual more poetic small-scale nature studies contributed to their popularity with Cantonese merchant patrons. Farther north, at China's other main contact point with Western trade and ideas, something similar was happening with

the rise of the Shanghai School. There too a growing merchant class supported artists who were well grounded in the established literati painting tradition, but who also made important innovations in style and subject matter. In both places, China's new coastal bourgeoisie seemed to want an art that was readily identified with the high style of the past but also had something new—an art that carried the social prestige of literati painting but did not depend on detailed knowledge of historical traditions and literary associations for its appeal. In other words, something safely Chinese, not foreign; something that connected with upper-class gentry styles and values, not popular or folk art; something that would confirm the social status of men who made their fortunes in business, often in business with foreigners, but who still craved the social status conferred by supposedly scholarly tastes in art.

Much more detailed research will have to be done on the styles and patronage of nineteenth-century Guangdong painting before much can be said with confidence about the indirect influence of foreign trade on the emergence of new trends in Chinese painting, but it does seem that by mid-century more was stirring in the art world of China's southern coastal center than one would expect in a provincial backwater. The fact that none of this was noticed in the north has less to do with the significance of the new social and cultural dynamics than with the long-established patterns of metropolitan-provincial relations within the Chinese culture world.

In any event, Ju Chao, Ju Lian, and several other members of the Ju family had established a well-known style and school in the Canton area by the second half of the nineteenth century. Ju Chao apparently remained more of an amateur painter in the accepted literati ideal; his younger cousin Ju Lian became perhaps the most successful professional painter and teacher in Guangdong in the later decades of the nineteenth century.

Painting to earn his livelihood, Ju Lian produced a much larger corpus of works than his cousin, in a much wider variety of styles. His art was also livelier and more innovative, drawing on the freer and more spontaneous style of Meng Jinyi as much as Song Guangbao—hence his seal "between Song and Meng." That phrase reveals his predecessors but does not do him full justice as an innovator and inspirer of further innovations. Although he painted ink landscapes in a broad, free, expressive manner they "were done for himself as self expression . . . a kind of relief and enjoyment."[15] Similarly, figure painting, a genre where other Cantonese painters, such as Su Liupeng and Su Renshan, made some of the most interesting innovations in nineteenth-century art, remained a sideline with him. His real forte, where he made his reputation, was in flowers and birds, more particularly, grasses and insects. The latter had been a rather minor genre of Chinese painting

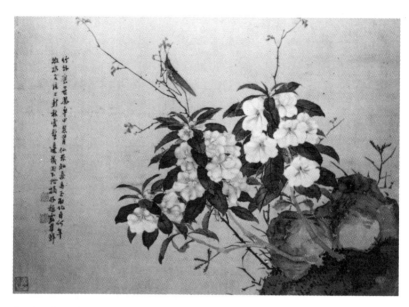

8. Ju Lian, *Flowers and Grasshoppers*, n.d.

since the Song. Under Yun Shouping's influence, it enjoyed something of a revival in the early Qing. With Ju Lian leading the way, it became very popular in late nineteenth-century Guangdong (figure 8).

It is not easy to assess Ju Lian's full stature as an artist in this genre. There is a temptation to look backward, through Song Guangbao and Meng Jinyi to Yun Shouping, and see Ju as essentially a talented but somewhat facile perpetuator of an old national style at the provincial level. Certainly, he became stereotyped in much of his work. Once he had perfected his successful formula for attractive and salable pictures of birds, flowers, rocks, and insects, he repeated himself over and over. Most of his paintings were in the small-scale album leaf format, and there is no question that he overproduced in order to satisfy a ready market for such works. Furthermore, there is no evidence that he attained greater insight into his subjects or new heights in his art as he grew older. He sustained a high level of competence and professionalism but never rose above it in the manner of the greatest Chinese painters.

The other temptation to minimize Ju Lian's accomplishments comes from the achievements of his followers. He did not have the breadth of vision, the innovative boldness, or the historic opportunity of his most famous disciples. But despite his limitations, it must be recognized that he

succeeded in combining minute attention to nature with a keen decorative sense to produce pictures much more lively and interesting than most nineteenth-century Chinese painting. And there is no question about his popularity.

Again, one can speculate about the reasons for his commercial as well as artistic success. We know that he got more commissions for paintings during frequent trips to Canton than from the gentry neighbors in his home village of Lishan in Panyu district. The manner in which he obtained these commissions casts some light on the gentlemanly pretensions of the high-class professional artist. Ju Lian would not deal with unintroduced strangers face-to-face but rather through go-betweens or by having written orders slipped under the cover of his sedan chair on his weekly trips to Canton. We can assume that most of these surreptitious orders came from Cantonese merchants, though probably not from the wealthiest merchant houses who would have had social access to gentry circles. In other words, Ju Lian's art had a fairly wide popular appeal. His fresh, lively, and realistic nature studies appealed to semi-cultured patrons as well as upper-class connoisseurs. Also, his close observation of nature possibly reflected some awareness of the Western value of realism. Or, at a somewhat different level, his attention to common local flora and fauna probably appealed to a regional self-awareness as the growing political and intellectual ferment of the late nineteenth century made Cantonese more conscious of their local roots. Whatever the reasons for their popularity, his bees in front of brightly colored flowers or cicadas on limpid stalks of grass are bright, fresh, and interesting.[16] They do not look like tired repetitions of an old tradition, as does much of late Qing Chinese painting.

Ju Lian may not have been a great artist, but he certainly was a good one; he may not have been a major innovator, but his attention to nature revitalized a minor genre and led to much greater innovations in the next generation. He was not the founder of the modern Lingnan School, but he was its progenitor.

The Guangdong Apprenticeship

The founders of the Lingnan School—Gao Jianfu, Gao Qifeng, and Chen Shuren—served their apprenticeship in traditional Chinese painting at the studio-school Ju Lian established at the age of 47 in his home village of Lishan. They were only three of the many students, or disciples, that Ju Lian trained during three decades as professional painter and teacher. In fact, despite his scholarly connections and gentry life-style, Ju Lian was

something of a prototype for the modern Chinese artist who supports himself solely through painting and teaching.[17] His studio, the "Hall of the Whispering Lute," was not exactly an art school. He maintained the traditional master-disciple relationship and took talented pupils who could not afford to pay for instruction, letting some of them live with his family. But the number of disciples indicates that his home was as much school as studio, and his twentieth-century reputation would flow as much from his students as from his own works.[18]

The most famous of those students, Gao Jianfu (1879–1951), entered Ju Lian's studio in 1892 at the age of 13. He came from a relatively modest family background in the nearby town of Yuangang. The fourth of six sons, he was orphaned at an early age and went to live with an uncle who was a traditional doctor and amateur painter. Through this uncle he was introduced to Ju Lian and, with one brief interruption, lived at the painter's home and studio for the next seven years, thus acquiring a traditional classical education and an artistic training under the master's roof. During these years, he met another promising student, Chen Shuren (1883–1949), beginning a lifelong personal friendship and artistic connection.

Less is known about Chen Shuren's early life.[19] Apparently, his family had commercial connections, and he did not depend on Ju Lian for financial support as did Gao Jianfu. But Chen Shuren's relations with Ju Lian were also very close. He married into the family and may have lived at his teacher's home and studio, the "Whispering Lute Hall."[20]

The third founder, Gao Qifeng, had much less direct exposure to Ju Lian, although the foundations of his training in Chinese painting came from that source. Ten years younger than his brother Jianfu and consequently orphaned at a much earlier age, he depended on older siblings for support. By Qifeng's teenage years, Jianfu seems to have been his chief source of support and encouragement to study art. Sources differ on whether the younger Gao actually studied with Ju Lian.[21] If he did, the period was brief for by age 14 he was enrolled in a modern Christian school in Canton; not long after, Jianfu brought him to Japan for further art education. As the youngest of the three founders, Qifeng had the least direct exposure to the Ju Lian tradition. Nevertheless, he must have acquired a good deal of its technique and spirit through his older brother, because strong traces of the Ju Lian style appear in the younger Gao's work.

Thus, directly or indirectly, Ju Lian was instrumental in laying the foundations for the future Lingnan School. But exactly what did these three young painters acquire from this venerable Guangdong master? Their surviving early, pre-Japanese works show command of the standard repertoire of the Ju Lian School—flowers, insects, grasses, small birds, strange

rocks—done in its distinctive style with bright colors, careful draftsman-ship, realistic detail, "splashed water," and "sprinkled powder." Even later, when much more was added, some of these subjects and techniques would remain integral parts of the Lingnan School. In the pre-1905 years, Ju Lian's influence is overwhelming in the few surviving works of their discipleship period, although even then some of the later distinctive characteristics of the individual members of the Lingnan School start to emerge.

More works of Gao Jianfu, who was a direct disciple for the longest period, survive than those of his fellow students. Aside from a few early study pieces, which are interesting only for what they reveal of the master's insistence on draftsmanship and close observation, Jianfu's more mature works from around 1900 show him still very much Ju Lian's disciple. Perhaps, as Gao Jianfu later claimed, his teacher did insist on careful obser-vation of nature to develop creativity,[22] but these early works are almost indistinguishable from Ju Lian's. There is, to be sure, a certain strength to them that, compared to the teacher's work, verges on stiffness. A chirping bird on a flowering branch, painted at Ju Lian's studio, shows Jianfu's mastery of fine detailed brushwork in the bird and a certain ruggedness in the gnarled branch (figure 9). But the stiffer, less vivacious feeling of this work, similar to others from the period, probably comes from more than just color fading through age. This is even more apparent in Jianfu's insect paintings from these years. In a fan painting, dated 1900, a group of praying mantises attack each other beneath a prettily flowering branch (figure 10). It, and two long hanging scrolls from the same year (figure 11), show him painting standard Ju school subjects in the standard Ju Lian format. They may be a little stiffer, less spontaneous or self-assured, than the teacher's works. Jianfu may be striving a little too hard for effect by drawing the mantises in such active, aggressive postures, or he may already be showing signs of the heroic spirit that would carry him beyond decora-tive bird and flower pictures. But at this stage the most impressive feature of Gao Jianfu's painting is his mastery of the style and subjects of the Ju Lian school.

It is more difficult to judge the early work of Jianfu's younger brother, Gao Qifeng, because apparently none of the paintings from the period before he went to Japan has been preserved. In later works, there is some Ju Lian influence, perhaps transmitted through his brother. A hanging scroll dated 1907 may be his earliest surviving painting (figure 12). It shows a pheasant rising from a blossoming tree branch. The bird is more Japanese than Cantonese, but the flowers are reminiscent of Ju Lian. This is often true of Qifeng's small birds and flowers, which are much looser and more impressionistic than most of Ju Lian's or Gao Jianfu's paintings in this

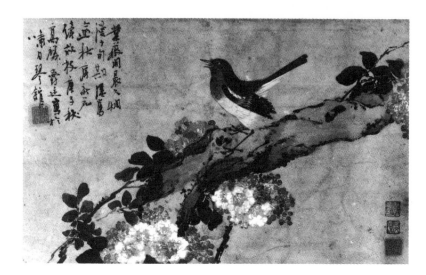

9. Gao Jianfu, *Flower and Bird*, 1900.

10. Gao Jianfu, *Praying Mantis*, 1900.

genre. Perhaps Qifeng leaned more to the freer Meng Jinyi side of Ju Lian than to the more controlled Song Guangbao tradition. More probably, the difference from his brother reflects both a different temperament and a much shorter Guangdong apprenticeship on Qifeng's part. The brevity of that apprenticeship meant a less thorough grounding in the Ju Lian tradition before exposure to the new influences of Meiji Japan.

The third of these Ju Lian students, Chen Shuren, also would develop

11. Gao Jianfu, paired paintings: left, *Mantis, Strange Rock, and Hydrangea*, 1900; right, *Bees, Strange Rock, and Peonies. After Yun Shouping*, 1900.

12. Gao Qifeng, *Bird, Blossoms*, 1907.

his mature style only after exposure to Japanese influences. In some ways, Chen was the closest follower of the Ju Lian School. Flower and bird painting remained his favorite genre throughout his life, and he brought to it charm, delicacy, and freshness worthy of the best in that tradition. An early painting of peonies dated September 1903 shows that at 20 he had already acquired these qualities and was developing an artistic personality somewhat different from his fellow disciples and future colleagues (figure 13). The colors are fresher and livelier than Gao Jianfu's; the drawing is more precise and controlled than Gao Qifeng's. All three came out of and were strongly affected by Ju Lian's school, but even in their apprenticeships they showed signs of developing their own distinctive artistic personalities. Before that could happen, however, new influences from a larger world had to impinge on their provincial consciousness.

Their first exposure to that larger world came through the provincial metropolis of Canton. There, foreign influence, new ideas, and growing unrest created an intellectual and political milieu far removed from the tranquility of Panyu. Gao Jianfu reached Canton in 1903 after seven years with Ju Lian and five more under the patronage of a wealthy local painter and collector, Wu Deyi. Himself an older disciple of Ju Lian, Wu Deyi was an artist of some reputation, but his main value to the young Gao Jianfu was through his art collection, which included central Chinese painters from earlier periods. Through Ju Lian, Gao had directly imbibed that particular Guangdong tradition; through Wu Deyi he was exposed to the main currents of Chinese art since the Song. Thus, when he went to Canton at the age of 24, he already had undergone a long, more or less traditional training as a Chinese artist. Once in the city his intellectual, artistic, and political horizons started to expand rapidly. His interests could hardly have been purely traditional to begin with, for he immediately enrolled at Canton Christian College. Later renamed Lingnan University and eventually Sun Yat-sen University, this was a leading center for new ideas and foreign influences in South China. At that time it was run by American Presbyterians. Jianfu and several of his brothers were Christians. Whether he was baptized before or after enrollment is not clear, but he soon absorbed many of the intellectual and political currents agitating educated young Chinese at the beginning of the century. These included an aggrieved nationalism feeding on the repeated humiliations China had suffered at the hands of the foreign powers which, in turn, fed mounting anti-Manchu sentiment over the government's failure to defend the nation. Closely allied to these was a growing sense of urgency about implementing widespread economic, political, and institutional changes if the nation were to survive at all in a social-Darwinian world where the weak perished. All

13. Chen Shuren, *Peony*, 1903.

this would crystallize in a revolutionary ideology for Gao Jianfu and his generation with the founding of the Tongmeng hui (Alliance Society) in 1905, but the years immediately before were important for starting Jianfu, his friend, and his brother in that direction before they left Guangdong.

Artistically, these years were important too, because Jianfu was directly exposed to Western art through a French painting teacher who is known only by his Chinese name of Mai La.[23] When Gao took a position as teacher at a "modern" school in 1905, he met another foreign artist who would have a much more powerful influence on his life and on the genesis of the whole Lingnan School. He was a Japanese Nanga painter (in the Chinese style) named Yamamoto Baigai. Through him, Jianfu began to study the Japanese language and got the idea of studying art in Japan.

For Chen Shuren the road away from Panyu was more directly political, although it led to the same end—art study in Japan. By 1903, Chen was writing for an anti-Manchu revolutionary newspaper published in Hong Kong, *Guangdong ribao*. This soon led him into Sun Yat-sen's revolutionary movement, although sources differ on whether he personally met Sun before or after going to Japan.[24] At any rate, he was close to such important Cantonese revolutionaries as Wang Jingwei, Feng Ziyou, and Liao Zhongkai and became an early member of the Tongmeng hui when it was formed in Japan in 1905. Chen remained active in Tongmeng hui and, later, in Guomindang (Nationalist party) affairs for the rest of his life.

Gao Qifeng, considerably younger than the others, simply followed his brother. He may have briefly studied with Ju Lian, but by 1903 he was enrolled in a Christian elementary school in Canton. Two years later, when he was only 16, his brother took him to Tokyo.

Thus, once these three young disciples of Ju Lian had left their native place, the new intellectual and political currents in Canton and Hong Kong quickly swept them far beyond the local or provincial scene. Caught up in a national revolutionary movement that sought to remake China into a modern nation in a larger world, they were exposed to foreign ideas and foreign art, which made even Canton seem small. Within two years, all three had joined the exodus of Chinese students to Japan.

2

For Chinese writers in the first decades of the present
century, revolutionary fervor and sentimentality, while
seemingly unrelated, were their two main sources of
inspiration.

Liu Wu-chi, *Su Man-shu*

The Japanese Connection

The first known Chinese visitors to Japan were Buddhist monks in the
sixth century A.D. Since then, cultural interchange between the two coun-
tries, though often interrupted, remained an important part of East Asian
history. But the direction of the cultural influence was almost entirely one
way, from China—the "Middle Kingdom," universal empire, repository
of all true civilization—to the remote island kingdom of the Eastern seas.
Never incorporated within the Chinese empire or even its outlying tribu-
tary state system, Japan still could be considered, by Chinese and Japanese
alike, as belonging at least partly within the Chinese sphere of cultural
influence. Chinese who went to Japan, such as the Buddhist monks of the
Tang period or the Confucian loyalists of the late Ming, came as purveyors
of higher civilization and as teachers to the culturally provincial Japanese.

Therefore, it was a major reversal in the historic relations between the

two countries when, in the aftermath of Japan's startling victory over China in the Sino-Japanese War of 1894–1895, Chinese students started flocking to Japan to learn how the Japanese had so quickly mastered the secrets of Western "wealth and power." In 1895 there were only 200 Chinese students in Japan; by 1900 the number had grown to 700. After the second dramatic display of Japan's modernization, the victory over Russia in 1905, the number jumped to 5,000, reaching a peak of 8,000 in 1908.[1]

But numbers tell only part of the story. For a crucial transitional generation of Chinese intellectuals and political leaders, Japan became the closest, most accessible, and possibly most relevant mentor for how to build a modern industrialized nation-state. The repeated defeats and humiliations of the late nineteenth century, climaxed by the Boxer debacle in 1900, had shown that China's own tradition no longer provided the necessary lessons for survival in the new world of imperialistic power politics. Especially for young intellectuals, those answers had to be sought more in Western learning than Confucian texts. Study abroad suddenly seemed the quickest and most effective way to get that Western learning. Japan was not only closer and more economical to live in than Western nations, but it also had absorbed Western knowledge without losing its distinctive natural identity. Moreover, Japanese culture and language seemed less remote for young Chinese contemplating study abroad. The object was Western learning, but the medium was late Meiji Japan. And, of course, the medium affected the message.

Chinese Students and the Meiji Model

Intellectuals were not the only Chinese attracted by Japan's success in modernization. Even the conservative Qing government saw the Meiji model as a means of instituting controlled political change and, especially after 1900, actively sponsored students going to Japan. But the Qing government found it much easier to encourage students to study in Japan than to control what they learned and how they applied it. Many students who went to study Western science ended up in more familiar humanistic subjects; others turned to political organization, military science, and social theory. Often they failed to complete a formal course of studies at a recognized Japanese school, but they did absorb the radical political ideas circulating among overseas students and the general atmosphere of late Meiji Japan. It was, of course, an atmosphere highly charged with the fierce nationalism of a country that had recently overcome threats to its independence and emerged victorious in two wars.

Sharing the animus against Western domination, but much more successful in dealing with it, Japanese nationalism was an inspiration and a source of envy to many of the Chinese studying in Japan. Against a background of continued government weakness and national humiliation, it turned many of these young intellectuals toward a militantly revolutionary nationalism. In August 1905 the veteran anti-Manchu revolutionary Sun Yat-sen fused various provincial student groups into the Alliance Society (Tongmeng hui). This was the organization that would spearhead the Revolution of 1911 and be the direct ancestor of the Chinese Nationalist party (Guomindang). Founded in Tokyo with its headquarters and revolutionary publication (*The People's Newspaper*, or *Min bao*) there, it drew a large number of overseas Chinese students into its organization and, through the running controversy with the organ of the reform party of Liang Qichao, the *New People's Newspaper* (*Xin min congbao*), it stirred political and patriotic feelings among many more.

Especially from 1905 to 1911, Tokyo was the matrix for the new ideas that were moving the next generation of China's intellectual and political leaders away from the world of their fathers. It was also the center of the revolutionary agitation that would end the imperial system. Japan had become a transmitter of Western ideas, an inspiration for Chinese nationalism, and a convenient place for revolutionary organization. At a crucial turning point in Chinese history, the millenium-long relationship between the two countries was reversed. China, with many of her most able and ambitious youth going to Japan as eager students rather than culturally self-confident missionaries, now became the cultural borrower. For a brief period, the decision makers and opinion molders of China—conservatives, reformers, and revolutionaries alike—saw Japan as China's mentor in modernization. The period was not long, because Japan's own imperial ambitions would make her the chief enemy of twentieth-century Chinese nationalism, but at this juncture the Japanese connection was fundamental in molding the intellectual and political leadership of early twentieth-century China. This fascination with the Japanese example reached its peak of intensity between 1905 and 1911, exactly the period in which the three young Cantonese artists who would form the Lingnan School arrived in Japan.

From Guangdong to Japan

The difference, and distance, between Canton and Tokyo is symbolized by Gao Jianfu's first experience in Japan. Arriving early in 1906 during the dead of winter, he had no warm clothes to cope with Japanese temperatures

and, because the Guangdong Students Association, which he had counted on to provide shelter and support was no longer in existence, he was cold, homeless, and destitute.[2] This was a chilly reception in the outside world and an unpromising beginning to his career as a foreign student. But in these desperate circumstances old Guangdong connections and luck came to his aid. He happened to meet a former friend from Canton, Liao Zhongkai, on the streets of Tokyo. Gao had formerly taught painting to Liao's wife He Xiangning, so the traditional bonds of friendship and the teacher-pupil relationship secured the freezing young artist a place at Liao's house until he was able to support himself by selling his paintings. It was a chance meeting of more than temporary significance for Gao's life and politics. Liao Zhongkai was one of Sun Yat-sen's leading lieutenants in the Alliance Society. The renewed acquaintanceship with Liao led Gao Jianfu to a meeting with Sun and a place in the inner circle of the Alliance Society's leadership. He probably had nationalistic sympathies before coming to Tokyo and knew some Alliance Society members, but it was in Tokyo that Gao Jianfu began his lifelong association with the Alliance Society and its successor, the Chinese Nationalist party. It was also during these years in Tokyo that he became a revolutionary activist himself.

Unfortunately, there is little more recorded about Gao Jianfu's sojourn in Tokyo. He studied art, he sold paintings, and he joined the Alliance Society. The titles of the paintings he contributed to a sale in Tokyo to raise funds for Chinese flood relief give some idea of the highly charged patriotic spirit in his art: *Shi Kefa Writing His Suicide Letters*, *Hua Mulan Joins the Army*, *Chinese Ships Defy Danger at Sea*, *Flood Disasters*, *Refugees*.[3] In summer 1907 he returned to Canton to bring his younger brother Qifeng to Tokyo. The next year Jianfu accepted Sun Yat-sen's order to return to Canton to work in the revolutionary underground there; his stay in Japan was brief, under three years. Qifeng appears to have been in Japan for an even shorter period, while a third, even younger, brother, Jianzeng, did not arrive in Japan until after 1911 and died before returning home.[4] However, from their surviving paintings, it is apparent that the short experience in Japan had a decisive impact on all of them.

The same is true for the final member of the original Lingnan School, Chen Shuren. He differed from the Gaos in that he stayed longer in his initial period of study abroad and later had much more extensive overseas experience in a long career as Nationalist party functionary and government official. But he too came to Japan in the period just after the Russo-Japanese War (1904–1905), entering the same atmosphere as the Gaos, although he chose to study in Kyoto at the prestigious Municipal Art School.[5] While there, he also became an Alliance Society member, and he

returned to China when the revolution broke out in 1911. After the revolution he went back to Japan, this time enrolling in the Literature Department at Rikkyō University in Tokyo. As with the Gaos, there is little specific information about his student experience in Japan, but they all left one unmistakable record of what they had learned during those years—their art.

The main source for Japanese influence in the genesis of the Lingnan School, therefore, is the painting that the Gaos and Chen Shuren produced. In understanding why certain developments in late Meiji art most affected them, it is necessary to keep in mind the general situation of Chinese students in Japan at this time. They were freed from traditional social, cultural, and political restraints, although they did not manifest the fierce cultural iconoclasm that characterized the next generation of young intellectuals in the May Fourth period. Instead, their radicalism was more directly political—anti-government and anti-Manchu. They sought to save China by borrowing new ideas from the West, ranging from republicanism to social Darwinism, but they did not yet see the necessity to discard most of China's cultural traditions.[6] As long as the Manchus were in power, the revolutionaries did not link China's present weakness with her traditional culture. That would come later when the overthrow of the Manchus and establishment of a republic had not "saved the nation" in the way they had expected. But for the decade before 1911, the formative period in the lives of these artist-activists, radical Chinese nationalism did not yet require cultural iconoclasm or strong agitation against foreign imperialism. Artists could still draw heavily on the cultural legacy, although trying to revivify it. Activists could still concentrate their ire on the alien Manchus.

In later years the expansionist emphasis in Japanese nationalism would turn Chinese patriots against Japan, but at this time Japanese nationalism was much more a source of inspiration than a menace. Contrasting their own nation's weakness and backwardness with Japan's rapid progress and military victories, they were favorably impressed with Japan's accomplishments and eager to emulate them. Sun Yat-sen himself was extraordinarily optimistic about how Japan could help his revolutionary cause. Why then should radical young Cantonese artists have any doubts about contemporary Japanese art as yet another example of adapting traditional culture to the demands of a new nationalism? Their nationalistic feelings prohibited any direct Japanization of Chinese painting just as much as any Westernization, but they did believe that certain developments in Japanese art showed how China could develop a new national style of painting, both modern and still Chinese. In art too, the Meiji model was compelling.

Although they ostensibly went to Japan to study Western painting, these Cantonese artists did not directly turn to the Western-style art of late Meiji Japan. Gao Jianfu is supposed to have been a member of the leading Western-style art societies in Tokyo: the White Horse Society, the Pacific Painting Society, and the Water Color Study Society.[7] But none of his extant paintings from this period is in a Western style. There is simply no trace of either Kuroda Seiki's "impressionism" from the White Horse Society or the more formal neoclassicism of the other pole of late Meiji Western-style painting, the Pacific Painting Society. To be sure, there are some Western elements in the syncretic style adopted by all three artists during and after their study in Japan. But all of these elements—fixed perspective, shading, atmosphere, and light effects—are already found integrated with Oriental brush-and-ink painting in existing Japanese-style painting schools. It was to the schools of Oriental or Japanese painting that the young Cantonese turned, not to Western art per se.

Significantly, the most relevant of those schools was highly nationalistic, but not traditional. It was the movement initially stimulated by the American educational advisor and enthusiast for Japanese art Ernest Fenollosa, who arrived in Japan in the early 1880s, when modernizing Japan's fascination with everything Western was leading to the neglect or abandonment of native artistic tradition.[8] Partly due to his efforts, but more to those of his disciple Okakura Kakuzō, this neglect of Japanese art was replaced by an enthusiastic and often highly nationalistic appreciation for Nihon-ga (Japanese-style painting).

The leading artists in putting Fenollosa and Okakura's ideas into practice were Kano Hōgai (1828–1888) and Hashimoto Gahō (1835–1908). Both came out of the Kano School, a tradition that had its distant roots in Song period Chinese painting but had long ago adapted to Japanese tastes and become the official art school of the Tokugawa government. The Kano style featured the bold use of ink and a heavy, often angular line, but by the nineteenth century constant repetition had drained the school of its earlier force. Hōgai and Gahō, inspired by new ideals and some exposure to Western art, represent the last creative outburst of the long-lived Kano School and, more significantly, the birth of a new kind of Japanese painting (figure 14).

This revivalist movement in painting came in the context of a general reaction against the wholesale Western cultural borrowing of the first decade after the Meiji Restoration of 1868. In art it led to the governmental establishment of the Tokyo School of Fine Arts (Tōkyō Bijutsu Gakkō)

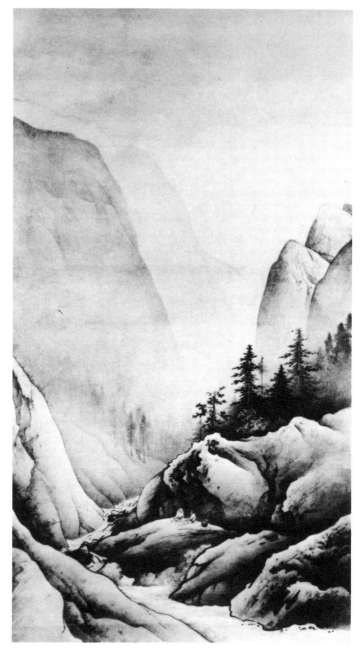

14. Hashimoto Gahō, *Landscape*, n.d. (Courtesy of the Philadelphia Museum of
Art. Given by Mrs. Moncure Biddle in memory of Ernest F. Fenollosa.)

with Hashimoto Gahō as chief painting instructor and Okakura Kakuzō as chief administrator and art theorist.[9] Concentrating on "Japanese" (i.e., brush and ink) painting for its first decade, it was undoubtedly the premier art school in Japan. When Okakura resigned from the school in 1898, ostensibly because of his opposition to including Western-style art in the curriculum, it did not appreciably slow the momentum of the new national painting movement. Okakura immediately founded the privately run Japanese Academy of Fine Arts (Nihon Bijutsu In) to continue his ideas of a pure Japanese painting. But pure did not mean purely traditional, for "Japanese-style painting" already had absorbed both techniques and ideas from the West, with none of them more important than a strong emphasis on individual creativity. Therefore, the leading figures at the Japanese Academy of Fine Arts, younger artists such as Hishida Shunsō (1874–1911) and Yokoyama Taikan (1868–1958), were boldly innovative in their works after 1900. By the time the young artists from Canton arrived in Tokyo, despite internal rifts and challenges from Western-style artists returned from study in France, the Japanese-style painting movement was still ascendant in the Japanese art world.

Although Okakura Kakuzō had become something of a maverick in the official Japanese art establishment, his ideas about a rejuvenated national art were widely accepted in the highly charged patriotic atmosphere of late Meiji Japan. Art as a national treasure, art as a stimulus to national pride, emphasis on creativity and absorption of some Western techniques as long as the national spirit remained, even pan-Asian ideals of Eastern spirituality[10]—all were attractive to the young artists from China who saw a desperate need for cultural as well as political rejuvenation in their own country.

The fact that the National Painting movement was originally Western inspired, that it sprang more from aroused nationalism than pure tradition, was no discouragement to the incipient revolutionaries from China. Already Christian in religion and republican in politics, they were no strangers to Western ideas. They wanted to change China and Chinese art, but their own training was in traditional painting and their nationalism reinforced a reluctance to depart too radically from the Chinese tradition. Fenollosa's original formulation had been more culturally nationalistic than that of native Japanese nationalists. Speaking to the Ryūchikai, a Japanese art appreciation society, in 1882, he had told them: "The Japanese should return to their nature and its old racial traditions, and then take, if there are any, the good points of Western painting."[11]

This kind of syncretism was too conservative, too suspicious of Western art, for the young Chinese artists who came to Japan some twenty years

later. They were neither so disdainful of Western art's good points nor so committed to old traditions. In their case, those traditions still seemed too strong and too restrictive, whereas Fenollosa had been reacting against the earlier Japanese tendency to be swept away by Westernizing enthusiasm. Even in the 1900s, there was no comparable enthusiasm for cultural Westernization in China, so even a syncretic art incorporating Eastern and Western elements seemed radical. Okakura's Japanese Academy of Fine Arts offered the theory to "reconstruct the national art on a new basis"[12] and, on the practical level, the achievements of his and other schools of national-style painting provided convenient models.

Gao Jianfu may have studied at either the Tokyo School of Fine Arts or the Japanese Academy of Fine Arts. The Chinese sources are disturbingly confused on this point, referring to him as being the first Chinese student to gain admission to the "Tokyo Academy of Fine Arts," which they claim was the highest official art school in Japan.[13] That would have to be the Tokyo School of Fine Arts (Tōkyō Bijutsu Gakkō) in Ueno Park. But, apart from the implausibility of a student with little more than one year's study of Japanese gaining admission to an elite government school, the school's records do not show him as an admitted student.[14] Perhaps the confusion in names means that Gao really studied at the Japanese Academy of Art, Okakura's private art institute, then located on the outskirts of Tokyo. That school's favorable attitudes toward Chinese art may have made a well-trained painter from China more welcome there, despite his limited preparation in formal Japanese academic subjects. Regardless of which of these two schools Gao Jianfu attended or whether he was a formal student at all, in a broad sense Okakura's new National Painting movement was reflected in both institutions, and it provided the intellectual framework for the syncretic style that the Lingnan School would adopt.

Curiously, however, the strongest stylistic influences on all the Lingnan artists came not from Tokyo, where the Gaos studied, but from Kyoto. This may seem paradoxical when Tokyo was supposedly the center for the new ideas that drew Chinese students to Japan, but Kyoto also made unique contributions to the modernization of Japanese art. This started over a hundred years earlier with two Kyoto artists, Maruyama Ōkyo (1733–1795) and Matsumura Goshun (1752–1811), founders of a distinctive Kyoto tradition, usually referred to as the Maruyama-Shijō School or simply the Shijō School.

Although more than a century passed before the young artists from Canton arrived in Japan, the genesis of the Maruyama-Shijō School is not irrelevant to their artistic evolution. Before leaving China, Gao Jianfu had already become interested in the problem of assimilating the "scientific"

aspects of Western art into Oriental brush painting. In some ways, the Maruyama-Shijō School, especially its founder, Maruyama Ōkyo, had worked out a practical solution to that problem long before young Chinese nationalists or Japanese Nihon-ga theorists had had to grapple with it under the pressures of massive Western cultural intrusion at the end of the nineteenth century. Of course, the absence of such pressure in an eighteenth-century Japan still virtually sealed off from the outside world made the effort at artistic syncretism by Ōkyo and his followers very different in its specific character and general cultural significance from that attempted by later artists in China or Japan. The earlier Kyoto artists were not defending an endangered national cultural identity or seeking to stimulate a new national consciousness through art. They simply saw an opportunity to use some of the techniques and concepts of Western art as a means of enriching and invigorating their own tradition.

If the eighteenth-century artists did not face any Western cultural pressure, they also did not have free and easy access to Western art. Under the Tokugawa seclusion policy, all that was available to them were the copperplate engravings in Dutch scientific books and Chinese "eyeglass pictures" done in the manner of Western prints for a three-dimensional stereoscopic device, which was introduced through the only open port at Nagasaki.[15] But it was enough to arouse interest in the illusionistic effects, the sense of space and distance, obtained through such novel Western devices as chiaroscuro (shading) and fixed point (vanishing point) perspective.[16]

A superb draftsman with a solid compositional sense and great curiosity about how to get closer to visual reality, Ōkyo took these hints about Western art and turned them into a new approach to ink-and-brush painting. It is generally claimed that he brought a new realism to Japanese art. In his work the "realism" comes from a closer attention to the actual appearance of objects, based on close personal observation and sketching from life. It is reinforced by selective use of devices from post–Renaissance European painting, such as fixed point perspective and shading, which give a stronger illusion of depth and volume. Similarly, in subject matter Ōkyo and his followers showed a preference for the actual scenery of the Kyoto environs—the seasonal changes of its flora and its fauna, such as monkeys, foxes, hedgehogs, and weasels (figure 15). This contrasted with the usual choice of more refined subject matter by the older Japanese schools or of Chinese sages and scenery by the newly risen Nanga (Chinese-style literati painting) masters.

This does not mean that the new Kyoto-based school approached the realism of European painting, let alone nineteenth-century European realist schools, either in technique or philosophy. The Kyoto painters retained the

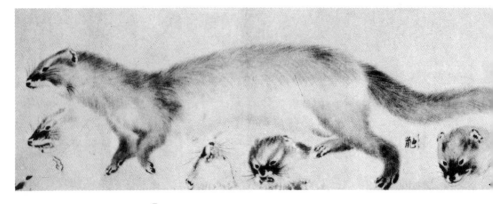

15. Maruyama Ōkyo, *Sketch of a Weasel*, n.d.

techniques, materials, subjects, and philosophy of brush painting in distinction to the few eighteenth-century Japanese artists who went all the way in trying to emulate Western realism by imitating Western techniques and copying Western pictures. Those artists, notably Shiba Kokan, were interesting harbingers of later Western cultural influence, but they were largely ignored in their own lifetimes.[17] On the other hand, Ōkyo, using representational techniques from Western art while retaining the main features of his own tradition, was enormously influential during and after his life. Through close observation of nature, extensive preparatory sketching, careful brushwork, and skillful handling of space based on Western ideas of perspective, he laid the foundation for a school that remained important throughout the nineteenth century and offered Japan some preparation for meeting the more serious Western challenge toward the end of that century. Realism—partly through appropriation of selected Western techniques and partly through a more direct approach to the material world—was a prominent characteristic of the Kyoto-based school Ōkyo founded. But there was also another side, a conflicting tendency, in the mature Maruyama-Shijō School that helped account for its long-lasting popularity in Japan and its appeal to visiting Cantonese artists a century later. The more lyrically expressive, poetic, or even "romantic" side of the Shijō School came mainly from its second great master, Matsumura Goshun.[18]

Again, the original stimulus toward this direction came from a foreign source, although one thoroughly assimilated to Japanese needs and sensibilities. Before studying with Ōkyo, Goshun had been a disciple of Yosa Buson (1716–1784), one of the greatest masters of Nanga painting in Japan. Based on Chinese literati painting of the Yuan and Ming dynasties, by the

mid-eighteenth century it had evolved into a sophisticated Japanese interpretation of the Chinese scholarly artist's tradition. With such painters as Buson it brought a poetic sensitivity and individually creative expressiveness to Tokugawa period painting, which had fallen under the domination of the increasingly sterile official Kano School.

Matsumura Goshun combined the new solidity or realism of Ōkyo's art with Nanga-derived lyricism to produce a distinctive Kyoto school that took its name from the fact that he and most of his disciples lived on Shijō Street (Fourth Avenue) in Kyoto. The urban character of the school and its dependence on the Kyoto merchant class for patronage is another significant aspect of how the Shijō School anticipated the situation of Japanese and Chinese artists a century later when they would have to absorb new influences and create art with a new flavor to appeal to the tastes of a rising bourgeois class.

The Ōkyo-Goshun synthesis retained enough literary and cultural associations to give it prestige with sophisticated urban patrons but, through Ōkyo's representational realism and Goshun's emotional sensitivity, it also had a broad public appeal in its emphasis on "atmosphere and a sense of locality."[19] Perhaps it is the creative tension between the two original impulses behind the school—Ōkyo's "sketching school"[20] contact with immediate reality and Goshun's poetically inspired emotional sensitivity—that accounts for the school's continued vitality throughout the nineteenth century. Its realistic, but emotionally expressive, animal studies were a hallmark of the school, but so were misty landscapes of the Kyoto area, done with moist ink washes, which evoked that strong "sense of locality" while conveying lyrical and romantic feelings. Ōkyo, though impressed by the realistic sense of space and volume in Western-derived pictures, had translated those features into a Japanese idiom through such devices as using the unevenly loaded flat brush (*hake*) to produce various atmospheric and volumetric effects.[21] But in typical Shijō School landscapes the consequent deemphasis on line and reliance on broad ink washes produced misty, romantic effects more than Western realism.

Realistic, but also romantic in the sense of being freely expressive and evoking wistful poetic emotions in the viewer—this was the essence of the Shijō School. Apparently, it satisfied the tastes of the Kyoto bourgeoisie. By the second half of the nineteenth century, its influence had spread to Tokyo. When the new Japanese-style painting movement sought to revitalize national art, even though its originators came out of the Kano tradition, they could not ignore the lessons of the Shijō School. Its last great master, Takeuchi Seihō (1864–1942) was even more relevant to the new times because he willingly absorbed a new dose of Western art in a much

more direct manner than through Ōkyo's peep show stereoscope. In 1900–1901, Seihō traveled widely in Europe where he was much impressed by the plein-air naturalism of Corot and the luminous intensity of Turner's skies and ocean views.[22] By the end of the decade, when the Chinese art students were in Japan, Seihō was basically a syncretist, "probably the most successful of those artists of his period who attempted a fusion of the art of Japan and the West."[23] He was able to combine the two original impulses of the Shijō School, realism and romanticism, while incorporating more immediate Western influences. This combination was very attractive to the three founders of the Lingnan School making Seihō, without a doubt, the greatest single Japanese artistic influence on them.

There is no problem in seeing how Chen Shuren as a student at the Kyoto Art School was exposed to the Shijō School in general and Seihō, in particular.[24] But how did the Gaos in Tokyo receive a similarly deep impression? By the late Meiji period, there were several channels for Kyoto School influence in Tokyo. Since the middle of the nineteenth century, Kyoto artists, such as Kishi Chikudō (1826–1897), had brought Shijō painting to Tokyo, and their works could still be seen there. More directly relevant were several prominent Kyoto-trained artists teaching at the leading art schools in Tokyo when the Gaos arrived there. The most famous, Kawabata Gyokushō (1842–1913) and Terasaki Kogyo (1866–1919), were somewhat eclectic in that they had spent most of their careers in Tokyo and had picked up elements of the Kano style that were important in the new Japanese-style painting. But their early training was in Kyoto, and their mature works retain a strong Shijō flavor whose realistic character is further strengthened through direct exposure to Western art.[25]

Seihō himself remained teaching in Kyoto, but there were many ways that his and other Kyoto artists' influence could reach Tokyo. To begin with, the Shijō School was noted for its high-quality woodblock reproductions, several excellent volumes of which were available to students in Tokyo.[26] There were also the lower-quality, but easily purchased, prints found in cheap reproduction volumes and the new art journals being published in Tokyo. Reproductions by themselves could arouse curiosity but might not give the necessary artistic details for mastering new techniques. Apart from the Kyoto-style artists teaching in Tokyo, these details and techniques were available through another modern art institution—the national exhibition. The public art exhibition was one more Western innovation that would help reshape traditional art, first, in Meiji Japan and, then, in twentieth-century China. It started in Japan soon after the Meiji Restoration. By 1907 the national government had assumed direct control over the most important annual exhibition, the Bun Ten, under the spon-

sorship of the Ministry of Education. The Gaos would take up the idea of public exhibitions and government sponsorship as part of their plans to modernize Chinese art. They would also find in these early Bun Ten exhibitions some important sources for their own art.

In short, the world of modern Japanese painting had been sufficiently unified by this time so that Chinese students in Tokyo could fully imbibe Kyoto influences. Their general preference for what might be called the modernized Shijō School, artists such as Takeuchi Seihō, Yamamoto Shunkyo (1877–1933), and Hashimoto Kansetsu (1883–1945), was an indication of what they were looking for in Japanese art—emotional impact, dramatic effects, enough stylistic innovation to give a credible claim to modernity, and at least an echo of Western realism without abandoning Eastern traditions of brush and ink.

Realism and Romanticism

The evidence for this fascination with the Shijō style and its dual emphasis on realism and romanticism must be sought directly in the art these young Cantonese painters produced during and after their Japanese sojourn. One way of looking at it is according to the different genres or types of subjects they painted, for many of these were new to them. But the new subjects—tigers and lions, hawks and eagles, snowy mountains and misty rivers, whimsical monkeys and curious foxes—were only part of a whole approach to art that departed considerably from their original Guangdong training. In Japan stylistic influences, and even philosophical ones, were as important as thematic ones. For understanding the effect of their Japanese experience on these Chinese painters, it is important to study not just what they painted, but how.

In Guangdong, under Ju Lian's tutelage, they had specialized in flowers, birds, plants, and insects. If they had been looking for something familiar in Japan, they could have found it in the Japanese Kachō (bird and flower painting), which still bore the marks of the Chinese paintings in that genre, which had entered Japan through the Nagasaki trade connection in the eighteenth century.[27] Like Ju Lian's local Guangdong tradition, much Kachō had distant roots in late Ming bird and flower painting, although by this time it had passed through a long process of Japanization. But it was still somewhat old hat for these bold young Chinese artists who were looking for something more novel, more exciting, more dramatic. One of the genres they found this in was animal painting.

In particular, they took up with enthusiasm the Japanese manner of

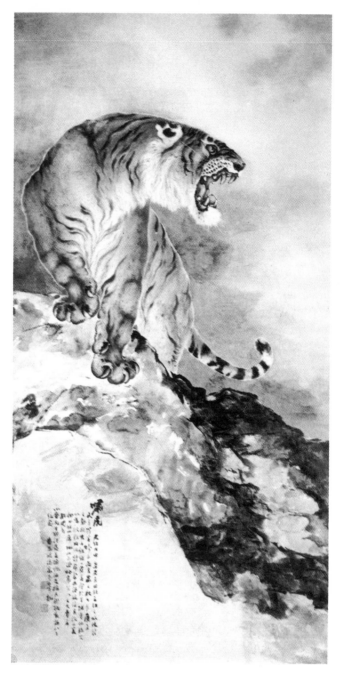

16. Gao Qifeng, *Roaring Tiger*, 1908.

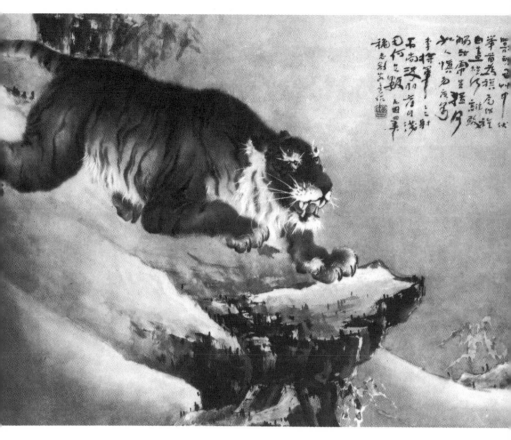

17. Gao Jianfu, *Tiger*, 1915.

depicting bold, fierce, predatory animals—lions, bears, and, most impor-
tantly, tigers. Tigers had a long pedigree in Chinese painting, but the kind
produced by all three of the Gao brothers was very much in the Japanese
style. The most obvious feature is the naturalism and restless ferocity of
their tigers (figures 16 and 17). This and the picturesque settings amid
snowy crags or moonlit fields came straight from contemporary Japanese
tiger painting. It is less obvious exactly who their exemplar was in this field
since there were so many competent Japanese tiger painters. There is strong
stylistic evidence that Gao Qifeng saw the second Bun Ten national exhi-
bition in 1908 where Mio Goseki's impressive *Tigers in the Snow* was
displayed.[28] In any event, these southern Chinese painters were much taken
with the dramatic possibilities of such majestic beasts in snowy settings.

Whether they were more influenced by Mio Goseki, Kishi Chikudō, Nishimura Goun, or some other famous Japanese master in this genre, these are not Cantonese tigers.

There also is an interesting difference in approach to the subject between the two senior Gao brothers. Gao Qifeng's tigers are more realistic and perhaps more ferocious (figure 16). Restless, prowling, always roaring or snarling—they established his reputation as the premier tiger painter among Lingnan artists and one of the best-known tiger painters in modern China. The only surviving tiger painting by the youngest Gao brother, Gao Jianzeng, is in this same style. His older brother Gao Jianfu, on the other hand, is less well known for his tigers, and his extant paintings show a rather different style and temperament (figure 17). The setting is often the same, moonlight or snowy mountains; the beasts are similarly powerful and prowling; teeth and claws are just as prominent; the same kind of emotional appeal or even allegorical message about China's need for boldness and bravery may be present. But, even in his most detailed work, as in the 1915 painting of a tiger stalking through a moonlit snowy landscape, Gao Jianfu's tigers fall a little short of Qifeng's in painstaking realism. More significantly, the tiger's expression, although fierce, is not quite the naturalistic ferocity of Gao Qifeng's tigers. With Jianfu there is an additional emotional expressiveness in the tiger's face, perhaps even a touch of whimsy, which he might have found in the tiger paintings of his famous Japanese contemporary Takeuchi Seihō, but which also might come from a long tradition of Chinese animal paintings. In their paintings of tigers, the distinction might be subtle but, along with differences to be noted in other spheres, it seems to indicate that Qifeng absorbed late Meiji Japanese painting techniques more directly and perhaps more deeply. In contrast, Jianfu blended them more into Chinese traditions and tried to give them a more personal meaning.

In any event, all the Lingnan artists were deeply impressed by contemporary Japanese animal painting. Along with his tigers, Qifeng also produced studies of proud and majestic lions. These lions, painted with realism and vigor, certainly were an innovation for Chinese painting. There are no examples of Jianfu painting this subject, but other Lingnan artists, such as Chen Shuren and Jianfu's pupil He Xiangning, painted great, menacing, stalking lions (figure 18). Again, Japanese sources for their works abound. Takeuchi Seihō did several famous lion pictures in this period, although here too the work of a lesser painter, Mochizuki Seihō, exhibited at the 1909 Bun Ten, may have been more directly influential.[29] For the Chinese artist-patriots, these lions served even more directly as

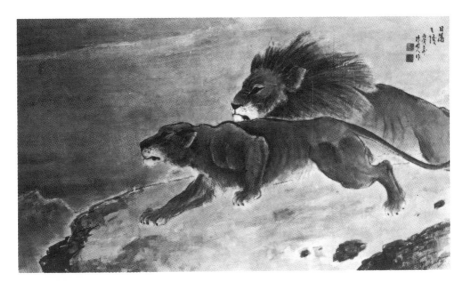

18. Chen Shuren, *Lions*, 1926.

symbols of resurgent Chinese nationalism. In the 1920s, Gao Qifeng was especially commissioned to paint a roaring lion for the Sun Yat-sen Memorial Hall in Canton.

The big cats gave dramatic expression to the artists' heroic aspirations and political ideals, but other animals were just as important for the mastery of new techniques that would approach Western painting in realism without abandoning brush and ink. Gao Qifeng was probably the most skillful emulator of Japanese animal pictures. His paintings of deer are similar to those of Takeuchi Seihō in style, composition, and attitude.[30] His horses are also unusually realistic for ink painting and very much in the Shijō naturalistic tradition. But it is in Gao Qifeng's paintings of water buffalo that he best displays the technique of giving solidity and volume to animal subjects by an uneven loading of the brush, which produces an effect somewhat similar to what Western painters achieve through chiaroscuro. This Shijō School technique was widely practiced by its twentieth-century descendants, such as Takeuchi Seihō and his well-known student Hashimoto Kansetsu. As evidence of direct and specific influence on Gao Qifeng, there is the close correspondence between his painting of two water buffalo and Hikida Hoshō's screen painting shown at the 1909 Bun Ten exhibition (figures 19 and 20). If Gao Qifeng did not see this exhibition, he must have studied the illustrated catalog very carefully. However, in the

19. Gao Qifeng, *Water Buffalo*, n.d.

20. Hikida Hoshō, *Water Buffalo*, 1909.

larger sense it was the Chinese artist's absorption of general techniques and approaches to animal subject matter, rather than copying specific compositions, that was most important for the Japanese molding of his artistic personality.

The same can be said for the studies of smaller animals, such as monkeys and foxes, that had been important themes in Kyoto naturalism since Maruyama Ōkyo. Kyoto artists, notably Takeuchi Seihō and Hashimoto Kansetsu, continued to display the combination of realism and animated expression that gave the Shijō School much of its appeal right into the twentieth century. That appeal obviously was strong for the Gao brothers who took to monkey painting with great enthusiasm and expressiveness. Again, they often located their monkeys in dramatic snowy or moonlit landscapes, examples of which they could have seen at early Bun Ten exhibitions.[31]

They also tried, even harder than their Japanese exemplars, to give these most human of animals a strong, direct, and somewhat anthropomorphized emotional appeal. An undated (but from the style probably early) work by Gao Qifeng shows a solitary monkey gazing intently at the moon (figure 21). He sits on a large limb, which provides a strong horizontal to this simple composition. The monkey's curled fingers and toes are done with the unevenly loaded brush technique, his body in broader ink washes with fine strokes for the fur. The picture most effectively combines an expression of intense stillness and concentration with a sense of incipient movement. The tension in his limbs and flexed fingers, his thrust-forward head, and tense body suggest he is about to spring. The rhythmically drawn small branches, which provide a contrasting diagonal, add to the sense of movement. All in all, it is an excellent example of the Ōkyo-founded tradition of vividly and naturalistically drawn animals. The techniques are similar to Seihō and could have been copied from his works, but there is in the posture of the animal and overall composition a slightly more dynamic and dramatic quality, a more intense effort at direct emotional impact.

This heightened emotional appeal, adding to the romantic component at the expense of realism, can be seen even more clearly in many of their other works in this genre. A painting by Gao Qifeng dated 1910 depicts a gibbon swinging on a snow-covered vine toward a snowy branch, while a large pale orange moon shines over his shoulder. Again it is Shijō style, but the action, the atmosphere, the snow, and the moon all make it even more dynamic and dramatic than most Japanese works.

These qualities also emerge in more complex monkey landscapes, which show primate bands moving among trees and branches. In one painting,

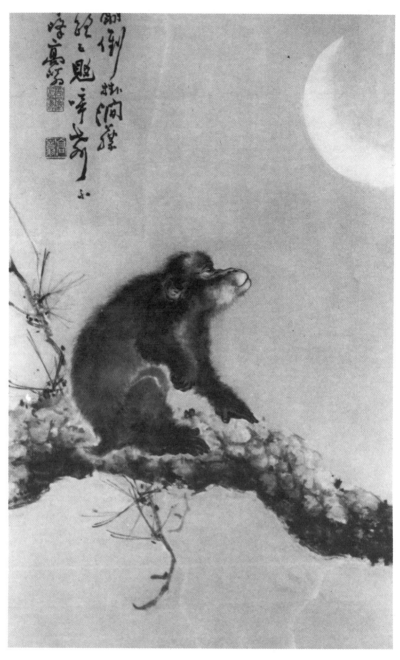

21. Gao Qifeng, *Monkey Gazing at the Moon*, n.d.

Gao Jianfu has a small group of monkeys in shadowy tree branches silhouetted against the same orange moon.[32] Gao Qifeng did another study of monkeys in the snow where the composition closely resembles that used by Mochizuki Seihō in the 1909 Bun Ten exhibition (figures 22 and 23). The monkeys are grouped on a long diagonal branch running from one corner of the picture to the other. But in the Japanese version, they are relatively still, and the atmospheric effects are much more subdued. In Gao Qifeng's painting, one monkey is walking down the branch and another hangs from it by one arm, while the background shows the dramatic light contrasts of moon through the clouds on a cold, snowy night. It is the same subject, the same composition, but again more dramatized (or romanticized) in its Chinese version.[33]

A comparison of fox paintings, a favorite subject for Japanese artists especially in the Ōkyo tradition, leads to the same conclusion. One of Gao Jianfu's most famous allegorical works, begun in 1914 but not finished until 1928, shows a fox stealing off with a dead chicken in its mouth (figure 24). The title is *The Strong Devour the Weak*. This social-Darwinian message was a standard part of turn-of-the-century Chinese intellectuals' education. The animals are done with considerable anatomical skill and realism, but other elements in the picture do not seem to fit well with its stern allegorical warning. The fox moves beneath languorously painted branches and grasses bathed in the pale light of a misty moon. When doing this scene, Gao Jianfu could not get away from the Shijō-derived mists and atmosphere. An earlier painting by Seihō, probably from the 1900s, shows a similar fox slinking through calligraphically drawn branches (figure 25). It may be the prototype for Gao Jianfu's fox.[34] It certainly is the source for a curious painting by Gao Qifeng, published under the title *Fox Suspicions*, but apparently a picture of a raccoon (figure 26). Whatever the species, the posture of the animal is exactly the same from turned head to curled tail, and the artist uses the same light washes for background and lightly sketched grasses for atmosphere. But a large crescent moon has been added, and the animal wears the guiltily furtive expression of a thief caught in the act. Neither of the Gao brothers was content to do a simple animal painting. They borrowed heavily from the Japanese masters, but they added more explicit allegorical meaning and exaggerated the emotional effects. Revolutionaries in politics, they were determined to revolutionize Chinese art by intensifying its emotional content, its popular appeal, and its capacity to carry an allegorical message.

The same features can be found in the related genre of bird painting. The young Cantonese artists already were accomplished flower and bird painters from their Guangdong training. In Japan they found a different

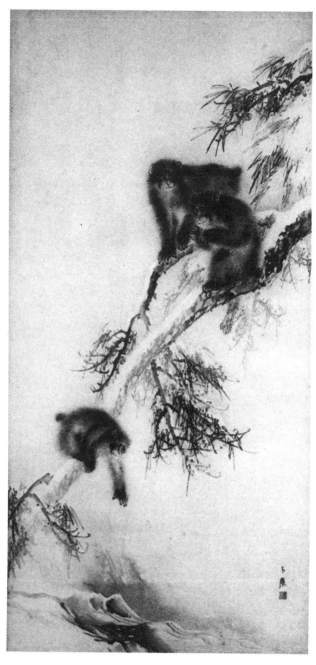

22. Mochizuki Seihō, *Monkeys in the Snow*, 1908.

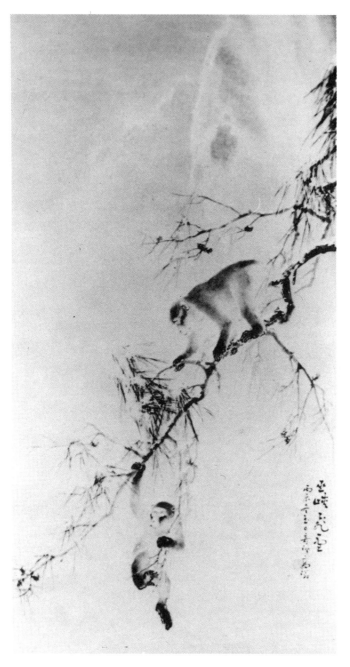

23. Gao Qifeng, *Flying Snow*, 1916.

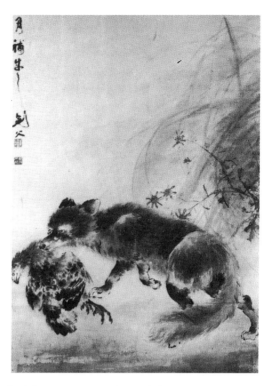

24. Gao Jianfu, *The Strong Devour the Weak*, begun 1914, completed 1928.

approach to different birds. Not the sparrows, hummingbirds, and para-
keets of the Ju Lian School, but great fierce birds of prey—hawks, eagles,
and owls—which may have been latent in their Cantonese heritage but
whose resurrection clearly came from Japanese examples. An eagle by Gao
Qifeng, dated 1908, clearly shows its Japanese and, in this case, Kano school
pedigree when it is compared to those done by the artistic leaders of the
new National Painting School—Kano Hōgai and Hashimoto Gahō in the
previous decades.[35] Such birds became a favorite subject for both the Gao
brothers. In some of their paintings, the Kyoto influence via Seihō and
others was apparent, but for this subject there was clearly a mixing of
Japanese stylistic influences. Nor should this be surprising, since by the
beginning of the twentieth century the originally distinct Kyoto and
Tokyo styles had been intermingled. In the Gaos' bird paintings, Shijō
naturalism, brush technique, and poetic qualities are strong, but there also is
something of the harder, more heroic mood and atmosphere of Kano

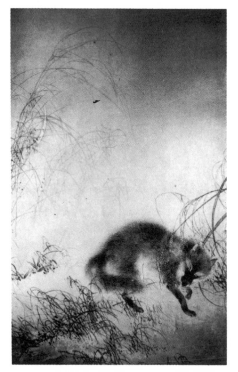 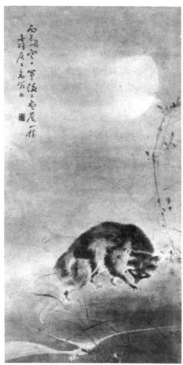

25.　Takeuchi Seihō, *Fox in Bamboo*, n.d.　　　26.　Gao Qifeng, *Fox Suspicions*, n.d.

hawks and eagles. For example, a painting by Gao Qifeng, *Autumn Eagle*, has more than a little of the Kano style, especially in the poised, aggressive wing posture (figure 27). But some of the brushwork, and particularly the boneless washes used in forming the tree trunk are more reminiscent of the Shijō style. In total, it is a composite picture, drawing on both Japanese schools. More obvious is the fierce, proud, heroic spirit of the bird, just slightly tempered by the nostalgia of falling autumn leaves.

That slightly sweet and lyrical touch, typical of the softer, romantic strain in the Shijō tradition, comes through more strongly in other pictures. A Gao Qifeng owl, painted during the year of his arrival in Japan, 1907, is neither fierce nor threatening as it perches before a romantic moon.[36] One might think that he had not yet changed his vision from the small, ornamental birds of the Ju Lian tradition, but later pictures of owls by Qifeng continue to invoke a mood of moonlit romanticism rather than heroic spirit.[37] Similarly Chen Shuren, who rarely did the heroic hawks or

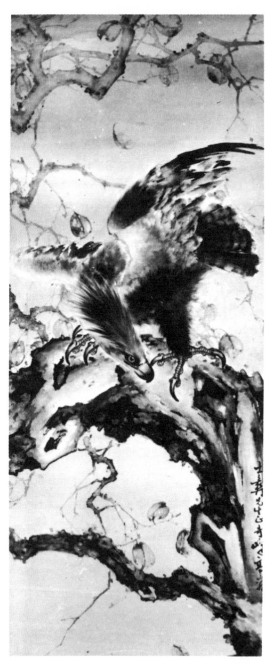

27.　Gao Qifeng, *Autumn Eagle*, n.d.

eagles of the Gao brothers, was equally fond of the misty atmosphere and full moon, as shown in his painting of two geese in the moonlight (figure 28). Although geese and rushes were a fairly popular subject in late Qing painting, such pictures of geese in flight were also stock-in-trade Kyoto subjects, going back to Maruyama Ōkyo and still prevalent when Chen Shuren was studying at the Kyoto School of Fine Arts. In this painting, Chen silhouettes the birds against a full moon, blurs the background with soft, colored washes, and sets the foreground with languidly drooping plants. The specific techniques and overall spirit seem much closer to Japanese tradition than to any Chinese prototype.

Although Chen Shuren and Gao Jianfu were both skillful bird painters, again it was Gao Qifeng who best captured the style and spirit of this Japanese genre. In addition to hawks and eagles, he painted brightly colored peacocks and snowy white cranes with great verve and realism. He also excelled at handling water birds, usually egrets or herons, set in the misty, leafy background of which Shijō painters were so fond. A fairly early, though undated, painting of a heron in flight closely follows the Kyoto school's use of light and atmospheric effects.[38] More directly, the rising heron closely resembles a panel of Takeuchi Seihō's two-screen painting *Clearing After Rain*, which had been one of the most widely acclaimed paintings at the first Bun Ten of 1907.[39] If one wishes to trace the pedigree of this scene back farther, it goes all the way to the founder of the Shijō School, Matsumura Goshun, in his large screen painting of *Willow Trees, Heron, and a Flock of Birds*.[40]

These large birds were not in the Guangdong artists' repertoire before they came to Japan, although small birds in the Ju Lian flower and bird tradition certainly were. But, even with such small birds, the Japanese experience caused considerable changes in how they were depicted. The Gaos, for example, again took from Seihō his adroit, spontaneous way of drawing sparrows. There is an early Gao Qifeng painting of several sparrows in a haystack that is taken directly from Seihō. Much later, in 1940, Gao Jianfu used almost exactly the same composition, an interesting example of deferred late Meiji influence in mid-twentieth-century Chinese painting.[41]

However, direct imitation is not that frequent nor that significant. More important is the general influence of prevailing late Meiji composition and feeling in bird paintings, whether the subjects were great birds of prey, moonlit waterfowl, or pert and lively small birds. For example, the Cantonese student-artists were fond of locating a solitary bird on a single horizontal branch to give a feeling of directness and immediacy to their works. This composition was not unknown in China. Ju Lian himself used

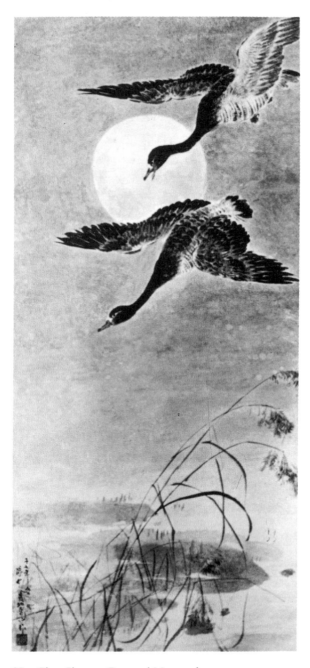

28. Chen Shuren, *Geese and Moon*, n.d.

it on rare occasions, but it was extremely common in late Meiji Japan and the Lingnan fondness for it seems to come from there. Or, to take another example in compositional method, they often used a long vertical format when combining trees, flowers, and small birds in one picture. Again, this was a favorite device among other schools of modern Chinese artists, but in their case the source of inspiration was Tokyo or Kyoto, not Shanghai.

Examples of specific influences, even where the subject or technique was previously known in China, could be multiplied. Japanese painters were fond of the "reserved white" technique for showing snow or ice on branches.* It became a standard device for Gao Jianfu and others. The scaly bark of the pine trunk, with all that tree's symbolic associations of fortitude, endurance, and bravery, was a favorite subject for Japanese artists ever since Ōkyo. The Gaos and Chen Shuren all painted this in a similar style, favoring the immediacy or realism of a close-up view of the pine's trunk or a large branch cutting diagonally across the picture plane. Similarly, when they painted willows, a tree rich in symbolic associations of a softer, more sentimental kind, they also leaned toward Japanese prototypes, in this case the moist broad ink washes popular with the Shijō School.

These are some of the most obvious areas of Japanese influence in their work. The overall conclusion is clear: when a subject or technique that did not appear in their oeuvre before going to Japan became an integral part of it afterward, there is little doubt about its source. Yet, in the long run, it was not just borrowing, but the selective nature of their borrowing and the desire to apply it to China's modern needs, that made the Lingnan School significant for the history and art history of twentieth-century China.

We can see this when turning to the final genre where the Japanese example helped shape their style—landscape. None of the Cantonese artists was a landscape painter before going to Japan, so perhaps they were especially open to Japanese guidance in this area. As with other subjects, there are instances of direct borrowing by the young artists as they sought to master this important genre. For example, the horse and rider in a 1910 Gao Qifeng landscape are copied from a painting in the Bun Ten of 1908.[42] The thatched farmhouses in winter scenes painted by both the Gao brothers came either from Japanese paintings or the Japanese countryside. Architecturally they are not Chinese, certainly not southern Chinese. Or, to take another particularly striking individual instance, Gao Jianfu's rather flam-

* The term "reserved white" refers to the practice of leaving parts of the paper unpainted, which provides an esthetically pleasing contrast with the ink tones of the painted surface and also depicts snow, ice, or mist. For the use of this by the Lingnan School, see the foreground in figure 16.

boyant painting *The A Fang Palace on Fire*, which was praised by a later Chinese art critic for its originality in "appropriateness of composition and freshness of color," is actually based on Kimura Buzan's entry in the first Bun Ten of 1907.[43]

Again, more important than the relatively rare instances of direct imitation were the Chinese artists' attempts to catch the dramatic spirit and vivid atmospheric effects in the Japanese originals. These general influences—light, color, atmosphere, perspective—were the lasting lessons that the young Cantonese painters learned from contemporary Japanese artists. Thus, many of their early landscapes draw heavily on the atmospheric effects produced by the wet ink washes that gave the Shijō School its misty and romantic quality. Even later in his life when he experimented with modern subjects like airplanes, Gao Jianfu still located them in a misty, rainy landscape reminiscent of early Seihō works. He also retained the Japanese-acquired use of soft color washes to give a rather dreamy, romantic effect to many of his landscapes.

Of the three founders of the Lingnan School, Gao Jianfu was best known as a landscape painter. His debt to Seihō, here as in other genres, is obvious, but he also drew heavily on another Kyoto painter, the master of spirited but realistic snow landscapes, Yamamoto Shunkyo. Shunkyo's art was available to Jianfu in his Tokyo days through publications and exhibitions. The Japanese painter's heroic landscapes, especially snow scenes, seem to have had a strong influence on Gao's early landscapes. There are several of these where Shunkyo's compositions were a direct source of inspiration. In Gao's imposing *Kunlun Mountains* from 1916, a flat-topped massive cliff rises to the top of the painting just as in an earlier landscape by the Japanese master.[44] Or, in another snowy landscape from Gao's immediate post-Japan years, the receding razor-like ridges are again directly derived from Shunkyo (figures 29 and 30). The strong realistic quality to these mountains stems from the Japanese painter's avid interest in photography as an aid to more accurately depicting natural scenery. These more realistic mountains obviously made a lasting impression on Gao Jianfu because, more than twenty years later when he visited India, the same mountain ridges reappear in his rendering of a Himalayan landscape. Such visual evidence of Shunkyo's enduring influence is confirmed by the testimony of one of Gao's students from the 1930s to the effect that Jianfu admired Shunkyo equally with Takeuchi Seihō and owned reproduction volumes of works by both Japanese masters.[45]

Gao Jianfu was not the only Lingnan painter to be influenced by Yamamoto Shunkyo. Chen Shuren's early landscape style also bears a strong stamp of Japanese dramatic atmospherics in general and Shunkyo's compo-

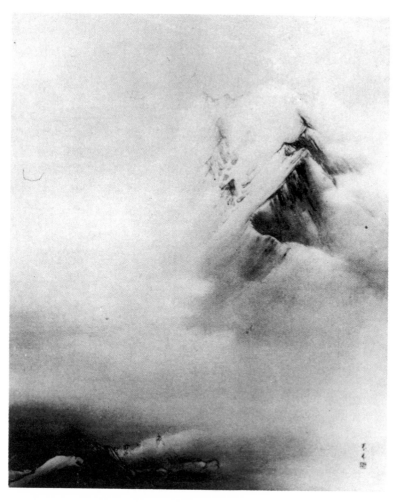

29. Yamamoto Shunkyo, *Snowy Landscape*, n.d.

sitions in particular. This is apparent from comparing one of the Japanese artist's foreign landscapes, where an American log cabin emerges from the snowy mists, with Chen Shuren's slightly later *Cruel Snow in the Rocky Mountains* (figures 31 and 32). The latter painting, reproduced in Shanghai in the mid–1910s, is probably too early to have been painted on Chen's own North American sojourn. Most likely, Shunkyo was the model for the young Chinese artist—in atmosphere, composition, and such details as the windblown trees and snow-roofed cabins.

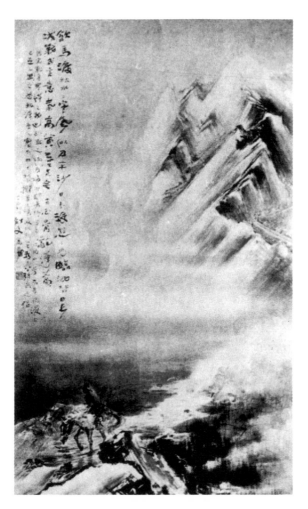

30. Gao Jianfu, *Snowy Mountain Pass*, n.d.

To repeat a central point, it is not so much isolated details that were important in forming the Lingnan School as the overall impact of late Meiji nationalistic ideas, artistic styles, and choice of subjects. In landscapes as in other genres, these young Cantonese artist-revolutionaries took Western realism, as translated by Japanese artists into ink painting, and combined it with a strong emotional expressionism that can be called romanticism. These two strains—realism and romanticism—often coexisting in an uneasy tension, were at the core of the Lingnan School's contribution to

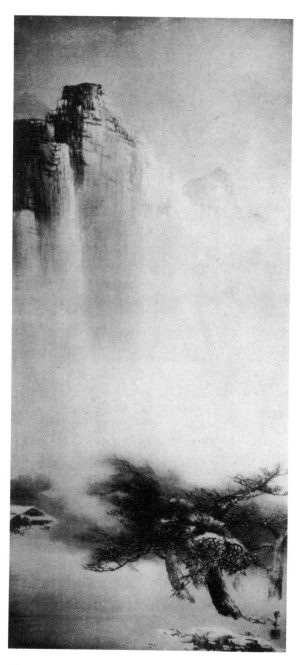

31. Yamamoto Shunkyo, *Landscape*, n.d.

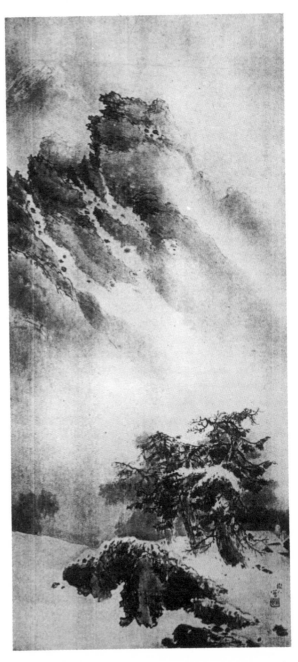

32　Chen Shuren, *Cruel Snow in the Rocky Mountains*, n.d.

modern Chinese art. In spirit as well as technique, their derivation came mainly from the art of late Meiji Japan.

The Japan Years in Perspective

Although their stay in Japan was relatively short (Gao Jianfu less than three years) and biographical information is regrettably sparse, there is no doubt that these were the formative years for the founders of the Lingnan School politically, intellectually, and artistically. In this they were typical of their generation. It was the generation of young intellectuals who broke with traditional ideas of Chinese cultural superiority and self-sufficiency as well as with existing patterns of political authority. It was the generation that began the process of exploring what the West had to offer beyond technology and techniques. It was the first generation of modern Chinese revolutionaries.

These young artists all became revolutionaries during their stay in Japan. They went there as patriotic and progressive students but, with the possible exception of Chen Shuren, not yet politically committed. They all became Alliance Society activists and were associated with its successor, the Chinese Nationalist party, for the rest of their lives. They had been trained mainly as traditional Chinese painters in Guangdong, even if Ju Lian had introduced some innovative techniques. In Japan, they absorbed both new techniques and a new approach to ink and brush painting, which made them artistic radicals in the conservative world of early twentieth-century Chinese painting. Even more fundamentally, they went to Japan as Guangdong provincials with no direct knowledge of the outside world or the main intellectual and political centers of China. They returned as cosmopolitans and nationalists convinced of the need to remake China into a modern nation in a modern world. Their artistic training started in Guangdong, and they coalesced into a coherent artistic school only after returning to Guangdong, but the intellectual and artistic foundations of the Lingnan School—what made these artists distinctive in modern China— were laid in turn-of-the-century Japan.

The same could be said for many other artists and intellectuals of their generation, especially writers. Lu Xun, Guo Moruo, Yu Dafu, and many other leaders of the literary revolution were students in Japan during those years. It is interesting to note how dual themes similar to the romanticism-realism tension in the Lingnan School manifested themselves in the literary works of that generation. The effusive emotional expression or sentimentality in many of these writers, the quality that led Leo Lee to dub them the

"Romantic Generation," [46] corresponds to the feeling in many of the early Lingnan School paintings. Heroic spirit and wistful pathos, above all lack of classical restraint in their unfettered expression of emotion—these are hallmarks of both the writers and the painters from this period. The fact that Gao Jianfu was a personal friend of one of the more self-indulgently romantic writers, the erratic and tragic Cantonese genius Su Manshu, underlines the affinity between the two kinds of artists.

As for the realist side of the Lingnan School spirit, there was the new generation of writers' concern with modernization, national salvation, and specific Western literary genres. Gao Jianfu developed a new style to paint modern things that had hitherto not been considered suitable for high art; the writers used new literary forms, such as the short story, to deal with modern themes and problems. Both sought to grapple more directly with the modern world than had traditional writers or painters. For both, realism was a modern value, but their need for emotional self-expression made it an unstable kind of realism leavened with a large dose of romantic sentimentality.

Among other Chinese painters studying in Japan at this time, none of them expressed the concerns of this pivotal generation quite so directly or so dramatically as the Lingnan School trio. A Shanghai artist, Chen Baoyi, studied Western art in Japan before 1911 but failed in his attempts to introduce it back into Shanghai after the revolution. Another Cantonese artist, Bao Shaoyou, was a contemporary and friend of Gao Jianfu but did not incorporate the same distinctive features of the Lingnan School into his work when he returned to Canton nor did he achieve a national reputation.

In some ways, the most interesting Japanese-trained contemporary of the Lingnan School founders was a fellow Guangdong provincial Zheng Jin (1883–1953) who, because his father was a resident merchant in Japan, had a much longer exposure to Japanese education and painting.[47] He studied both in Kyoto and Tokyo, absorbed much of the same late Meiji Japanese national-style painting as the Gaos and Chen Shuren, and also tried to blend it into Chinese art when he went back to China. But there the parallels stop. He did not become a revolutionary activist. He did not show the same kind of bold and dramatic spirit in his art or the fondness for strong emotional content and touches of Western-derived realism. In fact, many of his paintings are much more in the brightly colored, flat surfaced, and highly decorative Japanese tradition. He expressed this particularly strongly in the portraits of beautiful women for which he was best known. In Japan, he achieved much more recognition than the Lingnan School painters. Back in China, he played an important role in early Republican period art education by founding the Peking Special Art School. But,

unlike his Cantonese contemporaries, Zheng did not challenge the Chinese art world with a new style and a public role for painting. He was not without a sense of social purpose himself, as later he joined Liang Shuming's rural reconstruction program, but in the late 1930s he dropped out of Chinese social and artistic life to spend the last twenty-five years of his life in Macao. Zheng Jin, despite his Cantonese origins, came to Japan by a different route, absorbed different lessons there, and took a different path once he was back in China. Only by comparison does his career shed any light on the Lingnan School.

Therefore, although the Gao brothers and Chen Shuren were not the only Chinese artists to join the exodus of young students to Japan at the beginning of the twentieth century, they were the ones whose art and lives most closely connected with the main currents of Chinese history in the next few decades. They were the only ones to work out a theoretical approach to the problem of how to modernize Chinese art, while retaining its distinctive national identity. They were also the group of artists most directly involved in the national revolutionary movement.

The passion that filled Gao Jianfu and Gao Qifeng is
fundamentally political; this self-assurance comes from the
conviction that they and their revolutionary contemporaries
were the pioneers of the truth and the forerunners of the
future.

Christina Chu, *The Art of Gao Qifeng*

Genesis of a School:
Shanghai and Canton

The Gao brothers and Chen Shuren picked up their first revolutionary
ideas in Canton. In Japan they focused and sharpened them. Back in Can-
ton they, mainly Gao Jianfu, put them into action.

Revolutionary Politics

Probably the first to go to Japan, Jianfu was the first to return home and the
one who most directly participated in underground revolutionary activ-
ities. In 1908 the Alliance Society's headquarters in Tokyo deputed him to
found a branch in Canton. He organized a party cell there, using a painting
store as a front. This was not the first instance of the interconnection
between Jianfu's profession and his politics because the friendship with Liao

Zhongkai, who had introduced him to the Alliance Society in Tokyo, was partly based on his having been the painting teacher of Liao's wife. In that case, painting had led to politics. Back from Japan, it was painting as a cover for revolutionary activity.

Later, as deputy head of the society's political assassination group, Jianfu would use a porcelain store as a front for bomb-making activities. This role led to more political connections when he worked with the important Alliance Society leader Huang Xing. Their group arranged the bomb assassination of the Manchu Tartar general for Guangdong in 1911. They also provided supplies, including the flag, for the abortive New Army uprising of 1910 and the more ambitious attempt to seize Canton in February 1911. The latter uprising, which produced the ninety-six martyrs who are commemorated in the park at Huanghuagang could have ended Gao's own career along with those of his revolutionary comrades. But, according to his biographer Jen Yu-wen (Jian Youwen), before the uprising the members drew lots to determine who would join the first assault group and who would remain in reserve.[1] Gao Jianfu did not draw one of the "dare to die" lots, and the Lingnan School of painting was not nipped in the bud. After the bloody suppression of this ambitious effort to start the revolution in Sun Yat-sen's home province of Guangdong, Gao Jianfu lived on to fight, and paint, another day.

When the real revolution unexpectedly broke out in central China later that year, Gao Jianfu was the senior society member on hand in Canton and briefly took command of the revolutionary troops there, acquiring the title of military governor of Guangdong before the arrival of the prominent Alliance Society leader Hu Hanmin.[2] Once the Republic was founded, Gao resigned his political posts to devote all his energy to art. In view of his seniority in the Alliance Society and his work in Canton, this probably meant giving up fairly prominent posts in the new Nationalist party. However, because the fortunes of Sun's party quickly dropped as the Republic degenerated into military dictatorship and warlordism, that too was probably a lucky choice.

His younger brothers Qifeng and Jianzeng were not so active or prominent politically. Qifeng also met Sun Yat-sen in Tokyo and became an Alliance Society member. In the eulogy at Qifeng's funeral twenty years later, another old revolutionary, Wang Jingwei, would testify to his old friend's courage in sleeping peacefully in a room stored with explosives, presumably the revolutionary pottery shop in Canton before 1911.[3] There was, however, no reference to his having played the kind of leading role in conspiratorial revolutionary activity that his brother assumed. Similarly, the youngest brother, Jianzeng, although under Jianfu's guardianship, also

seems not to have been active politically. He was, after all, only 17 at the time of the revolution.

The last of the Lingnan School founders, Chen Shuren, would go on to have the longest and most prominent political career, but before 1911 he was not as much of a revolutionary activist as Gao Jianfu. Chen remained in Japan till after the revolution and then briefly went to Wuhan, not Canton, before returning to Japan for further study. There he started working with the "Overseas Chinese" branch of the Nationalist party, taking a different career path from the Gao brothers. That path would lead Chen to the central committee of the Nationalist party, but it meant that painting always remained an avocation with him, not a full-time profession. It also meant that he stayed abroad much longer, first in Japan, then in North America, so that he had a less direct role in the politics of the Manchus' overthrow and the early years of the Republic. As for art, he had a much longer experience in Japan than the Gao brothers but was not so directly involved in introducing Japanese ideas and techniques into early Republican China. That task and the founding of the *Lingnan pai* as a distinct school and movement were left mainly to the two older Gao brothers.

The Gao Brothers in Shanghai, 1912–1917

Before 1911 Jianfu had been the dominant member of the Gao family, bringing the younger Qifeng to Tokyo and supporting his study there after Jianfu returned to Canton. As older brother in a fatherless family, he seems to have continued the family leadership after the revolution. He brought Qifeng and the still younger artistically inclined brother, Jianzeng, to Shanghai where they ran an art bookstore and publishing house. The driving force behind this family enterprise seems to have come from Jianfu, although a non-artistic older brother, Gao Guantian, joined in the venture.[4] They spent most of the next six years in the city that was the commercial, financial, and, in many ways, cultural capital of modern China. This experience also was important for their development as artists and their emergence as a distinct school.

Because the decision to go to Shanghai, like the earlier decision to go to Japan, originated with Gao Jianfu, it raises some interesting questions about his personal motives or ambitions and also about Chinese cultural and intellectual life at the beginning of the Republic. For instance, why, after giving up his Japanese education, risking his life for several years doing underground work in Canton, and rising to a prominent position in the

revolutionary party, did he abandon politics just when the cause was apparently triumphant? The failure of the democratic Republic and its decline into warlordism had not yet become apparent when he left politics for art and Canton for Shanghai. Furthermore, if he wanted to choose the life of a professional artist over a promising political career, why did he move from Canton, where he had personal and professional connections so useful for establishing a reputation as an artist, to relative anonymity in the metropolis of Shanghai?

Half a century earlier, Ju Lian had put down the sword after a national crisis in order to pursue the life of a professional artist. In a sense, Gao Jianfu was following his teacher's precedent by turning from military-political activity to an artist's career as soon as the revolutionary battles were over. But there the parallel between teacher and disciple ends. They had been on opposite sides of insurrectionary struggles, motivated by different values, and Gao had achieved a much more prominent position among the victors. Moreover, the prospects and problems for a professional painter in China had changed dramatically in the intervening fifty years. But, most of all, the Gao brothers, through foreign training and foreign contacts, had had their intellectual and artistic vistas expanded far beyond the horizon of their old teacher.

Conceivably Ju Lian saw art, even a professional artist's career as long as it was clothed in the respectability of literati mores, as another way of preserving the traditional cultural and social values that he had defended against Taiping iconoclasm. For Gao Jianfu, the new values of progress and patriotism suffused his art as well as his politics. Inspired by the Japanese example, he saw art as an integral part of, and a stimulus to, national rejuvenation. Becoming a full-time artist did not, therefore, necessarily mean abandoning the goals of a revolutionary nationalist. He could hope to continue promoting them with the brush; there were many others who would continue promoting them with the gun.

The decision to leave politics once the heroic struggles of bringing about the revolution were supposedly over may also have sprung from the same romantic impulses noted in his Japanese period. For an adventurous and idealistic young artist, revolutionary plotting and uprisings were one thing; political compromise and routine administration quite another. The artistic name he had given himself in Japan, Jianfu, or "Sword Father," is reminiscent of the swashbuckling knights-errant from Chinese popular tradition. Perhaps, when taken along with the chosen names of his younger brothers, "Strange Peak" and "Sword Monk," it provides another clue to a temperament more attuned to action than administration, to art than politics.

Some biographers speak approvingly of Gao Jianfu giving up rank and

power for the purity of an artistic life. In reality, the separation from politics was far from complete. He would not be tempted into taking an official position, but he did support Sun Yat-sen's attempts to launch a "second revolution" after Yuan Shikai turned the Republic into a military dictatorship.[5] He also retained close personal ties with the Cantonese faction of the Nationalist party leadership and received some important favors from the party when it held power.[6] But most fundamental was his belief that social-political and artistic life were not sharply separated realms. His new philosophy of art allowed him to carry on the same patriotic mission in painting as in politics—the rejuvenation of China as a nation and a culture.

Therefore, Gao Jianfu's withdrawal from politics, at least in the beginning, should not be seen as a traditional retreat from a corrupt world into a quasi-eremitic pursuit of art and self-cultivation. Later, perhaps, there was an element of world weariness in his concentration on art, but not at this stage. After the Revolution of 1911, he did not return to his home village in Panyu. He did not even stay in Canton but headed for the largest, most dynamic, and most cosmopolitan city in China—Shanghai.

There may have also been some practical, economic motives involved in the decision to go to the center of modern China. Gao Jianfu and his brothers had to making a living in a country where the new forms of government and private patronage they had seen in Japan were not yet developed. At the same time, the old forms of merchant and gentry patronage were declining and, in any case, might not be available to young artists introducing new styles and techniques from abroad. If a new clientele for new styles in art were to be found anywhere, it would be Shanghai, the commercial capital and focal point for all modern influences in China. And, in case the new style of painting did not immediately catch on, Shanghai was the publishing center of China and a better prospect for Jianfu's planned art bookstore and publishing house.

However, it is unlikely that the business possibilities of Shanghai were the sole attraction. By the early twentieth century, Shanghai had become the place to be for Chinese interested in the new and modern in politics, ideas, life-styles, literature, or art. The cultural center of China had long been in the Jiangnan area around Shanghai. By the late nineteenth century, Shanghai's growing wealth and sophistication had led it to supplant traditional cities, such as Suzhou, Hangzhou, or Nanjing, as the center of artistic activity. With such resident masters as Zhao Zhiqian, Ren Bonian, and Wu Changshuo, the Shanghai School had become the most influential movement in Chinese painting during the late Qing. Like a magnet, Shanghai drew artists from all over China, partly because of the market

for their art but partly because to achieve a national reputation you had to be recognized there. New ideas, commercial opportunities, national recognition—all were to be found more readily in Shanghai than in the far southern province of Guangdong.

The Gaos did not exactly come to the big city as small-town provincials seeking big-city sophistication. They had their revolutionary credentials, the Japanese experience, and a new style of ink painting. In order to transmit what they had learned in Japan, it was natural to go directly to the center of new China. There, much more than in Canton, they could find the audience, the critics, the artists, and the patrons necessary for popularizing what they called the "New National Painting." "New" meant Shanghai; "National" meant going to the center of the country.

The art publishing house represented a new type of professional career open to the aspiring artist but also revealed the difficulties of establishing the new art in a Chinese painting world where more conservative tastes generally prevailed. Even in Shanghai, focal point for the new in China, painting remained almost entirely within the confines of accepted Chinese tradition. True, the Shanghai School had stretched that tradition to include somewhat more popular subject matter, which catered to the less erudite tastes of the Shanghai business classes. But this significant shift in taste and patronage had ample precedent in the eighteenth century with the rise of the Yangzhou eccentrics and their merchant-class patrons. There was no direct sign of Western influence in the Shanghai School, despite the strong foreign presence in Shanghai and the foreign stimulus to the growth of the new Shanghai bourgeoisie. That class may have been tied economically to the West, but culturally it stuck to the traditional Chinese scholarly style in art or, at least, a vulgarized version of that style. Nor had the May Fourth intellectual revolution yet unlocked most young intellectuals' curiosity about all forms of Western culture, including art. At the beginning of the Republic, Western art was virtually nonexistent among Chinese in Shanghai. Only later in the decade would Liu Haisu open the first oil painting school in Shanghai, and then there were hardly any buyers for that kind of art. So, though the Gao brothers' Japanese-derived New National Painting was much more Chinese or Oriental than Western, it was still too innovative or too different to gain immediate acceptance in the heart of China's art world and art market. Artists solely dependent for a livelihood on their talents, without private patrons or government connections, had to open some new channels. The Shenmei shuguan (Esthetic Bookstore) was one of those.

Although Ju Lian had been a professional painter, it would have been unthinkable for Gao's teacher to have gone directly into business. Artists

cultivated the manner and appearance of their gentry patrons. Shanghai by the early twentieth century was a new world where the Gaos were attempting to establish a new kind of respectable career for the artist and a new function for art in a modern country. The model, of course, was late Meiji Japan with its independent professional artists, urban art market, flourishing art publications, public exhibitions, modern art schools, and government support for the arts. Their bookstore–publishing house was as much concerned with introducing new art, mainly what they had learned in Japan, as with making money. It was a private capitalist venture, but its purposes were public and esthetic.

This was true of all Gao Jianfu's business enterprises. For instance, he was interested in decorated porcelain as an art and a potential export industry for a modernizing China. His own handpainted porcelains won a prize at the Panama International Exposition in 1912.[7] He then attempted to get government support to revive China's porcelain industry as a lucrative export business. To this end, he visited the famous kilns at Jingdezhen in 1912 and the following year went to Japan to buy samples of that country's successful exportware. But his hopes of government backing collapsed with Yuan Shikai's usurpation, and Gao's China Porcelain Company soon folded.[8] A similar enterprise in Shanghai, the Shanghai Women's Embroidery Academy, was managed by Gao's wife;[9] apparently it too did not last long.

The bookstore–publishing house was also no great commercial success. Apart from the first reproduction volumes of the Lingnan School's paintings, its most significant publishing venture was an illustrated fortnightly, the *Zhen xiang huabao* (True Face Pictorial) or, to use its English subtitle, *The True Record*. It ran for almost a year from May 6, 1912, to March 6, 1913. An early issue explained its contents and purpose: it "contains all the latest news of the realm and embraces politics, society, industry, commerce, education, etc., and circulates throughout the world. Therefore, it is a splendid advertising medium."[10] It was, in fact, a combination of news, social and political commentary, "modern knowledge," and information about art. The copious illustrations included photographs and lithographs as well as some reproductions of drawings or paintings by the Gao brothers and their compatriot in Japan, Chen Shuren (figure 33). In some ways, it resembled the famous pioneering Shanghai illustrated news magazine of the late nineteenth century, the *Dianshi zhai huabao* (Lithographic Studio Illustrated Magazine) but was more serious, more political, and more artistic in its coverage. Where art (or simply drawing) met politics in the political cartoon, it ran several that were pointedly anti–Yuan Shikai. Perhaps the cleverest, published in June 1912, showed a three-panel process

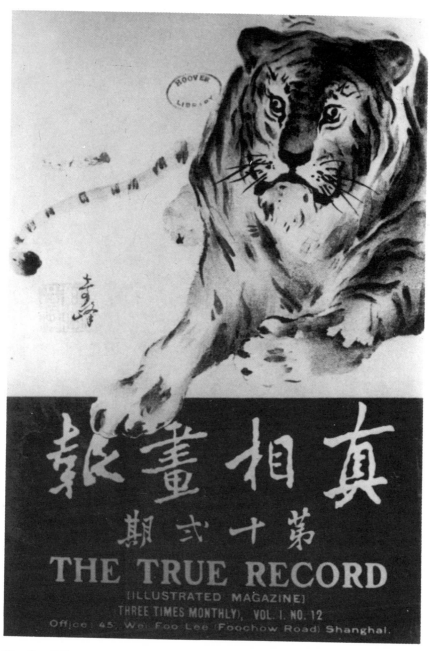

真 相 畫 報

第 十 弍 期

THE TRUE RECORD

(ILLUSTRATED MAGAZINE)

(THREE TIMES MONTHLY), VOL. I. NO. 12

Office: 45, Wei Foo Lee (Foochow Road) Shanghai.

33. Gao Qifeng, tiger on the cover of *Zhen xiang huabao*, 1912.

of creating the "model republic." In the first panel ("Past"), Sun Yat-sen in artist's garb measures a picture of a majestic tiger preparatory to starting on a blank canvas. In the second panel ("Present"), Yuan Shikai takes over as the artist to the consternation of a group of onlookers in semi-modernized apparel. In the third panel ("Future"), onlookers and artist alike are dumbfounded when the copied picture turns out to be a mangy dog instead of a tiger.[11]

However, the magazine and its artist publishers were not interested in making their mark in the Chinese artistic or political world through the cartoon medium. They published some sketches and illustrations in their magazine, including three drawings signed by Gao Jianfu for "higher elementary and middle school use," [12] but the black-and-white printing on poor paper was inadequate for conveying their new style in which light, color, and atmospheric effects were so important. Similarly, the reproduction volumes of their works published by the Esthetic Publishing House could only give a rough idea of their new approach to Chinese painting. Therefore, they had to rely as much on the printed word as the printed picture in order to carry their message about a new art to a broader audience.

Chen Shuren, writing from Japan, contributed a long serialized work, *New Painting Methods: A Guide to Independent Study*, presumably translated from the Japanese.[13] He and Gao Jianfu also wrote on other aspects of art and art history. The most interesting of these, also by Chen Shuren, was on the animal paintings of the quintessentially Victorian artist Edwin Landseer (1802–1873).[14] Chen praised Landseer's realism based on an insistence on "drawing from life" and heartily approved of this artist's widespread popularity. The particular Western artist Chen chose to introduce to modern Chinese readers was significant. As we have seen, all the Lingnan painters were much impressed by Japanese animal painting; so in a sense it is natural that an English animal painter would attract Chen's attention. But Landseer's "realism" in technique is only part of his art. He was also so overwhelmingly sentimental in the way he showed animals that a twentieth-century critic remarked, "no other man in the history of art managed to paint animals so much as if they were human beings." [15] This was the key to his popularity in early and mid-Victorian England. When we look at the striving for expressive emotional content and the portrayal of human emotions through animal subjects in the early Lingnan School, we recognize an affinity between the tamed-down and sentimentalized romanticisms of mid-Victorian England and the artistic sensibilities of these aspiring revolutionaries in early twentieth-century China. Again, in their hands, realism acquires a romantic temper.

Unfortunately for these young painters turned art theorists, their art and their views on art did not find the same broad acceptance among Shanghai city dwellers as Landseer's paintings had among the English bourgeoisie. Unable to get more financial help from Sun Yat-sen's embattled revolutionary party and unable to find enough advertisers in business-run Shanghai, the magazine was forced to suspend operations in early 1913. The bookstore–publishing house lasted a little longer and may have served some function in spreading new ideas and new art. But, even in Shanghai, conditions were not yet right for such enterprises. Similarly, the Lingnan School's new-style art did not exactly take the commercial and cultural capital of China by storm.

Apart from their publishing activities, the public exhibition was another form of publicizing the art that they had learned in Japan. Gao Jianfu pioneered the introduction of this institution into China. During the Shanghai years, the Gao brothers arranged to show their works publicly, not only in Shanghai but also in the important nearby art centers of Nanjing and Hangzhou. This too was a significant innovation in the Chinese art world. Paintings would be available to a much larger audience; artists would no longer be so dependent on small, elite circles of collectors, dealers, connoisseurs, and fellow painters. The forerunner of Western art in Shanghai, Liu Haisu, remembers the Esthetic Bookstore as being the first place to sell paintings publicly,[16] but opening the art market to a wider public does not seem to have led to immediate financial success for the Gao brothers. Their Japanese-learned innovations—elements of Western-style perspective, shading, light effects, etc.—may still have been too bizarre for contemporary taste. Nevertheless, for Chinese art as a whole the public exhibition and sale of art was an important innovation, and the Gaos were among its earliest promoters.

Despite the growing public dimension to early twentieth-century Chinese art, older forms of more personalized organization continued to be important in Shanghai's intellectual and artistic circles. The connections Gao Jianfu formed there may have been as important as the new institutions of publishing and exhibitions. Although biographical information on these early years is sparse, we know he belonged to a group of Shanghai art lovers called the Art Appreciation Society, who held monthly painting viewings at the Ha Tong Gardens.[17] Gao's famous fellow Cantonese, the philosopher, statesman, and calligrapher Kang Youwei (1858–1927) was one of the group. More indicative of how Gao was able to develop personal contacts with the elite of central China's cultural and artistic world was the presence of the Anhui painter, critic, and connoisseur Huang Binhong (1864–1955). This was the inner circle of China's cultural elite, a

far cry from Guangdong's provincial art world. Such contacts would influence Gao Jianfu's views on art and painting, not so dramatically as during his Japanese period, but nevertheless significantly. They would also, in the long run, help his reputation and that of his school.

The Shanghai sojourn also led to a rather different kind of artistic connection, which proved useful some twenty years later. Gao Jianfu spotted a talented young teenager doing cheap decorative fan paintings in Shanghai. With the sharp eye for talent that would make him such a good teacher, Gao gave him a job at the Esthetic Bookstore and helped start Xu Beihong (1896–1953) on one of the most successful artistic careers of twentieth-century China.[18] Years later, after Xu had returned from Paris, he retained contact with, and affection for, the Lingnan School painters, although his approach to modernizing Chinese art was very different. These kind of Shanghai-originated artistic connections may have been as important as the school's political connections in obtaining favors and recognition for it under the Nationalist government after 1927.

The New National Painting in Shanghai

The term *Xin guohua* (New National Painting) started to be used for works by the Cantonese group in this period.[19] They liked the term, because it emphasized both national character and modernity, exactly the combination toward which they were striving. Critics and detractors, offended by the new and foreign elements in their painting, soon labeled them the *zhezhong pai* (eclectic school), with the strong implication that their painting was neither fish nor fowl.[20] But the most bitter criticism along those lines came later, after they had returned to Canton. In Shanghai during the 1910s, the fledgling school seems not to have attracted that much attention.

If they did not exactly overwhelm the Shanghai art world in this first foray into central China, what influence did Shanghai have on their art? Not so much as Japan: surviving paintings from these years and the reproductions in inexpensive volumes from the Esthetic Publishing House show strong continuity with the Japanese period. The subjects are mainly the same—birds and animals in fierce and dramatic poses; "atmospheric" landscapes depending on mists, rain, or snow for much of their effect; night scenes where trees or grasses sway in the wind or nocturnal animals furtively prowl under the ubiquitous full moon. In some cases, even the precise details in their landscapes, such as the thatched high peak roofs of mountain farm-houses, are unmistakably Japanese.

The reasons for this continued preference for Japanese styles and motifs

can only be inferred, partly from the articles in *Zhen xiang huabao*, but mainly from the paintings themselves. The strongest factor had to be the modernity supposedly contained in their Japan-acquired techniques. After all, they were revolutionaries who represented the new and modern. They were also, in the context of China's cultural geography, southern provincials whose bid for recognition in the artistic capital of China had to come from the innovations that their foreign experience could bring to Chinese art. They could hardly get attention as Guangdong flower and bird painters, and to imitate established Shanghai styles would sacrifice their individuality and submerge them in the anonymity of the crowded Shanghai art market. In short, modernity was their only real entrée into the art world of central China, and their modernity was unmistakably Japanese. Not even the political embarrassment of Japan's "21 Demands" on China during World War I could shake them from pursuing their new learned-in-Japan formula for a national art that was modern, but still linked to tradition. In the long run, they had to play down the specifically Japanese elements in that syncretic formula, but in these years it was still difficult to tear off the Japanese wrapping from this new package for Chinese art.

In Gao Qifeng's work, the Kyoto (more precisely, the Shijō School) flavor is particularly strong. His fondness for broad ink washes and strong tonal contrasts already distinguished him from his older brother, who even then worked with a drier brush and put more emphasis on line. This distinction—Qifeng "wet," Jianfu "dry"—marks a significant difference in style and temperament between the two brothers. It should not, however, obscure the common features derived from their Japanese training, which made their paintings stand out as unique and different in the context of early twentieth-century Chinese painting. In comparison with the Western-style artists of the next decade, their painting was still very Chinese, but in comparison with what still prevailed in Chinese art at the beginning of the Republic, even in the Westernized cosmopolis of Shanghai, it was something new and exotic. The tendency toward Western-style fixed perspective, the modified use of shading somewhat akin to Western chiaroscuro, the light effects, shadows, and atmospherics—all revealed their Japanese training and, at that time, set them apart from their purely Chinese-trained colleagues. Qifeng was the most directly "Japanese" of the group, but Jianfu and Chen Shuren were also introducing a new style and a new approach to Chinese ink painting.

The newness, or foreignness, of their approach was nowhere more apparent than in their snow scenes. Snow, either in landscapes or on the leaves of trees and bamboo, was hardly new in Chinese painting. But it was

a rather unusual subject for southern painters, and the way they showed it was unmistakably derived from Japan. Sometimes, as in a collaborative work of two ducks huddled along a snowy riverbank, they used the Japanese "reserved white" technique to indicate snow on the ground or clinging to branches. At other times they used extremely light ink washes or white powder to get a snow effect. Gao Qifeng's nocturnal monkeys on snowy branches against a moonlit sky make a particularly striking use of these techniques. Jianfu, more a landscape artist, has several rugged mountain scenes from this period where lonely travelers pass beneath snow-capped peaks, or a solitary mountain hut stands against a blizzard.[21] They are, as suggested in the last chapter, strongly reminiscent of the contemporary Kyoto landscape painter Yamamoto Shunkyo.

In general, Gao Jianfu's landscapes are grander in scope and drier in style than those of his brother. The "dryness' is, of course, relative and varies considerably from painting to painting. At his most "Japanese," as in *Kunlun Mountains After Rain*, undated but stylistically attributable to this period, he uses light washes for atmospheric background contrasted with dark heavy washes for rocks and foliage (figure 34). The overall effect is striking, dramatic, or even romantic in the sense described in the last chapter. To the Western eye, there may appear to be faint traces of the nineteenth-century European romantic landscape, although a Chinese art historian would see a pedigree going back to the monumental landscapes of the Northern Song with some Southern Song atmosphere added. The latter view would not be wrong or even disputed by the artist himself, since sometimes he referred to his school as "New Song Painting." But we should remember that this antique Chinese lineage had been mediated through late nineteenth-century Japanese painting, which was itself heavily Western influenced.

It is probably stretching the point to find a Turneresque searching for the "sublime" in even the most romantic of Gao Jianfu's landscapes, but, when we remember that Takeuchi Seihō, one of the contemporary Japanese masters Gao most admired, had been deeply impressed by Turner, the possibility of some once-removed European influence cannot be dismissed. The Kunlun Mountains are a remote and exotic locale for a Chinese landscape; Gao's picture does strive for a sense of wonder, if not astonishment. In short, it is a wild, romantic landscape far removed from the serene placid view of nature usually prevailing in Chinese landscape painting after the seventeenth century. Whether or not Turner and other European romantics lurked in the background, Gao Jianfu sought to infuse a new, exciting, and emotional view of the world into the body of Chinese art.

The fact that even in these early years he could also produce much more conventional and tamer landscapes does not negate the significance of the

34. Gao Jianfu, *Kunlun Mountains After Rain*, n.d.

more radical works. Somewhat uncertain in conception and slightly imperfect in execution, nevertheless they were his boldest attempt to shock the Chinese art world to move in new directions. Still, this did not mean that Gao was ready to cut himself off from the main features of the traditional painting style. Even in radical works, such as this Kunlun landscape, he retains an interest in line, brushwork, and calligraphic effects. The writhing branches that dominate the foreground and fade into the mountain mists in this painting are its most striking feature. Although for Gao the direct source for this would appear to be Japanese landscapes by Yamamoto Shunkyo or another Kyoto painter, Kawai Gyokudō, this handling of foreground trees was also very much in the Chinese landscape tradition.

Gao Qifeng was unable or unwilling to devote much attention to bare branches; his trees were usually Shijō-style willows whose lush foliage could be captured in fluid and delicate washes. Pure landscapes, as opposed to a tree and riverbank setting for a bird or figure picture, are relatively rare. His hanging scroll landscapes were often extremely "boneless," no outline or detailed brushwork, just loose ink washes to build whatever structure the pictures possess. If this sounds a little like the "broken ink" experiments of Zhang Daqian in the 1960s or somewhat later by some innovators in the People's Republic, there is no real connection. Qifeng's inspiration was the Shijō School, not abstract expressionism. His wet washes were an extension of Kyoto mists and rain, instead of a search for a new dimension in Chinese painting.

More indicative of his interest and potential in landscape painting are eight album leaves, undated but presumably from early in his Shanghai period, which show him working with more care and effectiveness in this intimate form of landscape painting (figure 35). Each scene is more structured, details such as houses and boats capably drawn, and rocks and mountains outlined in bold, thick strokes. But the main interest still lies in the tonal gradations, or rather sharp contrasts, between lighter and darker ink. In this, the landscape leaves are vaguely reminiscent of Xia Gui, one of the Southern Song masters that his brother most admired, but there are also affinities with the great contemporary Japanese painter Yokoyama Taikan. Although Taikan's famous landscape hand scroll *Wheel of Life* was not done until 1926, the resemblance is probably more than coincidental. The tonal contrasts, bold outline strokes, and overall poetic quality of the Chinese artists' landscapes suggest they came from the same late Meiji matrix that would produce the much more powerful and exuberant work of the older Taikan. Gao Qifeng was not so powerful or prolific a landscape painter, but these early works show that he was not untalented in that genre.

35. Gao Qifeng, *Landscape*, n.d.

Big birds and fierce animals were more his forte and were the subjects that first drew attention to him in China. They were even more novel in early twentieth-century China than the Gao brothers' romantic landscapes. Both of them produced fierce stalking tigers and great poised eagles in the early years back in China. The ideological significance of such nationalistic symbols has been explained. Qifeng probably produced more and achieved greater "realism," if we can apply that term to naturalistic drawing of menacing poses in dramatic settings. Qifeng's skillful and realistically detailed drawing of animals is also evident in his pictures of other subjects—cranes, peacocks, monkeys, even a bear.[22]

The romantic aspects of these animal pictures—either heroic or sentimental—have already been explored in discussing their Japanese derivation. There is a third Japanese style, which only Qifeng mastered, of purely decorative pictures, especially peacocks, which were a favorite subject in Japanese screen painting. Back in China, Qifeng transferred the subject to scroll painting on a grand scale. A good surviving example, dated 1917, is a vertical scroll over eight feet long showing a gorgeously colored peacock preening itself on a pine branch (plate 2).[23] With the

peacocks, color was a prime element, but he was also fond of doing other large, graceful birds—cranes, egrets, even a phoenix—in dazzlingly pure white.[24] Gao Jianfu and, less frequently, Chen Shuren also did animal and large bird paintings (eagles, geese, and ducks). But cranes, egrets, and peacocks, the brilliantly plumaged decorative birds, were Gao Qifeng's exclusive province among the founders of the Lingnan School. There, the eye for naturalistic detail, originally learned from Ju Lian and expanded by the Kyoto realistic tradition, combined with his sense of the poetic and emotional to produce bold, arresting pictures.

The landscapes and symbolic animal paintings were the most important genres for conveying the Lingnan School's larger message, artistic and political, to early twentieth-century China. Still, it must be remembered that in the early Republican period even Shanghai was not very receptive to radical artistic innovations. Because both of the Gao brothers hoped to make a living as professional artists, they also continued to produce less ambitious and less heroic pictures of small birds, which were more familiar to Chinese viewers.

Sparrows or magpies in flight, chickens and ducks on the ground, crows on a fence—Gao Qifeng was particularly adept at such subjects. Gao Jianfu still did the detailed insects he had first learned from Ju Lian, but neither of them went back to their old Guangdong style for bird or insect pictures. A Jianfu grasshopper, dated 1914, is still drawn in the Ju Lian manner, but the rest of the picture, trees and grasses bathed in the light of a misty moon, is straight from Japan.[25] Similarly, Qifeng's ducks and roosters find their prototypes in late Meiji painting right down to the snowy banks or Japanese haystacks he poses them before. And, finally, the bird and tree composition favored by all members of the incipient Lingnan School—a strong diagonal or vertical branch or tree trunk as roosting place for great birds of prey—had no precedent in their pre-Japanese works.

In sum, though back in China, their art remained strongly flavored by what they had learned in Japan. Yet it seems unlikely that they could remain entirely impervious to the influence of their surroundings in China's most vital intellectual and artistic center. What signs are there in their painting that the art, tastes, and intellectual currents of Shanghai affected it? The question is not easily answered. The formative influences for their individual and collective styles had come in Guangdong and, more decisively, Japan. Although each artist would continue to develop in his own way, the mold of the distinctive Lingnan style had been set. Thus, the changes in these years were slower and less dramatic. As students in Tokyo, they had been actively seeking and absorbing; no longer students, in Shanghai they sought more to create tastes than to absorb them.

There is, for instance, little sign of the dominant Shanghai School's influence in their work. They do share certain features, such as a fondness for quaintly commonplace subjects, but that was present both in late nineteenth-century Guangdong and the Kyoto tradition in Japan. There is no need to see the Gaos' Japanese pedigreed roosters as part of the Shanghai scene, although the already established market for such subjects may have had something to do with their painting them while in Shanghai.

The pronounced verticality (long and narrow format) of many of their compositions is another feature they had in common with the Shanghai School. This, too, may or may not have been influenced by prevailing market tastes in Shanghai. There is no evidence that the Gaos personally knew or associated with Wu Changshuo, Wang Yiting, or any of the other leaders of the Shanghai School. On the contrary, Gao Jianfu's known artistic friends, such as Huang Binhong and Kang Youwei, were of the neo-literati circles who brought more classical scholarly tradition than contemporary market taste to bear on their Cantonese artist friend. In any event, we see in Gao Jianfu's work, not only the drier brushwork and greater emphasis on line that accorded with Chinese scholarly tastes, but also instances of his displaying the Chinese artist-connoisseur's versatility by painting "in the manner of" various ancient masters, including Fan Kuan, Lan Ying, and Shi Tao.[26] There also are two paintings from 1916 that draw on the tradition of the inspired eccentricity of the Chan Buddhist or Taoist recluse. In one, a jolly monk plays a flute; in another, a bizarre Taoist or, possibly, a Chan sage watches incense rise from a gourd.[27] The subject and the style coming from the Chinese eccentric literati or religious recluse tradition, not from his Japanese background, may indicate the influence of his Shanghai friends, his own developing interest in Buddhist philosophy, or both.

From the Shanghai period on, Gao Jianfu, in some ways the most scholarly of the founders of the Lingnan School, showed more interest in China's literati tradition even as he attacked its stagnation and called for a revolution in art as well as politics. Later in his life, that conflict between tradition and innovation would become stronger or more obvious. During the Shanghai years, it was overshadowed by the drive to establish their new Japanese-learned art, but Jianfu carried the burden of tradition with him more securely than did his younger brother. Qifeng, perhaps more deeply impressed by his Japanese experience, shows no sign of imbibing these traditional influences in his Shanghai years. Less the theorist than his older brother, at this time he practiced a less ambiguous modernity in his art.

The third Gao brother, Jianzeng, belongs stylistically to the Japanese period in the development of the Lingnan School, but his few surviving

works date mostly from 1912–1916. After the Revolution, Gao Jianfu sent him to Japan to study painting. In 1916, on the eve of returning to China, he died unexpectedly at the tender age of 22. Few of his paintings survive, and fewer have been published (figure 36).[28] As one would expect from his education, his paintings show a strong Japanese influence similar to those of his brothers after their Japanese sojourn. His landscapes are much like Gao Jianfu's without their monumentality; his animal paintings are closer to those of Gao Qifeng but not so naturalistic nor so expansive. He lived long enough and painted often enough to leave evidence of a disposition and a talent quite close to his brothers. He did not, however, have the time to make his own distinct contribution to the evolution of the Lingnan School. Perhaps his most important role was in maintaining a direct family link with the Tokyo art world for his brothers during their Shanghai years. That would help explain how post-1908 developments and specific compositions from Japan continued to appear in Jianfu and Qifeng's work after they had returned to China.

While the Gaos were in Shanghai, Chen Shuren lived abroad, first in Japan and then in North America, but he remained in contact with his old friends and classmates, contributing to their magazine and also including his works in some of the Esthetic Bookstore's reproduction volumes. There are fewer of his works in those volumes than of the Gaos, and fewer of his surviving paintings can reliably be dated to that period. Still, there is enough to observe a broad similarity between his work and that of the Gao brothers. He did many of the same subjects—birds, animals, and landscapes—although he was somewhat fonder of flower painting than the others and, in fact, throughout his life was best known for his flowers and birds. Moreover, even when he chose the same subjects as the others, he treated them with more delicacy, but less dramatic power. His landscapes do not achieve the rugged grandeur of Gao Jianfu's even when the same Kyoto master, Yamamoto Shunkyo, is the obvious source of inspiration. Nor do his hawks have the fierceness of Gao Qifeng's birds or his water buffalo the same degree of realism (figure 37). Delicacy, sensibility, and a less flamboyant poetic quality were hallmarks of Chen Shuren's personal style, but in broad outline his work stood closely beside the Gaos'. The fact that he continued along the same general line when he was away from Shanghai and China confirms that it was their Japanese training, plus the foundations laid by Ju Lian, that made these artists a distinct school. The direct artistic influences of the Shanghai period were minimal or at least of secondary importance.

But there was more to living in Shanghai than just the art world narrowly defined. How did these painters fit into the general intellectual-

36. Gao Jianzeng, *Japanese Landscape*, 1909.

37. Chen Shuren, *New Moon*, n.d.

political atmosphere of the May Fourth period, when, even before 1919, Shanghai was almost as much a center of the "New Thought Tide" as Peking? These were not "ivory tower" artists, removed from the events of the world around them. How did their art reflect or relate to the intellectual revolution that was already starting before they left Shanghai?

Again, the answer seems to be, not directly or in an obvious manner. The "realism" in their depiction of some objects fits into the generally positivistic and culturally pro-Western position of the modernists. Gao Qifeng's animals, particularly his horses and water buffalo, could be seen in that light, but these had started almost a decade earlier in the different cultural-intellectual climate of the pre-1911 revolution years. More radical innovations in contemporary subject matter—airplanes, motor cars, World War I tanks—come slightly later. Shifting the focus from subject matter and style to alleged metaphorical political content, a much later critic from the People's Republic period professes to find indirect comments on political events of those years in some of Gao Jianfu's paintings.[29] There is no doubt that the rearing horses, roaring tigers, and soaring birds carried a general allegorical message, but to suggest that poetically sad subjects, such as withered lotuses, dead willows, small birds in snow, autumn crickets, and falling leaves, were a comment on the sad state of the nation's politics after 1913 is going too far. These subjects go back to the prerevolutionary Japanese period. Snow and ice gave them the opportunity to show their newly acquired atmospheric techniques; falling leaves and autumn colors were part of the more general romanticism that infused their work. A snowy branch need not be a comment on Yuan Shikai's establishment of a military dictatorship.[30]

That vague and sentimental spirit of romanticism—the other side of the Shijō tradition and part of the general spirit of their age—seems to be more important than direct political comment. Perhaps the inconsistency or contradiction between the sentimental and the heroic strains in their work continued to blunt effectiveness in conveying any simple and straightforward revolutionary message, but in this too the Lingnan artists fit the temper of their times. Heroic assertion, represented by the soaring eagles and roaring tigers, decay and sadness as seen in withered flowers and falling leaves—both represented a preference for feeling and emotion that we have already noted among the literary figures of the early twentieth century. In the case of these painters, that spirit and the artistic techniques to express it had been acquired in Japan before the May Fourth cultural and intellectual revolution got under way. The Lingnan School artists went along with the new times and new interests in some ways, but not in others. Most notably, they lacked the militant antitraditionalism or cul-

tural iconoclasm of the May Fourth generation, not to mention the explicit politicization of art that would follow.

The founders of the Lingnan School may have been influenced by their Shanghai sojourn but, judging from their art and subsequent political behavior, not nearly so deeply as by their stay in Japan. They belonged not to the May Fourth generation, but to the previous one whose basic approach to questions of China's new politics, culture, and, in their case, art was molded by their late Meiji experience. They would change and grow, but their fate, both in politics and art, was very much that of the pre-1911 generation of revolutionaries.

Art and Politics in Canton, 1918–1927

By 1918 the Gao brothers had abandoned their efforts to establish themselves in art and business in Shanghai and had both returned to Canton. In one sense, it was a retreat from the lofty expectations of 1911. At the national level, their new Japanese-derived art had not succeeded much better than their revolutionary democratic-republican politics. But just as the political debacle in the early Republic did not mark an end to the Nationalist party's national fortunes, the retreat to Canton did not take the Gaos out of the mainstream of twentieth-century China's political or artistic development.

After the military power of Yuan Shikai and his warlord successors had smashed Sun Yat-sen's hopes for a parliamentary democracy, Sun too retreated to his home province, which he planned to use as a regional base for resurrecting a revolutionary republican government in all of China. It would be forcing the parallel somewhat to claim that the Gaos did exactly the same in the art sphere. But they too decided that, after failing to revolutionize the center of China, they would use local connections and perhaps provincial pride to establish a secure territorial base. For them such a base meant a reliable livelihood as professional artists, recognition in cultural and political circles, teaching positions in leading educational institutions, and a growing circle of eager and talented disciples.

This was the basis for turning a general artistic tendency into a clearly defined regional school, the Lingnan School, and for turning vague ambitions about a new art for China into a clearly recognized movement for a new national painting. There was an important ambiguity, or even contradiction, between the two terms. The Lingnan School was the appellation commonly applied to them after their return to Canton; "New National Painting" was the name they preferred to express their revo-

lutionary and nationalistic goals. Provincial roots and national ambitions: For a time in early twentieth-century China, the two seemed to come together for Cantonese artists as well as politicians. As a seaport open to the outside influences that China needed to rebuild herself in a modern world, Canton could lead the nation instead of playing a peripheral frontier role. In the long run, it did not quite work out that way, neither for Sun Yat-sen nor Gao Jianfu. But for a brief period in the 1920s, with Sun Yat-sen's revolutionary government reestablished in Canton and the Lingnan School established as the most vital and controversial art movement of South China, it looked like it might. The return home in 1918 was less a retreat than a tactical adjustment in their plans to bring about a revolution in China's national art. In no way was it intended as a retreat into provincial obscurity.

The exact circumstances of and motives behind their return to Canton are unclear, but the inscription on a Gao Qifeng painting of 1917, "A work while a guest in Shanghai," indicates that by then he was clearly thinking of Canton as his real home.[31] In the same year, politics again entered Gao Jianfu's life when he was contacted by the Guomindang's "Army to Restore the Constitution." As a former military organizer and underground conspirator, his nonartistic talents must have been in demand as the collapse of Yuan Shikai's monarchial ambitions plunged China into the confusion of the warlord era. According to one source, Sun Yat-sen wanted to name him Guangdong provincial chief, an honor and burden that he "forcefully declined."[32] Be that as it may, in 1918 he went to the northern Guangdong town of Changzhou where the local military commander Chen Jiongming had pledged his army to restore Sun Yat-sen's "lawful" republican government. In 1920 he entered Canton when Chen's troops succeeded in recapturing the provincial capital. This apparently was the end of Gao's direct political and military involvement in the Guomindang cause. He was given positions in Sun's new Canton government that were suitable for an artist interested in education or economic construction rather than political or military activity, becoming a member of the Guangdong Industrial Art Commission and head of the Provincial Industrial School.[33] This distance from direct political involvement had its advantages, for it allowed Gao to stay in Canton through the political vicissitudes of the next few years, benefiting from his old revolutionary political party associations when the cause was ascendent and escaping persecution when it met with temporary reverses.

Gao Qifeng's return to Canton was even freer of political content. In 1918 he accepted a teaching post at the Canton Institute of Technology and gave occasional lectures at Lingnan University where he was made Profes-

sor of Art in 1925. Both of the Gao brothers remained on good terms with the revolutionary government but were only tangentially involved in its politics. Jianfu, with his higher political profile, was urged to serve on such ceremonial bodies as the Guangdong Committee for Commemorating the Martyrs of the Revolution but declined. Art was clearly their main occupation and teaching had become an important part of it.

In some ways, their new role as teachers was reminiscent of their own training under Ju Lian. Both established private studios with disciples in addition to their institutional teaching positions. Gao Jianfu, according to the testimony of one former student, even had his personal disciples go through the traditional kowtow ritual when he accepted them for study.[34] He also took some of them, especially the impoverished, into his own home in the manner in which he had lived in Ju Lian's house. Certainly the proteges from both Jianfu's Spring Slumber Studio and Qifeng's Heavenly Wind Pavilion considered the bond with their teachers to be intensely personal and lifelong. Still, the new elements in the Lingnan School's teacher-student relationships were as important as the old. From the beginning, Jianfu had his private students organize regular public showings of their works in order to publicize the new style in painting and establish the school's reputation before a broader public. He was also a pioneer in organizing official art exhibitions. The Guangdong Provincial Art Exhibition in 1920 was one of the first government-sponsored art exhibitions in China.[35] Later, from the 1930s on, Qifeng's disciples held annual exhibitions to preserve the memory of their deceased teacher.

The old pattern of master-disciple relationship still held, but new institutions, such as public exhibitions, were also important for establishing and promoting a school of art. Similarly, official connections were useful in promoting the larger exhibitions, securing commissions, and obtaining teaching positions at the new institutions of higher learning. Such positions both helped support them as professional artists and raised their prestige in the art marketplace. These new features of the social and economic organization of art in China were reminiscent of Japan when they had been students there at the turn of the century, and their enthusiasm for exhibitions, art schools, and government awards reflected that Japanese experience. They pioneered these institutional innovations in Chinese art in Canton during the 1920s, just as they pioneered innovation in style and subject matter. By the next decade, all those new institutions became important parts of the Chinese national art scene.

So, for the Gaos the decade between 1918 and 1927 was essentially a period of establishing their artistic reputations and careers in contact with, but generally not participating in, the Nationalist revolution of the 1920s.

The third member of the school, Chen Shuren, remained directly involved in politics, first as an overseas functionary for Sun Yat-sen's revived revolutionary party and then as a central participant in the turbulent events of the mid-1920s. Back in Japan for further study after 1911, he became editor of the Guomindang's overseas magazine during 1915–1916. He was then sent to Victoria, Canada, to become director of party affairs in North America and editor of the party organ *New Republic Newspaper*. He came back to Hong Kong in 1921 after spending most of the previous two decades overseas.

In 1922 when the military commander at Canton Chen Jiongming rebelled against Sun Yat-sen's leadership, Chen Shuren rushed back to join the embattled revolutionary leader on the warship on which he had taken uncertain refuge in Canton harbor. Perhaps because of this exhibition of fearless devotion to the party leader and perhaps because of his long service to the cause, Chen then rose rapidly in the ranks of the shaken party. He became director of the party's General Affairs Department and one of the nine members of the special preparatory committee to reorganize the Guomindang when it entered into the historic alliance with the Soviet Union and the Chinese Communist party.[36] In the reorganized Canton revolutionary government, he worked closely with former Alliance Society associates, first Liao Zhongkai and, then, after Liao's assassination, with Wang Jingwei. These associations with the old Cantonese leadership of the "left Guomindang" did not benefit his political career when Chiang Kai-shek won out in the struggle to succeed Sun as party leader. Chen remained in Canton during the Northern Expedition, when the Canton Commune episode in 1927 removed him from political power. After the reconciliation between Chiang Kai-shek and Wang Jingwei in 1931, Chen joined the Nanjing government.

During these years, Chen did not stop painting, although this was not his most productive period. His political activities also gave him no time to establish his own school of disciples as the Gao brothers were doing. Later, when he was removed from the inner circles of Guomindang power politics and his government positions became more honorific than demanding, he had more time for his painting and poetry. Like the Gaos, his political connections enhanced his reputation as an artist, but, unlike them, he never became a full-time professional painter with students of his own.

Chen Shuren remained the third member of the Lingnan School, but establishing it as a specific school and force in the Chinese art world was the work of the Gao brothers. In 1918 moving back from Shanghai to Canton must have seemed like risking a return to the relative obscurity of the provinces. Other provincials of their generation who made it in Shanghai

or Peking, Huang Binhong and Qi Baishi, for example, did not go back to their provincial homes. But Guangdong was not Anhui or Hunan. As the fires of national revolution rekindled in Canton, the founders of the Lingnan School were once again right where China's future was being determined. The Gaos did not directly involve themselves in its politics, but the success of the Guomindang revolution in the 1920s put them in a good position to promote their artistic revolution on a national scale. Whether by that time a revolutionary art based on late Meiji Japan was still relevant to China's needs was another question. Nevertheless, by 1927 the Lingnan School had the advantages of a firm regional base in the South and good connections with the new national government.

The Lingnan School: Style and Content

For artists so closely attuned to contemporary political and social movements, it would have been surprising if their art had not been influenced by the tumultuous events of the 1920s. The main features of the Lingnan School in style, content, and general approach to art had already been formed before the Gao brothers established the institutional basis of a school at Canton in the 1920s. Still, there was room for some development, perhaps maturation, in their painting and some reflection of the concerns and events of those historic years in their work.

Some prime examples of the intersection of their artistic and political beliefs can be found in the paintings they did for the Sun Yat-sen Memorial Hall built in Canton in 1926. According to later recollections by Zhao Shaoang, Gao Jianfu contributed a landscape, *Autumn at Thunder Peak* (famous site of the ruined Thunder Peak pagoda near the West Lake, Hangzhou), and Chen Shuren a flower painting, *Flowering Kapok* (plate 3).[37] The paintings cannot be identified with certainty, but the titles suggest that Gao Jianfu's was one of his romantically melancholy landscapes, in this case done to mourn the dead father of the Chinese revolution, and Chen Shuren's was one of his numerous paintings of the flowering kapok tree. It may even be the one shown in plate 3, which dates from that year. The kapok is a distinctly Guangdong flower and would serve as an appropriate memorial to the Guangdong-born Sun Yat-sen. The flowering tree would also symbolize his ideas continuing to bloom after his death.

These then, were suitable artistic contributions to the revolutionary cause, but the contributions of Gao Qifeng, the specialist in heroic animal pictures, were more appropriate as a means of inspiring further efforts for the cause. He produced three large paintings of symbolically heroic animals

for the hall—a lion, an eagle, and a horse.[38] The subjects were familiar ones for him and so was the style—realistic detail and modeling in the animals, bold impressionistic brushwork in the background. The overall effect is one of power, courage, and revolutionary spirit. The lion became one of Qifeng's most famous paintings, partly for artistic reasons but partly because of its political message (figure 38). According to the ideology or value system of the Lingnan School, that was no drawback. The revolutions in art and politics were supposed to complement each other.

In these years, other Lingnan School artists also painted lions as an appropriate symbol for the new nation, aroused and militant. Chen Shuren, not usually an animal painter, did his sole extant lion picture in 1926. He Xiangning, widow of the assassinated left Guomindang leader Liao Zhongkai, herself a close friend and erstwhile pupil of Gao Jianfu, also did ferocious lions in the Lingnan style (figure 39).[39]

Of Gao Qifeng's other animal symbols, the eagle most closely matches the heroic spirit of the lion painting. The painting of a fierce eagle poised for flight on a rock over a stormy sea, which was published in a later reproduction volume, may be the "sea eagle" from the Sun Yat-sen Memorial Hall, although this is far from certain (figure 40). The eagle too combines naturalistic detail, highlighting of the claws and beak, with a loose, bravura effect in the background.

The lions were new symbols for Chinese political art; the eagles were somewhat new in the way they were used. The third of Gao Qifeng's subjects for the memorial hall, the horse was a very old symbol in Chinese political iconography.[40] Unfortunately, we cannot identify that exact painting with any certainty, so analysis of the new use of this old symbol has to come from several horse paintings done by Gao Qifeng in this period and a general appreciation of horse painting in the oeuvre of the Lingnan School. *White Horse and Autumn River*, only available in a poor-quality reproduction volume, bears the same title as the painting for the Sun Yat-sen Memorial Hall, but it is dated 1924, the year before Sun's death so, unless Qifeng donated or copied an existing painting for the memorial hall, it can hardly be the same painting (figure 41). Although it was probably not known at the time, there is also the fact, potentially embarrassing for a national monument, that the horse is copied from an entry in an earlier Japanese national exhibition.[41] The autumnal setting is different, but this is one more example of the continuing influence of Japanese models on a nationalistic school of Chinese painting. A white horse might still be a horse, but a Japanese pedigree could prove embarrassing.

However, in April 1926, the popular Shanghai pictorial magazine *Liang you* (Good friend) ran an article, "Famous Recent Paintings of the Re-

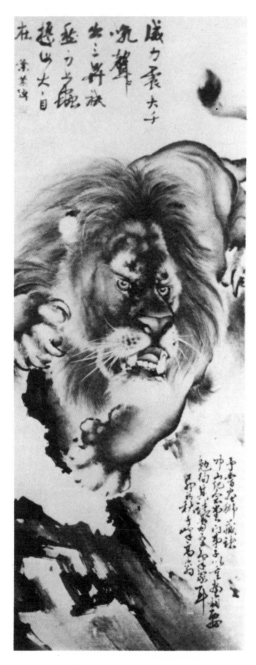

38. Gao Qifeng, *Roaring Lion*, 1927.

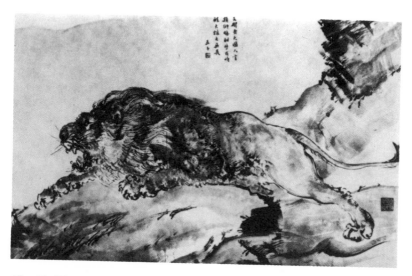

39. He Xiangning, *Lion,* 1927.

nowned Lingnan Painter Gao Qifeng," which discussed his contributions to the Sun Yat-sen Memorial Hall and showed a picture of this same *White Horse and Autumn River* or of another painting very like it.[42] So, after all, this may still be the right horse or at least the prototype for the one in the memorial hall.

When compared to some other Qifeng horse paintings from this period, the autumn river horse becomes a likely candidate for a commemorative symbol. There is a painting of a white horse in the Hong Kong Museum of Art that lacks the autumn river but has no shortage of autumn leaves, where the horse is seen in the same right profile, but with head less markedly turned toward the receiver and tail hanging limply, rather than swishing with nervous energy (figure 42). On close examination, it appears to be the same original Japanese horse (the markings are identical) in two different poses. Both are rather wistfully sad autumnal pictures with three main elements—horse, branches, and falling leaves. So is a third horse painting from these years, but here we have a horse of a different color, in a different pose (figure 43). It shares the autumn sadness mood with the white horse pictures, but with the horse viewed from the rear naturalism prevails over any possible symbolic associations. Actually, here too the pose comes directly from a Japanese painting shown in the 1908 national exhibition, so Gao Qifeng should not be credited with inventing a new view of East Asian horses.[43]

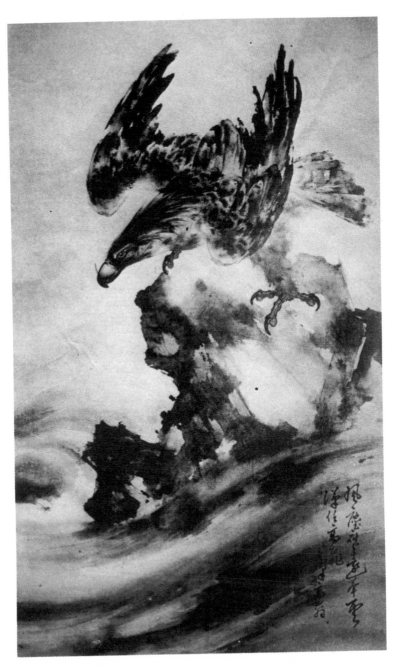

40. Gao Qifeng, *Sea Eagle*, n.d.

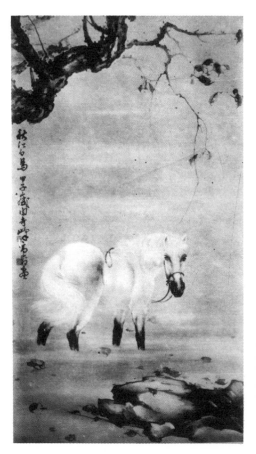
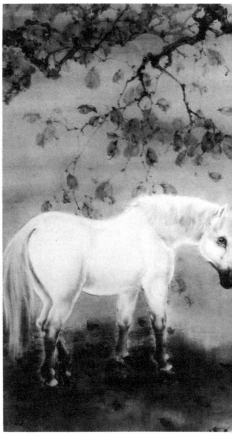

41. Gao Qifeng, *White Horse and Autumn River*, 1924. 42. Gao Qifeng, *White Horse*, n.d.

More important than unacknowledged Japanese precedents are questions about the symbolic significance and naturalistic representation of the white horse. In both pictures there is the commonplace reference to passing time and natural decay. The undated white horse may also be somewhat more naturalistically drawn, hindquarters better than front. *White Horse and Autumn River*, however, is definitely more animated with the swishing tail, turned body, and head directly facing the viewer. The bridle, not present in the Japanese original, may suggest willingness to serve (the people? the revolution?). The tree branch in the upper left is compositionally more dynamic. The falling leaves are less oppressive. In short, while keeping to his formula for autumnal sadness, in this painting Gao Qifeng

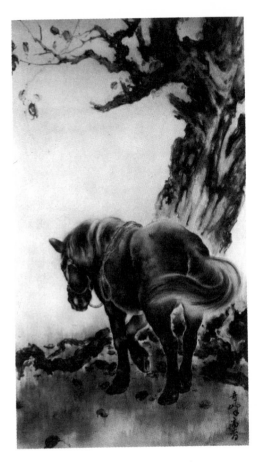

43. Gao Qifeng, *Horse and Tree*, n.d.

created a more obviously noble, if not heroic, image of the horse. It is still not nearly so militantly heroic as the lion or eagle, but in China a horse represented patience, perseverance, and a pure spirit as much as heroic exertion. Together with the *Roaring Lion* and *Sea Eagle, White Horse and Autumn River* was not inappropriate for rounding out a symbolic tryptich.

As for the other Lingnan School painters and horses, Chen Shuren rarely painted animals and hardly ever horses.[44] Gao Jianfu sometimes put horses into his landscapes, though seldom as the focus of the picture. There was, however, one important exception that deserves some discussion, because it illustrates several points about Gao Jianfu's artistic intentions and techniques at this time (figure 44).

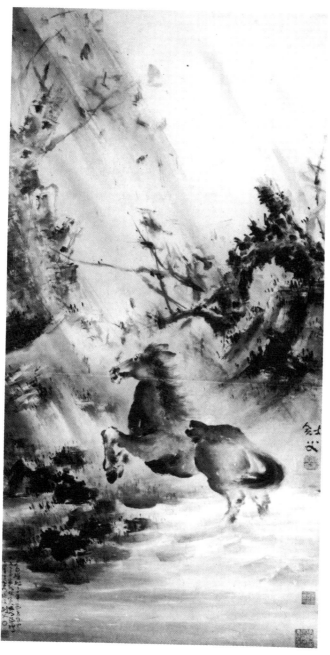

44. Gao Jianfu, *The Steed Hualiu in Wind and Rain*, 1925.

Around 1925, about the same time as Qifeng's white horse, Jianfu did a painting called *The Steed Hualiu in Wind and Rain*. It too is a symbolic picture at a pivotal time of the Chinese revolution, but in many ways it differs from his brother's horse paintings. Instead of naturalistic detail and the solid volume of a real animal, Jianfu uses more traditionally Chinese techniques to emphasize the spirit of the animal more than the appearance. The atmospheric effects, "wind and rain," learned in Japan are prominent, but the style also harkens back to Chinese painting of the Southern Song. This can be seen in the broad diagonal brush strokes to show the driving rain and the open space on the upper right-hand side vaguely recalling the Southern Song one-corner composition. As if to even further affirm this painting's Chinese pedigree, Gao named it after one of the legendary eight heroic steeds of the early Zhou emperor Mu Wang (reigned 1001–946 B.C.). It is not a Japanese- or Western-influenced horse. The technique and references are Chinese; the spirit and allegorical meaning are heroic. Certainly this is how Jianfu's contemporaries interpreted it. His close friend and artistic executor Jen Yu-wen inscribed the painting, as expressing the artist's "personal and social philosophy of struggle and resistance."[45] The rearing horse against a background of driving rain, wind-tossed trees, and roiling waves does convey that revolutionary, nationalistic message.

However, one more point can be repeated about this painting and about much of the art of the Lingnan School. It is also romantic. A wild horse, untamed nature, the stormy elements—whether by design or accident, through indirect influence or similar temperament—Gao Jianfu produced a thoroughly Chinese painting that strongly resembles early nineteenth-century European romanticism. To confirm this, note closely the wildly staring eye of Gao's horse and compare it with a Chinese horse painting on the one hand and with almost any Gericault or Delacroix horse on the other.[46] The evidence of either artistic influence or temperamental affinity, or both, is hard to deny.

The elder Gao also did eagles and tigers during these years as symbols of resurgent China, but he never gained quite the reputation in this genre that his brother did. Jianfu's contributions to the revolution in art and politics came in other areas. First, he was the leading theorist, organizer, and spokesman for the Lingnan School, although the most complete exposition of his ideas about the social and political implications of a new art did not come until the 1930s. Second, in the 1920s, it was Gao Jianfu who led the way in introducing new subject matter and new compositions into his paintings. A view of the stairway leading to a mountain temple is so Western in its emphasis on fixed perspective and solid geometric form that the Chinese mists and brushwork seem slightly incongruous (figure 45).

45. Gao Jianfu, *Evening Bell at the Misty Temple*, n.d.

This is one of his boldest attempts at combining distinctive features from
Chinese and Western painting. If it fails, it is not for want of boldness. The
same can be said for a rather curious picture of a 1920s vintage automobile
crossing a rickety stone bridge (figure 46). But here Gao is also experiment-
ing with introducing modern subjects, representative of the new age, to his
compositions. He had started these experiments somewhat earlier. A pic-
ture of two World War I tanks titled *Two Monsters of the Modern Age*

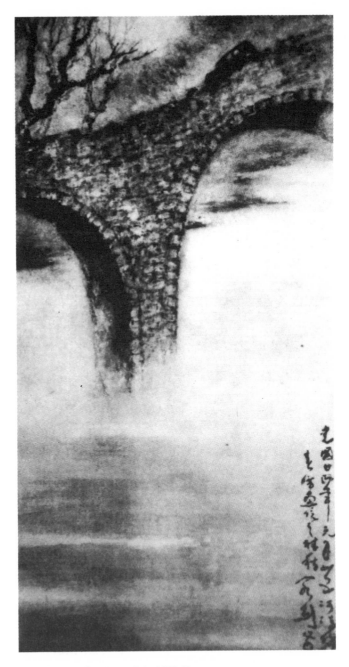

46. Gao Jianfu, *Automobile*, 1935 (?).

47. Gao Jianfu, *Flying in the Rain*, n.d.

apparently has not survived. If the mechanical monsters were put in the same kind of misty picturesque setting as his automobile, they too must have seemed rather curious harbingers of modernity.

Gao was much fonder of another unequivocally modern subject, one that had even stronger symbolic associations with a new age. That was the airplane (figure 47). Several of his aeronautical paintings survive, and often

they are the feature for which Gao Jianfu is best remembered.[47] He did enough paintings of them to fill a whole room at a 1927 exhibition in Canton. The extra-artistic point to these pictures was made by hanging Sun Yat-sen's slogan on the wall, "Aviation to Save the Country."

Usually, however, their paintings were less political and less modern. In theory, the Lingnan School was supposed to take any subject for its paintings, especially the new and dramatic. In practice, they most often painted fairly traditional or commonly accepted subjects—birds, animals, trees, branches, bamboo, flowers, landscapes, Buddhist monks, and occasionally grasses and insects. The explanation for such a discrepancy between modernizing theory and traditional subjects may lie in the market for their paintings. At least some Canton art and cultural circles showed themselves very hostile toward the Lingnan School's syncretic innovations: for several years art critics in Canton newspapers ridiculed the exhibitions of works by the Gaos and their students, and old-fashioned art lovers even defaced some works at these new-fangled public exhibitions.[48]

From the present, it is hard to understand why these Cantonese traditionalists took such violent exception to a kind of painting that was still more Chinese than Western and bore the mark of its Guangdong (Ju Lian) pedigree as much as its Japanese characteristics. Probably it was just because this new style called itself *guo hua* (national-style painting) but did not retain all the elements of traditional Chinese painting. In the 1920s conservative defenders of the "national essence" (or "national painting") could afford to disdain the small amount of Western art that had gained a toehold in a provincial center like Canton. But Chinese-style painters who threatened to sabotage the national tradition from within by smuggling in foreign things—that brought out the traditionalistic polemicists and the patriotic art vandals.

Although such violent opposition did not deter the Gaos (it may even have helped publicize their art), it still may have made them worry about getting too far ahead of prevailing tastes. Meanwhile, the struggling new revolutionary government was not in a position to provide much patronage for a more directly political art, and, even if it had, the Gaos' conception of the modern artist as an independent, though socially minded, professional would probably not have let them accept the role of official artists. The complete dedication and subordination of an artist's taste and vision to political imperatives was a product of the revolution of 1949, not of 1927. But not accepting direct political patronage meant they had to please private patrons perhaps less cosmopolitan and modern-minded than themselves. It was not a dilemma unique to the Lingnan School, nor did such pressures cause them drastically to change the style and motifs they had

acquired in Japan. Nevertheless, the return to a Chinese environment and Chinese market had to have a tempering effect on their artistic radicalism.

One sign of that in their work is the gradual replacement of Japanese-inspired scenes and subjects with pictures of the local Guangdong flora, landscapes, and famous places. For example, the incidence of snow scenes decreased as they lost touch with the northern locale and the artistic models for it. The moist and misty style of other Kyoto-derived landscapes could be held onto longer as equally applicable to the humid Pearl River delta. The lotuses, chrysanthemums, pines, and willows could be southern or northern, Chinese or Japanese, but the banana leaves that started to supplement bamboo in their flat black ink paintings were unmistakably southern Chinese. Even more clearly of regional origin were the bright red blossoms of the kapok tree (the Cantonese painter's local equivalent of the celebrated plum blossom), for which Chen Shuren, in particular, became famous (plate 3).

Banana palms and kapok flowers (later Gao Jianfu would use the rounded effect from an unevenly loaded brush to paint coconuts) were clearly local subjects, perhaps appealing to local tastes.[49] The occasional fondness for the picturesque commonplace in their works may or may not have come from the same cause. Gao Jianfu, in particular, liked to do still life studies of such common vegetables as taro roots and pumpkins. Perhaps it was part of his publicly stated belief that anything could serve as a subject for the new painting and that emphasizing such ordinary subjects would break the artificial limitations of literati taste and put painting more in touch with contemporary reality and popular taste. Or perhaps this too was designed to appeal to a broader stratum of the local public. Whatever the cause, this was not the most original of the Lingnan School's characteristics. Already a paradoxical fondness for the commonplace had become an accepted part of high-class painting, both in Shanghai and Canton, long before the Gaos made their mark. There was also a similar tradition in modern Japan of which they were well aware, as shown by the striking similarities between a Gao Jianfu painting of a gardener's watering can and one done a few years earlier by Takeuchi Seihō.[50] Adaptation to the local scene, perhaps combined with pressure from anti-Japanese nationalism, weakened but did not eradicate either Japanese stylistic influence or an occasional nostalgic reference to a Japanese motif.

Thus, the flower and bird (or, more often, birds on branches) paintings remained their most frequent subject, still drawing on Japanese-learned taste and techniques. There were the previously noted differences in individual style and temperament. Gao Qifeng's birds are more substantial but his branches, rocks, or blowing reeds are more sketchily done. Gao Jianfu,

relying more on line and a stronger brush and less on wet ink washes and deft touches in the birds, painted fewer birds and more tree trunks and branches. Chen Shuren had a still different style. Less impressionistic in his birds than Qifeng, not so strong in his brushwork as Jianfu, he had a surer and lighter sense of color and composition than either of them. All of them showed evidence of their Ju Lian training in the handling of birds, flowers, and insects, although Qifeng was much freer and looser than the others. None of them showed any inclination to pursue Western realism in this genre. Even Gao Qifeng, who had the technical means to do so, seems to have largely abandoned his early studies of realistically drawn small birds in a naturalistic setting. By the 1920s he was using simpler compositions with loose black ink washes more than the earlier experiments with carefully controlled perspective and realistic detail.[51] Perhaps it was easier to paint this way, especially for the routine productions that a well-known artist had to do on social occasions, or, again, it might have been what friends and patrons expected. But it might also have been because the artist felt better able to express his feelings in this traditional genre. Whatever the reasons, these revolutionary painters continued to be active in the flower and bird genre. For every airplane they drew, there were a hundred birds; for every automobile, a thousand flowers.

Similarly, what little figure painting they did was not of people in modern dress or of modern people at all. As far back as the Shanghai period, Jianfu had done some paintings of Daoist hermits and Chan monks. Qifeng followed suit with pictures of strange holy men, including the founder of Chan Buddhism, Bodhidharma.[52] These paintings were not especially numerous, and the significance of their subject matter is not clear. It may have represented the introspective and spiritual side to Gao Jianfu's personality that would grow in later years. It may have been a scholarly painter's affectation, playing with references to eccentric and high-minded recluses. Or again, it could have been a concession to popular taste: such figures were already common in Guangdong painting.[53] In any event, it did not fit in with the revolutionary and modernist aspects of the Lingnan School's mission. Later Gao Jianfu painted a few pictures of traditional "beauties," but neither he nor his colleagues painted contemporary figures in contemporary dress. In other words, despite Gao Jianfu's rhetoric about depicting the contemporary world, their modernism did not include painting modern figures.

Their big birds and animals may have had symbolic modern significance, but they too were never shown in any kind of modern setting. Of course, eagles flying with airplanes or tigers roaring at automobiles might have looked a bit incongruous. But the horse was an animal that could

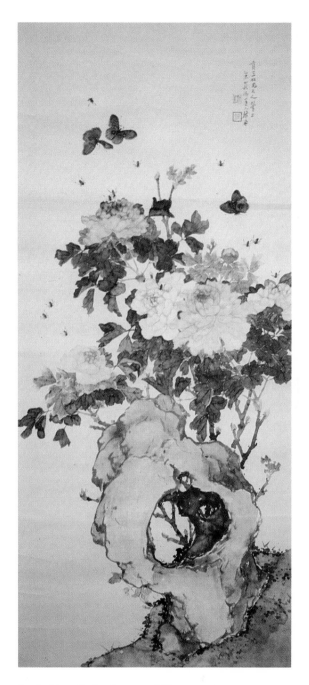

1. Ju Lian, *Rocks, Insects, and Flowers*, n.d.

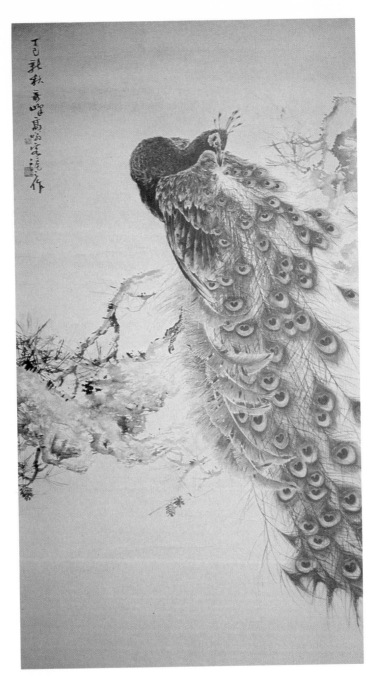

2. Gao Qifeng, *Peacock*, 1917.

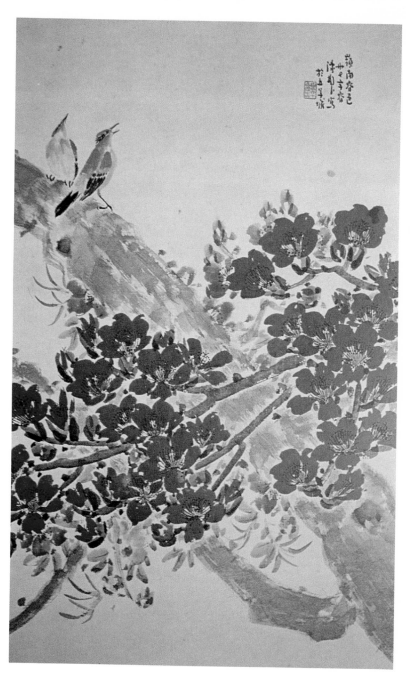

3. Chen Shuren, *Flowering Kapok*, 1946.

4. Gao Jianfu, *The Five Story Pavilion*, 1926.

stand beside contemporary figures or even, as the Guomindang battlefield painter Liang Dingming showed, figure in scenes of modern war.[54] Not in the Gaos' works. Despite the meticulous naturalism of Qifeng's horses, they always appear in purely natural settings. Gao Jianfu's famous horse painting from just this time, 1925, also depends entirely on symbolism for any reference to contemporary political issues. Here too the Gao brothers drew back from directly painting the social or political life of their own era.

The landscape paintings from these years provide further evidence of the inherent tension between claims to modernity and the appeal of tradition, between foreign learned techniques and native popular taste. Chen Shuren's most prolific years as a landscape painter were ahead of him. Gao Qifeng worked in the genre only rarely, and when he did his best results were usually obtained in small, intimate scenes of egrets in a willow tree or a lonely fisherman amid the reeds on a misty river. These pictures, even when painted in the hanging scroll format, have something of the intimate or direct exposure effect of an album leaf landscape.

In contrast, Jianfu painted much more expansive and complex landscapes. As mentioned earlier, he had drawn heavily on certain features of late Meiji landscape painting, particularly the realistic mountain scenery of Yamamoto Shunkyo. But the lure of the Chinese landscape tradition was also strong and as early as 1918 he was doing studies "in the manner of" various past masters. Although he painted relatively few landscapes in the 1920s (or at least few survive), there are two from this period, now in the Hong Kong City Art Museum, that show two different sides to him as a landscape painter. The first, dated 1926, is a painting of an actual monument in Canton, the Five-Story Pavilion on Yuexiu Hill (plate 4). But it is far from being a contemporary scene of the bustling revolutionary activity in the city during that year. The pavilion is a picturesque historic monument, its fading red bricks glowing against an orange sunset, while a flock of crows rise from the ruin. The perspective, coloring, and light effects are all "modern" in the sense of not being in the Chinese landscape tradition, but the mood, reinforced by the inscription's reference to passing time and decay, again is that melancholy reverie not so very different from the romantic ruins that late eighteenth-century European painters found in Italy.[55] In other words, this is still the romantic, even other-worldly, side of the Kyoto tradition.

The other landscape, dated 1927, is a world apart in style, subject, and manner. Titled *Rushing Water Through Myriad Ravines*, it is the kind of large-scale landscape (165.5 × 63.3 cm.) that represents no particular scene except the artist's mind and the numerous other landscape paintings he has

studied (figure 48). It is not "in the manner of" a past master, although there may be references to Lan Ying (1585–ca. 1660) or even the Northern Song master Li Tang (ca. 1050–1130). But its main significance is that it shows that the painter is familiar with many currents in the long tradition of Chinese landscape painting. There may also be Japanese elements in the coloring and treatment of the cascading torrents in the middle ground. It is in fact something of a composite painting, the kind of tour de force that is expected from an artist thoroughly grounded in the Chinese landscape tradition before he goes on to establish his own individual style within that tradition. This was fine for the average Chinese painter, even the aspiring master, but did it suffice for an artist trying to revolutionize China and Chinese art? Then why did he produce such complex and obviously time-consuming works? Again there is no conclusive answer. It might have been for the local market, to prove his status as an accomplished Chinese artist, or because the more modern and innovative style of the 1926 work did not completely satisfy him or his artistic associates. Whatever the answer, the problem of modernizing or revolutionizing Chinese painting was only partly one of incorporating new subject matter. It also required new ways of viewing and depicting old subjects.

This problem occurs even in Gao Jianfu's most "modern" paintings, his pictures of airplanes and automobiles. They too incorporate some new techniques, most noticeably fixed perspective, shadows, and light effects, but for the most part keep the modern mechanical symbols very secondary to the largely traditional landscape they are set in. The car is no larger than the lonely traveler or solitary fisherman of his other landscapes. The air-planes appear more like small birds or insects over a misty plain and distant pagoda. Forty years later, radical art critics in the People's Republic of China would accuse traditional landscape artists of only making token concessions to modernity by hiding their dams and mountain highways in the mists and peaks of traditional landscapes. Of course, Gao Jianfu lived in a different time, and his innovations aroused the ire and ridicule of conservatives, not modernizers. But, in style and spirit, he too failed to capture the spirit of the new age. Perhaps it was enough that, more than either of his colleagues, he started to show what the problem was.

Between 1918 and 1927, the Lingnan School had solidly established its position and its syncretic approach to modernizing Chinese art. At that time, they still considered themselves as modernizing Chinese art, and as true revolutionaries in art and politics. Since most of their political friends were on the left of the Nationalist party in mid-1920s and most of the opposition to their art came from cultural conservatives, perhaps they still deserved that reputation. In the decades after 1927, when the Nationalist

Gao Jianfu, *Rushing Water Through Myriad
~~nes~~, 1927.

49. Gao Qifeng, *Bird on Branch*, n.d.

political revolution had succeeded after a fashion, they would apparently get their first good opportunity to realize their national goal in art. How much of a chance they or the Guomindang really had is a complex question of historical interpretation. In any event, the Lingnan School's successes and failures would be closely bound with, and in some ways illustrative of, the fate of the Nationalist party itself.

4

The areas where culture developed the earliest today are the
areas where it is most lagging, most miserable. Areas where
culture developed later, on the other hand, are more advanced,
more dynamic. . . . In China, the Pearl River valley developed
later; the Yellow River valley's Northwest is our most
ancient center but today it is also the poorest. Doing a little
deduction from this we can suggest that perhaps the renewal
of Chinese painting must look to the Pearl River valley.

Fu Baoshi, 1935

From Region to Nation:
The New National Painting

In 1927 the military successes of the Northern Expedition carried the
Nationalist party from its southern redoubt in Guangdong to the capital of
a nominally reunified republic in Nanjing. This opened new prospects for
realizing the Lingnan School's goal of revolutionizing Chinese art. The
Gaos' teaching studios remained in Canton, but, along with Chen Shuren,
they now had connections with a national government that could give
their painting national and international exposure far beyond the provincial
confines of Guangdong. For almost twenty years, political disunity and
cultural conservatism had frustrated their attempts to spread the "new
national painting" in China. With national unity reestablished and their
revolutionary political party triumphant, at last circumstances seemed right
for the revolution in art.

Gao Jianfu had been a pioneer in bringing to China the modern institutional basis of art—public exhibitions, open art schools, government support for the arts, and art classes in the curriculum of public institutions of higher learning. Therefore, it was appropriate that he was made chief organizer of the new Nationalist government's first national art exhibition held in Nanjing in 1929. Naturally, the three masters of the Lingnan School were prominently represented, and so were several of their disciples.[1] Moreover, Chen Shuren was one of the judges for the exhibition.

The national exhibition was intended as a sign of the Nationalist government's internal political accomplishment in restoring unity to the wartorn country. Participation in international art exhibitions was a way of using art to promote China's foreign relations. The Lingnan painters were very active in this diplomacy through art, a policy that resembled the Meiji government's promotion of Japan's image abroad by sending the work of Japanese artists to various international expositions. In 1931 Gao Jianfu, Chen Shuren, and a young student of Gao Qifeng's, Zhao Shaoang, were all prizewinners at the Belgium International Exposition. Gao Jianfu subsequently won prizes at Sino-German art exhibitions held in Berlin in 1934 and 1935, at which time the German government acquired one of his works for the permanent collection of the Berlin Museum.[2] Chen Shuren also participated in the Berlin exhibition, had his works on display in the national galleries in Berlin and Paris, and helped organize the highly successful 1935 exhibition of classical Chinese art in London.

Gao Qifeng was chosen to arrange the first major exercise in artistic diplomacy, the initial Sino-German exhibition. He had traveled north to Shanghai for that purpose, when a sudden worsening of chronic tuberculosis led to his premature death in November 1933. The honors showered on him by the Nationalist government, including an official state funeral, were unprecedented for an artist, reflecting the Lingnan School's official prestige and highly placed government connections.[3]

By the mid-1930s, Chen Shuren was resident in Nanjing and painting more prolifically than at any time since his student days, although he still held official government positions. Gao Qifeng was gone, but his disciples carried on his style in Canton and showed some of their works in Shanghai and Nanjing. Gao Jianfu, the most famous of the three founders of the school, was getting more and more exposure and attention in the lower Yangtze centers of China's economic, political, and cultural life. In 1935 he had a one-man exhibition in Nanjing. In 1936 his friend and former

elementary school pupil Jen Yu-wen, now a representative to the national assembly, arranged an exhibition of Jianfu's works in Shanghai where many of the political, intellectual, and cultural elite of central China paid their respects to the famous Lingnan master.[4] Later in the year, Shanghai viewers were exposed to more works by Gao Jianfu and his students in subsequent exhibitions of Lingnan art. Two decades after the Gaos had left Shanghai, their art was more prominent in the metropolis of central China than ever before.

Meanwhile, in Canton Gao Jianfu continued to encounter bitter opposition from conservative art circles, despite the growing national prestige of his school. By the 1930s, this opposition centered around the Guangdong National Painting Research Society, which had good connections with important culturally and politically conservative groups in Guangdong.[5] These critics still considered his innovations a "heterodox path" leading to the ruin of China's "national painting." They also blasted his works as "imported foreign goods" and "copies of Japanese paintings," a charge that was more and more damaging in the increasingly anti-Japanese atmosphere of the mid-1930s. Gao could reply that they did not understand either the new national painting, which sought to preserve the best in China's own tradition while adapting to the new times, or modern Japanese painting, "which has synthesized and absorbed the techniques of Chinese and Western painting in its evolution."[6] Also, on the issue of using art to mobilize public opposition to Japanese aggression, it was Gao's new national painting school that produced works on contemporary political themes and supported public art sales to raise funds for resistance to the Japanese advances in the north, whereas his conservative critics disdained such vulgarization of art. By 1936 Gao held a teaching post at Canton's leading educational institution, Sun Yat-sen University, where he organized students into the Sun Yat-sen University Art Research Society in order to push the cause of a new approach to painting. But, with even the military governor of Guangdong Chen Qitang siding with his conservative opponents, Canton cannot have been entirely comfortable for him and his cause.

In any event, Canton was no longer at the center of the nation's political or cultural stage. That was farther north in the lower Yangtze Valley where he now had more sympathetic friends and connections. After repeated exhortations from these friends to come north in order to preach his message of a rejuvenated Chinese art in a rejuvenated country, in 1936 he accepted a visiting professorship at National Central University in Nanjing. This provided an important platform for his views. The Yafeng hui (Asian Wind Society) which he founded in Shanghai in 1937 to promote the new national painting provided another. Gao Jianfu and his call for a

new kind of Chinese painting were back at the center of China, and this time with much more prestige and official recognition.

The Theory of the New National Painting

Gao Jianfu's lectures at National Central University in 1936, subsequently published as *My Views on Contemporary National Painting*, form the most comprehensive and articulate statement of the Lingnan Shool's theories on art. Given at the height of the school's reputation, when its national aspirations seemed closest to being reached, the views contained in these lectures merit close attention.

The general thrust of Gao's lectures was toward innovation, creativity, and realism—a "a revolution" in Chinese painting. But the retention of the term *guo hua* (national painting) shows how much he was concerned with keeping a distinctive Chinese identity. In the contemporaneous controversy over "cultural construction on a Chinese basis"[7] Gao was on the side of the modernizers, not because he wanted to abandon everything in China's cultural tradition, but because, like Hu Shi, he believed "complete Westernization is, in reality, impossible."[8] Therefore, fear of cultural borrowing would only inhibit the changes necessary for a rejuvenation of Chinese art and national life. Gao advocated more Western-style painting in China as a stimulus for change and revolution. Chinese painting would retain its essential national character anyway, because a nation that could assimilate the Mongols and the Manchus certainly could assimilate Western painting.[9] The greatest danger to the nation was failure to change—to move with the times and produce a "contemporary painting" suitable to the contemporary situation.

His view of Chinese history and the history of Chinese painting supported this. The Tang and Five Dynasties had been a period of innovation, creativity, and foreign borrowing setting the stage for the "golden age" of the Song and Yuan.[10] The patterns set in that period had become fixed in the Ming and Qing, leading to stagnation and decline in the past 200 years. He did not fix the blame for such decline on foreign conquerors as did some modern Chinese nationalists. Instead, Gao attributed it to the dominance of literati painting and its theories, which, by emphasizing "mystical thought" and reverence for the past, diverted art from the direct, living experience necessary for continued creativity. In the dominance of literati values lay the cause for stagnation in all areas of the nation's cultural life—art, music, theatre, even medicine. The continued strength of these old values among artists and art connoisseurs was responsible for the lack of a

vital contemporary art in China: "They esteem life that is already dead, but oppose contemporary new life. . . . They [still] believe China is all-under-heaven."[11]

So Gao was on the side of the modernizers, the revolutionaries, against the prevalence of traditional painting and traditional values. As for the general charge against all modernizers that they were substituting Western culture for Chinese, Gao partially defused this by insisting that China's new national painting should draw from art traditions from all over the world—Indian, Middle Eastern, and Japanese—not just Western. This universal syncretism, taking whatever was useful for modern China from any source, perhaps could downplay the cultural indebtedness to the West. For the Lingnan School, it could also dilute their Japanese borrowings in a sea of universal artistic syncretism. In fact, such a vision opened up broader cosmopolitan vistas that could not but be pleasing to Chinese nationalists beleaguered by doubts about China's contributions to the coming world culture. Gao ended his lectures with this proposition: "In the twentieth century, with science progressing and communications developing, the scope of culture has expanded from the nation to the world. Painting has followed this and expanded to the world scope. I hope this new national painting [his *xin guohua*] becomes world painting."[12] This presented heady prospects for his new national painting, as China became potentially the leader rather than a follower in producing the new world art. Evidently Kang Youwei was not the only modern Guangdong visionary to see beyond Guangdong and China to a new world.

Back in the realities of China in the 1930s, however, there was little likelihood that the rest of the world, especially the West, was about to look to China's new national painting as a model for producing a universal art. The immediate task at home was to get Chinese to share Gao's vision of what China's new painting should be. In expounding that vision, he had to appeal to pride in past accomplishments and their continued relevance to the present, as well as to vaguer prospects for a global future. Actually, the Lingnan School's cultural syncretism had never been hostile to China's cultural tradition in total. Thus, for all his hortations to break with old conventions, create new compositions, draw closer to presentday life, and incorporate modern subjects in modern paintings, Gao's attitude toward the existing tradition in Chinese art was far from being nihilistic or even iconoclastic. He not only insisted that all innovation builds on tradition, but specifically praised the strong points of "old national painting," namely, its brushwork, use of ink, and "spirit resonance."[13] Brushwork and use of ink were, of course, strong points in his own painting. The third point, "spirit resonance," had long ago been established as the most important aspect of

painting by the Tang dynasty art theorist Xie He, in the most influential art treatise of China's long history, *The Six Canons of Painting*. It is hard to define "spirit resonance" with precision, but it has long been understood that it dealt with inner vitality and faithfulness to the spirit of the subject more than to its external appearance. Gao's retention of this cardinal value of traditional Chinese painting somewhat modifies the emphasis he puts on *xiesheng* (drawing from life) elsewhere in his lectures.

As we have noted, "drawing from life" and the adoption of specific elements of Western painting did not lead Gao himself into any kind of literal realism in his work. His revolutionary formula, first arrived at three decades earlier, was to combine the best of Chinese and Western painting, a combination that would not be more Western than Chinese. In the lectures of 1936, he defined the new national painting as "having the spirit and spirit resonance of national painting and also the scientific techniques of Western painting."[14] He did not use the famous rationalization for Western cultural borrowing adopted by the Confucian self-strengtheners of the late nineteenth century, "Chinese for essence; Western for utility," but there are echoes of this kind of thinking in his artistic syncretism.[15] Western techniques, and even the ideas behind the techniques, could be borrowed boldly since the underlying essence or spirit would remain Chinese: "I do not advocate completely accepting Western painting because that would be lifeless and have no inner national spirit."[16] National spirit and a lingering respect for much of the tradition he attacked suffused Gao's new national painting. Deep down, his values were still more those of the Alliance Society patriots of 1911 than of the cultural iconoclasts of the May Fourth period.

Thus, in the twenty-four maxims on new national painting that he laid down for his students at National Central University he advised: "The ideas must be new [but] the brushwork must be old," and, "One cannot get away from the old [but] one cannot get mired in the old."[17] On the crucial question of realism versus "idea painting" (*xiesheng* and *xieyi*), he told his students to work "from unlikeness to likeness and then from likeness to unlikeness."[18] The meaning of this rather cryptic phrase seems to be that the painter has to go through a process of observing and recreating the forms of natural objects before he can express the inner meaning or idea of his subject. As examples of painters who exemplified this, Gao cited such diverse artists as Xu Wei, Badashanren, and Picasso.[19] None of them would be recognized as exponents of naturalistic representation, but Gao insisted that the reason they could deviate from natural forms was because they had first mastered how to depict them and could then simplify and extrapolate the essential features: "The brush that paints the idea has been

developed out of the brush that does detailed work [*gongbi*]."[20] This was still well within the boundaries of standard Chinese art theory, even literati painting theory.

But there was one important place where he broke with literati views on painting and sided more with the modern May Fourth intellectuals who called for a revolution in Chinese culture in order to remake Chinese values and national life. Perhaps he did not go as far as some of them in what that would entail, but he agreed that art must be connected with contemporary events and could help remold the collective life of the nation. That was the central point to his revolution in art, and the connecting point between his life as a political and an artistic revolutionary. In Gao's words: "Art can change society, can transform the human heart."[21] With arguments reminiscent of his friend, the influential educator and philosopher Cai Yuanpei, Gao spoke of art as "spiritual food" that could morally improve the individual and the society.

The purposes of art, therefore, were social and public, not the pecuniary gain of the professional artist or the private self-expression of the ideal literati painter. Modern art must reach more than a handful of highly cultured cognoscenti if it were to serve those social purposes. Hence, exhibitions and publications were important, and Gao had been a pioneer in both. Also, the art must be comprehensible to its broader modern audience. In one passage on popularization, Gao sounds as much of a democratic populist as any of the Communist art critics who would follow twenty years later: "All art not compatible with the masses' demands definitely must fall into decay. Contemporary painting proceeds from this. It first must have lively truth adequate to move a general audience's hearts, minds and spirit. In other words this is called 'popularization' (*dazhonghua*)."[22]

Such "popularization" meant a style and content recognizable to, and appreciated by, the masses. On style, Gao did not use the argument that would become standard for Communist populizers in the United Front period of the late 1930s and 1940s, namely, that a style more Chinese than Western would probably be more readily accepted by the masses who had not been exposed to much Western culture or education. In the context of his argument with conservative artists of the mid-1930s, Gao probably did not want to give them that potentially anti-modernist weapon. He continued to emphasize innovation, but his art as much as his theories showed that the new elements would not supplant the basic features of Chinese-style painting. As for content, again he urged innovation and closeness to modern life. Scenes of war, pictures of the poor and humble—what he called "the appearance of life and reflection of reality"[23]—sounded like social realism, and perhaps that was the revolutionary art the times de-

manded. But his attachment to traditional artistic values and, perhaps, his attachment to the Nationalist party prevented him from drawing really radical conclusions from his theories about art and revolution. The Lingnan School, now favored with prestige and position under the Nationalist government, retained a middle position, which tried to balance the tensions between old and new, conservatism and radicalism. For a time, the difficulties and inherent contradictions in such a position were not readily apparent. For a time, Gao's national goals appeared to be realizable.

The Lingnan School in Central China

When Gao Jianfu came to Shanghai in 1935, his reception was much more impressive than when he had been a struggling young painter and art shop proprietor there soon after the Revolution of 1911. Now the Lingnan School was a nationally recognized art movement, and he himself a famous and well-connected artist. Only two years earlier, the mayor of Shanghai had led the funeral procession for his brother Qifeng. Now Jianfu's own exhibitions would be attended by the famous and influential from the political and cultural circles of central China.

For example, his one-man show in Nanjing in June 1935 drew a shower of praise for his revolutionary spirit and technical mastery. Chen Shuren called his old friend and fellow student the "forerunner in the artistic revolution."[24] The liberal politician and intellectual Luo Jialun said, "Jianfu's art is the hot blood of the revolution, refined and made into beauty." Gao's one-time protege Xu Beihong, now returned from Paris to become the most influential Western-trained artist in China, waxed even more enthusiastic: "His art is heroic and free, like the sound of a great bell. Those who are used to refined and luxurious sounds certainly cannot appreciate it. Really [he is] the forerunner of the revival of Chinese art."[25]

Perhaps even more noteworthy was the praise from a young Chinese-style painter who had just returned from study in Japan. Writing in a journal sympathetic to new art and the Lingnan School in particular, Fu Baoshi attacked the sterility of contemporary Chinese painting still dominated by a stagnant literati tradition.[26] He singled out five contemporary Chinese artists who might show the way in revolutionizing Chinese painting. Two of them were the most famous Western-trained artists in China, Xu Beihong and Liu Haisu, but the other three were the leaders of the Lingnan School—the two Gaos and Chen Shuren. Fu also praised several of Gao Jianfu's students for their boldness in smashing fetters and suggested that a peripheral area, such as the Pearl River delta, might produce the

boldness of spirit lacking in the conservative north and the complacent lower Yangtze region.[27] He was not a big name then, but Fu Baoshi would go on to become one of the most famous artists and influential art theorists of twentieth-century China. He did not later champion the Lingnan School's cause, but his high praise at this point shows how much greater an impression the school was making than during the Gaos' first sojourn in Shanghai.

Jianfu's subsequent exhibitions in Shanghai drew similar praise, critics admiring his works even when they disliked the more radical experiments of some of his students. The more modernist critics were most enthusiastic about his work, which indicates that it still stood on the radical side in the spectrum of Chinese painting. For critics like the modernist oil painter Ni Yide, who had written as early as 1932 that China needed a new painting that would cope with the modern world, Jianfu's art was an encouraging sign that the fetters of the old esthetic values could be broken without losing the poetic content of art.[28] Another modernist critic, Wen Yuan-ning, also saw Gao and the Lingnan School as a refreshing change from "the same monotonous succession of birds on branches, tigers, eagles on rocks, lotus-flowers, pines, etc., drawn with very little variation from the manner of the ancients."[29] Wen was even more pleased to note that the Western influence in Gao's works "has been so subdued to his essentially Chinese artistic mode of feeling."[30] In other words, in this critic's opinion Gao Jianfu, unlike most of his contemporaries, had succeeded in being both modern and Chinese.

To be sure, there was at least one radical critic, Chen Yifan, also writing in *Tien Hsia Monthly*, who thought that Gao and his followers were still not modern enough. They displayed "a new spirit of energy and realism … but it is a realism that has not yet freed itself from a too respectful vener-ation of the classic forms."[31] But most critics seemed to appreciate the retention of national flavor. For Li Gaoquan, in the journal *Yi feng* (Art wind), Gao Jianfu's art marked the beginning of a new era, a "great move-ment" to rejuvenate Chinese painting by incorporating new elements from abroad. And, unlike earlier synthesizers of Western and Chinese art, notably the early Qing court painter and Jesuit missionary Giuseppe Castiglione (Lang Shining), Gao penetrated to the inner spirit of Chinese art rather than just adding a few techniques.[32]

Gao Jianfu clearly was the spearhead of the Lingnan School's assault on the established centers of esthetic and cultural values in central China, but his colleagues and some of his students attracted favorable attention too. Gao Qifeng's works were published in a handsome posthumous reproduc-tion volume, *Record of the Glories and Sorrows of Mr. Gao Qifeng*, with

panegyrics by various dignitaries, including his old friend Wang Jingwei who was now premier of the Executive Yuan.[33] Chen Shuren, though he stayed in politics, also received growing recognition as an artist. He had at least one well-received individual exhibition in Shanghai, and two reproduction volumes of his works were published in that city in the mid-1930s.[34] The second of these had a French subtitle, *Les Oeuvres récentes de Chen Shuren*, and contained testimonials from both foreign and Chinese intellectual luminaries. The French novelist Romain Rolland, famous in China for his novel *Jean-Christophe*, contributed a laudatory introduction. The foremost oil painter in Shanghai Liu Haisu and the progressive-minded Minister of Education Cai Yuanpei added their best wishes. In many ways, the whole Lingnan School, and not just Gao Jianfu seemed to be coming into its own on the national scene.

Fulfillment and Frustration in Life and Art

The decade from the Nationalist revolution to the outbreak of the Sino-Japanese War saw the Lingnan School reach its peak in national prestige, but, like the Nationalist party itself, the period was not one of unqualified success in their lives or in their art. The greatest single setback came in 1933 with the untimely death of Gao Qifeng at the age of 44. In some ways it was not quite so tragic as the sudden death of the youngest of the Gao brothers, Jianzeng, seventeen years earlier. Qifeng (who had been suffering from tuberculosis for many years) had still had time to reach maturity and gain fame as an artist. However, it was a shock and a blow to the Lingnan School just as the time finally seemed ripe for it to realize its national ambitions. Gao Qifeng left a small band of talented and devoted disciples in Canton, but, with one exception, they failed to make an impact on the national scene.

His closest personal disciple and artistic executrix was Zhang Kunyi, a woman artist with whom he was closely involved during his last years. She met him as a student when she was already a married woman from a socially prominent family. Gao Qifeng had also been married during his years in Shanghai, but his wife had left him, taking their young daughter with her. Apart from his talent and artistic reputation, the younger Gao was an impressive figure. Taller than his diminutive elder brothers, Qifeng was strikingly handsome, after the ideal of the frail and talented young scholar common in traditional Chinese novels and modern Hong Kong movies. The frailness, in his case attributed to tuberculosis, did not weaken this image.[35] As for Zhang Kunyi, she was young, attractive, and talented. She soon became a favorite student, and more.

There are some small paintings from the late 1920s that Gao Qifeng dedicated to his "female disciple, Zhang Kunyi." When he built his Heavenly Wind Pavilion as a studio and residence on the banks of the Pearl River, she moved in with him as student, nurse, and adopted daughter. This was somewhat scandalous by contemporary standards. Not that it was uncommon for successful middle-aged artists, like successful businessmen or politicians, to have mistresses or second wives. But it was unusual for her to be a married woman from a prominent family. Still, artists should be expected to take a little artistic license, and, if we compare Gao's affairs of the heart with those of his literary contemporaries who spent their student days in Japan, his behavior does not seem extraordinary. In more ways than one, both writers and artists deserved the title, the "romantic generation."

In any event, Zhang Kunyi apparently was devoted to Gao and made his final years of illness and semi-retirement more tranquil and rewarding. Her grief-stricken eulogy, written in blood, was reproduced in the memorial volume to Gao.[36] Not surprisingly, her style was closest to Gao's of all his students. At times her paintings are virtually indistinguishable from his, prompting some to claim that he helped or even painted some of her pictures for her. That may be true for her earlier works, but she had mastered his techniques very well on her own, as her pictures done after Gao's death testify. There is little innovation or originality to her works. She was too faithful and too literal a follower to develop the Lingnan style further. But she preserved Gao Qifeng's version of the Lingnan style and got him some international recognition when, during World War II, she arranged a joint exhibition of his paintings along with hers at the Metropolitan Museum of Art in New York.[37]

Apart from his personal life, there is the question of whether Gao Qifeng's premature death cut short his development as an artist. Of the three founders of the Lingnan School, he was the quickest to evolve a consistent style and the one closest to his Japanese mentors. Perhaps that was because he went to Japan at a younger age than either his brother or Chen Shuren and consequently had less of a grounding in traditional Chinese art from Ju Lian. He never developed Jianfu's vigor in his brushwork or the freshness and delicacy of Chen Shuren's flower paintings, but in other respects he surpassed his senior colleagues. On the one hand, he had the best command of the quasi-realistic style of Japanese animal painting. On the other hand, he combined technical virtuosity with strong emotional expressiveness. Perhaps this was what Chen Shuren meant when he commented to Gao Jianfu, "You partake of the strange and marvelous; I of the orthodox; Mr. Qifeng maintains a middle position."[38] As with most one-line capsule summaries of complex artistic styles, this is oversimplified

and potentially misleading. In technique, Chen was not that orthodox, and Gao Jianfu, not that bizarre. But for the spirit or emotional content of their paintings, the remark shows some insight into the artistic personalities of the three artists. Not so bold or experimental as Gao Jianfu at his most daring, less restrained than Chen Shuren's quieter and more controlled spirit, Qifeng did in some ways represent the most successful adaptation of late Meiji Japanese painting to Chinese tastes. This can be seen in the continued popularity of his version of the Lingnan style among painters of subsequent generations in Canton and Hong Kong. However, it leaves unresolved the question of whether in his own lifetime that style was becoming somewhat formulaic, too easy, and hence too limited an answer to the challenge of producing a revitalized contemporary Chinese painting. His premature death denied him the opportunity to grow beyond his early successes to produce a more personal and more powerful artistic statement.[39]

In Gao Qifeng's last years, there are some indications that he was moving toward a more intimate and personal style. The large, heroic animal pictures disappear from his oeuvre; even in most of his paintings of small birds, the emphasis on colorful detail is replaced with a simpler style relying almost entirely on ink. A bird on a branch, stylistically similar to a number of such works done in his last years, illustrates this tendency (figure 49). The picture is intimate, impressionistic, and almost entirely boneless. Broad, wet strokes define the branch, not unlike many of his earlier works, but here the bird too is done in that manner. Meticulous, realistic detail has disappeared in favor of an impression of haste and spontaneity. One small dot of red, indicating that the tree is a flowering plum, is the only concession to color.

His landscapes also become wetter, darker, and more boneless. Some of the Japanese-derived contrasts of light and dark (and all the Japanese incidentals, such as snowy trees or thatched roof farmhouses) disappear in favor of a simpler, rougher texture and direct contact with Chinese scenery, as in the *Flower Bridge Mists and Rain* produced after a visit to Guilin in 1932 (figure 50).

One might interpret the looseness and the darkness of his later works as a sign of illness or depression, although he was well enough in 1932 to undertake the extensive sketching trip in Guangxi. It could also be seen as progression toward a more personal and more Chinese style, playing down the special effects and decorative quality acquired from his Japanese training. Or, more simply, it could be an extension of his preference for loose, wet washes over line as a means of defining form. But one thing that it does not show is any movement toward contemporary political or social reality

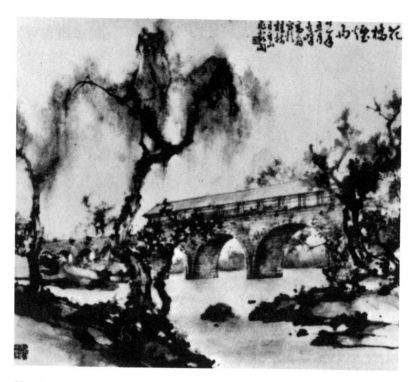

50. Gao Qifeng, *Flower Bridge Mists and Rain*, 1933 (?).

in his last years. Qifeng never even experimented with the modern subjects (cars and airplanes) that Gao Jianfu attempted to integrate into still traditional landscapes and, like his brother, he never did figure paintings of contemporary people. Qifeng may or may not have been evolving toward new modes of esthetic expression, but he was not developing the kind of contemporary painting closely linked with modern life that the elder Gao called for in the Nanjing lectures on contemporary national painting.

Thus, the "revolution in Chinese painting" remained mostly the responsibility of Gao Jianfu. He had always been the leader and primary spokesman for the movement. With both his artistic brothers dead, it was up to him to produce the works that would show how Chinese painting could move with the times and still retain its unique national character.

Jianfu remained in Canton after the success of the Northern Expedition. During the first few years of the Nanjing government, most of his old revolutionary associates, Cantonese leaders such as Wang Jingwei and Hu Hanmin, were out of favor with the Chiang Kai-shek–dominated govern-

ment. Moreover, his closest friend near the top of the Nationalist party hierarchy, Liao Zhongkai, had been assassinated several years earlier, a factor that may also have influenced Gao's withdrawal from active politics. He still had the credentials of an old revolutionary and many contacts in the new government, but they were not sufficient to draw him away from the artist's vocation or from the comfortable familiarity of Canton.

In Canton he seems to have enjoyed an artistic life somewhat similar to that of a gentleman scholar, but with signs of modern vigor, such as his passion for turning scenic outings into strenuous hikes. Other activities of the informal group of friends to which he belonged, the Qingyou she (Pure Travel Society) sound more like traditional art lovers' activities— drinking wine, visiting teahouses, and discussing art.[40] Professionally, his institutional teaching positions at Sun Yat-sen University and Foshan City Art School differentiated his life from that of the traditional painter, as did his continued insistence on the public dimension and social function of art.

The growth of his prestige throughout these years is attested to by a rather bizarre incident, which nicely captures the transitional nature of art, society, and politics in early twentieth-century China. A politically powerful military commander in Canton had long coveted a personally dedicated painting by Gao Jianfu. Finally trapping the reluctant artist at a dinner party, the general in true warlord fashion forced him to do a painting at pistol point. With great sang-froid, Gao completed a painting and inscribed on it, "For love of my head I paint this withered chysanthemum; a twenty years' painting obligation has today begun to be met."[41]

Warlords, strolling companions, and institutional teaching positions aside, the core of Gao Jianfu's artistic life was at his Spring Slumber Studio with his disciples there. Only with reluctance and after postponing his departure did he take the teaching position at National Central University. He then used his connections to promote the art of his leading students in the north.

This does not mean that in the early 1930s Jianfu was prepared to settle down to a life of tranquility and semi-retirement in his provincial hometown. His love of travel and new experiences remained undiminished. His family life was not entirely staid or conventional. Soon after 1911 he had married a revolutionary comrade whom he met during the days of underground activity in Canton. Song Minghuang bore him a son who died in infancy when Gao was still in Shanghai. A second adopted son was never close to his father, but his daughter Gao Lihua (Diana Kao) graduated from Sun Yat-sen University in the mid-1930s and assisted her father in his 1936 exhibition in Shanghai. Subsequently, she acquired the English-language education that Gao Jianfu always regretted having missed and took up an

academic career in the United States. After his first wife died in 1939, Gao remarried and had another son, Gao Lijie, who was still a child at the time of his father's death. None of his children became a professional artist.

There are no scandals associated with Jianfu as with his brother's relationship with Zhang Kunyi, but he too was active in romantic affairs. Apart from occasional mistresses in Canton, still the perquisite of a successful middle-aged male in his times, he had a long-standing relationship with Yang Suying, a prominent educator, poet, and painter in Hong Kong.[42] She was a modern woman of independent mind and considerable accomplishments, a leading voice for women's rights in Hong Kong.[43] Not a conventional beauty, she must have satisfied Gao's need for contact with the new and modern, as did the Westernized city of Hong Kong where he spent a considerable amount of his time from the 1930s on. But whatever modernism Hong Kong represented, that was not the important influence on his art at this time. Such influences came from another, more distant journey and perhaps from more personal factors in his life and personality.

In October 1930, Gao left for India and spent almost a year there traveling widely (from Ceylon to the Himalayas),[44] meeting such famous Indian intellectuals as Rabindranath Tagore and studying classical Indian art firsthand at the Ajanta caves and other ancient sites. At the time of his student days in Tokyo, with Pan-Asian theorists such as Okakura Kakuzō stressing India as a source of Asian spirituality and art, some contemporary Japanese artists of the new national painting school had drawn heavily on Buddhist themes. Whatever residual influences that early indirect exposure to India had left on Gao, when he went there as a mature artist the experience made a deep impression on him and his art.

In fact, his friend and biographer Jen Yu-wen claimed in 1936 that Gao's artistic development had entered a new stage since his trip to India. According to Jen, Gao's three stages were: (1) a foundation in Chinese painting under Ju Lian before going to Japan; (2) an eclectic style combining features of Eastern and Western painting based on his Japanese study; and (3) a new period of more tranquil and reflective painting based on "ancient Eastern influences."[45] From the perspective of his whole career, this judgment is overstated, and Jen Yu-wen does not mention a "new stage" in his later biography of the artist. Gao Jianfu had been much more impressionable and his art more malleable during his student years in Japan. Still, even as a mature and recognized artist, he was open to new influences. It was significant for the course of the new national painting movement that, at this particular stage of his life, when the political movement he had identified with was also losing its revolutionary thrust, he was most open to influences from "the ancient East" rather than from the modern West.

What were these influences, and what was their effect on his art? The direct influence of Indian religious art, notably figure painting, appears in a series of works he did in 1931 and 1932, copies of wall paintings he saw in Calcutta, Nepal, and Ajanta.[46] They show his interest in ancient Indian art and religion but, with the exception of adopting the brownish tones from Ajanta wall paintings, they do not seem to have had a lasting influence on his style of figure painting. By the mid-1930s, for instance, he was doing paintings of beautiful women where the only foreign influence was late Meiji taste and style.[47] There is one later figure painting, dated 1943, that apparently goes back to his Indian trip and the interest in ancient Persian and Egyptian art it aroused in him. It is a rather curious painting of a swarthy mustachioed soldier in full profile, using the full browns and oranges he added to his palette on the Indian trip. The one-eyed side view, though somewhat reminiscent of modern European figure painting, is much closer to ancient Egyptian wall paintings. Titled *Egyptian War Hero*, it is more of a curiosity than a benchmark in his career, evidence of the breadth of his interest in many kinds of art and perhaps a nostalgic glance backward twelve years after his Indian journey (figure 51).

There also are landscapes and pictures of Buddhist stupas, drawn from his Indian travels. The subdued colors, the feeling of sadness and decay that suffuses these paintings might be attributed to Indian philosophic, if not artistic, influences, but it should be remembered that a fondness for exotic ruins, softened sunset tones, and an atmosphere of gentle melancholy were all part of the romanticism first acquired in Japan. Gao Jianfu's ancient tower, painted in Canton in 1926, (plate 3) is not that different from the painting of ruined stupas done in 1934 (figure 52). Only the scene has shifted to an exotic locale even better suited to this romantic atmosphere.

But, if Indian art was not a decisive influence on him, was he nevertheless undergoing a significant gradual shift away from the more assertive and more experimental spirit of his earlier years? Was the passage to India part of a longer passage away from revolutionary militancy, toward a quieter and even more melancholy art? This raises the question of Gao's inner philosophical and religious life and, in particular, the role of Buddhism in it. All the Gao family were raised in the Christian religion; it was part of their generally cosmopolitan and modern outlook at the turn of the century. In his mature life, Jianfu did not practice Christianity. His interest in Buddhist subjects, usually eccentric monks, appears in his art soon after returning from Japan. Back in Canton he frequently visited the scenic Cloud Greeting Temple in neighboring Guangxi Province and was on good terms with the monks there. When local officials harassed the monastery in 1928, Gao used his friendship with the Nationalist governor of

51. Gao Jianfu, *Egyptian War Hero*, 1943.

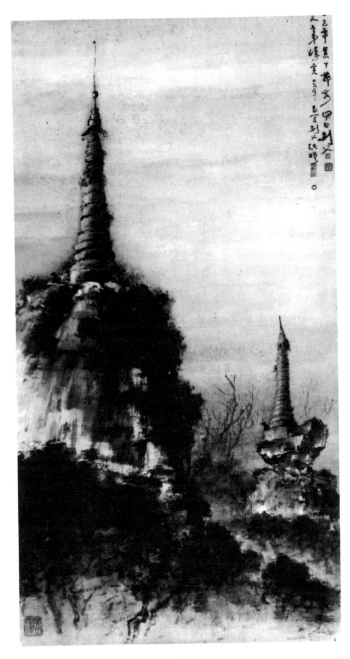

52. Gao Jianfu, *Ruins of Stupas*, 1934.

Guangxi to end the interference. In gratitude the abbot dedicated a pavilion to Gao for his use, with a commemorative plaque by the famous Guangdong calligrapher Liang Wanzhuang. He also had other Buddhist friends and connections, from the eccentric writer and painter of prerevolutionary days Su Manshu to the famous leader of the modern Buddhist revival Tai Xu.

By the late 1920s, the inscriptions on his paintings and his personal correspondence often contained references to Buddhist phrases and ideas, and he read the sutras.[48] His former disciple You Yunshan, who later became a Buddhist nun under the name Xiao Yun, believes he was deeply influenced by Buddhist religion in his beliefs and in his art. Even his biographer Jen Yu-wen, who was Christian, claims that in 1933 Jianfu considered becoming a Buddhist monk.[49] He did not, although Buddhist allusions continued to crop up in his writings and paintings until his death. In short, there is considerable evidence that Buddhism, in particular its message of transcending the suffering of the world, substantially modified the activism and belief in progress of his early revolutionary days.

This coincided with the onset of middle age (he turned 50 in 1929) and a serious illness in the early 1930s. Another legacy of his Indian trip was a chronic leg injury and eye damage from snow glare incurred while hiking in the Himalayas. The eye damage was potentially more debilitating for an artist, although it was only in his later years that failing eyesight started to interfere with his painting. But the Himalayan injuries must have been a blow to a man who had always enjoyed an active life and who was famous for walking the legs off his students and artist friends. More seriously, he also developed kidney problems that sapped his strength and, according to Jen Yu-wen, affected his spirt until he was cured by a famous Peking surgeon in 1935.[50] Tribulations of the body could have reinforced his philosophic predilection to find solace in Buddhism. Could physical miseries and other-worldly philosophy also have diminished the revolutionary meaning and spirit in his art?

There is no dramatic transition in his art such as occurred after his study in Japan. From time to time in the 1930s and 1940s, flashes of the old revolutionary spirit reappear and his basic style changes little. But there is a subtle shift in emphasis, in tone, in the spirit behind most of his paintings. The sorrows and tribulations of the world become more prominent, a tone of sadness or resignation more pervasive. The only painting he did of a contemporary event was of the Orient Library of Shanghai in ruins after the Japanese bombardment of 1932. Unfortunately, it has not survived, although later works suggest what it must have looked like (figure 63).

In 1936 Jen Yu-wen said that Gao's paintings had evolved from extreme

activity to tranquility, from stimulating revolution to reflection on construction, from passion to completeness.[51] This was part of the story, but Jen in his optimism about Gao's art and about the future of the Nationalist government missed the more somber overtones behind such a change. Perhaps, without the apocalypse that followed in 1937, once his health returned, Gao Jianfu would have been able to put the same optimistic spirit into his art that he expressed in his lectures at National Central University. He could still produce powerful paintings, but the bold animals and the dashing atmospheric effects of his earlier landscapes were behind him. This is readily apparent when we compare his stalking tiger or snow landscapes from the 1910s with either the Buddhist ruins or more conventional Chinese landscapes from the 1930s. In theory, Gao continued to criticize the conservatism and sterility of literati painting values. In practice, ever since his return to China, he was attracted to some of those values because they were inseparable from what was most distinctive in Chinese painting. Since the syncretic formula of the Lingnan School insisted on preserving that national character, it found it difficult to sustain a rigorous attack on the literati tradition. By the 1930s, Gao was occasionally using the term "new literati painting" for his movement, a semantic shift that expressed the rapprochement with at least part of that tradition.[52]

Another sign of this diminishing radicalism can be found in Gao Jianfu's calligraphy. Of the three Lingnan School masters, he was the most fond of putting fairly lengthy inscriptions on his paintings. Ironically, this had been one of the features of traditional literati painting that Gao had attacked in his National Central University lectures. Painters could add a written component to their works, but they should avoid the old conventions. In a new art, the message should be innovative, bold, and sincere.[53] But here too in practice Gao's radicalism lagged behind his artistic theories; his inscriptions often tended toward a Chinese scholar's fondness for classical poetry and literary allusions. Moreover, the style of his mature calligraphy was as wildly eccentric as any literati individualist could wish for, drawing partly from one of the well-known eighteenth-century Yangzhou eccentrics, Zheng Banqiao.[54] To be sure, those typically modern values of individuality and innovation appear in such features as his deliberately violating the standard upright position of the calligrapher's brush and instead slanting it almost horizontally in order to give a more painterly and unusual character to his calligraphy. But, in the long history of Chinese calligraphy, there were premodern eccentric precedents for this. Similarly, his habit of seeking inspiration for his calligraphy from the untutored handwriting of small children was very innovative, but also very traditionally Daoist.[55] So, although this eccentric individuality in his calligraphy,

the "wild grass" style he developed after the 1910s, was consistent with his "revolutionary" emphasis on individuality and creativity, it was also easily appropriated to the spirit, if not always the practice, of the literati esthetic. Moreover, a style of writing almost indecipherable except to the well-educated hardly squared with his call to take art to the masses. Scholarly attitudes and esthetics—the accumulated weight of the tradition he sought to change—somewhat compromised the revolutionary thrust of his art.

In brief, by the 1930s traditional Chinese values seemed stronger in Gao's painting, and, combined with the quiescent other-worldly influence of Buddhist philosophy, they modified the revolutionary nature of his art. It became less active, less militant, less connected with the contemporary world. His brave defense of the "revolution in art" in the 1936 lectures and occasional flashes of daring notwithstanding, the general trend in his art was toward conservatism, or at least less radicalism. This does not mean that his art deteriorated in his middle years. In some ways it became deeper, fuller, and more mature. But was it any longer moving in the same direction as China's onrushing political and social revolution?

As before, Chen Shuren continued to remain somewhat apart, pursuing a political career while painting in his spare time. His official position gave him some entrée into cosmopolitan art circles and a certain amount of prestige, but he lacked students or a personal following. However, the tortuous course of Chinese politics in the 1930s did give him more time and perhaps more need for his art. The Communist uprising associated with the Canton Commune in August 1928 ended his career as acting governor of Guangdong Province. Not until the reconciliation of the Wang Jingwei faction with the Nanjing government in 1932 could he resume a political career. In recognition of his long service overseas, he was rewarded with the honorific, but essentially powerless, position of chairman of the Overseas Chinese Affairs Commission of the Nationalist party. The duties were not demanding, and he had lots of time to act as a modern variant of the scholar-official who is better known as an artist and man-of-letters than as an administrator. While living in Nanjing, he was able to take frequent sketching trips throughout the country, and landscapes came to occupy a more prominent place among his works.

Although he remained best known for his flower and bird paintings, the development of a new landscape style is the most interesting aspect of Chen's painting in these years. His earlier landscapes were heavily influenced by early twentieth-century Kyoto painters, notably Yamamoto Shunkyo. Although they are somewhat more restrained than Gao Jianfu's landscapes inspired by the same source, the basic features of the late Shijō landscape style are readily apparent: not much outlining or clear demar-

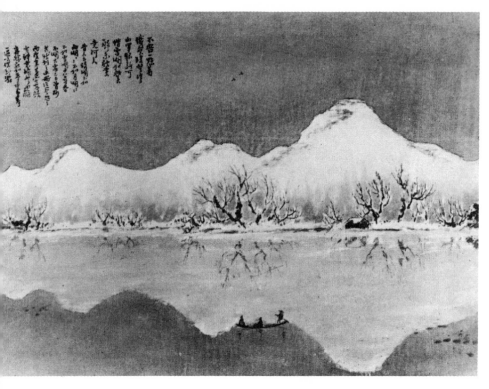

53. Chen Shuren, *West Lake*, 1931.

cation of forms; wet washes and broad brush strokes to achieve the atmospheric effects of mist, rain, and snow; shaded color; and an overall romantic effect, either sentimental or heroic. Thus, snowy mountains and misty rivers predominate in his early landscapes, but by the late 1920s this is beginning to change.

After his loss of political office in Canton in 1928, Chen had more time and more opportunity to travel and see the landscape at first hand. The theory taught by his Japanese mentors had been to paint actual places rather than mental constructions based on existing traditions of landscape painting. Now Chen could actually do this, and by the beginning of the 1930s it seems to have given his paintings of China's famous scenic spots, the Great Wall or the West Lake at Hangzhou, a new vividness and immediacy. For example, despite the continued fondness for the picturesqueness of a snow scene, his 1931 painting of the West Lake in winter does give the feeling of being in a real place (figure 53.)

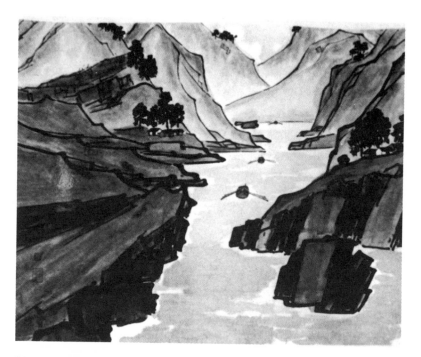

54. Chen Shuren, *Qing Yuan Gorge*, n.d.

During the 1930s and into the 1940s, this stylistic evolution went much further. Chen still painted famous scenic places, such as the Li River near Guilin or the Yangtze gorges, but the paintings become simpler, stronger in composition, and darker in color with heavy greens and browns predominating (figure 54.) His surviving son Chen Shi has suggested that the change in mood came from the personal tragedy of the death of Chen's first son Chen Fu, who was shot as a Communist agent by the military governor of Guangdong.[56] There is a poem accompanying a picture of a bird from 1933 that expresses his grief over that loss. Also, Chen's disillusionment with the course of the revolution and the downturn of his own politicial fortunes may have affected the tone or mood in his paintings. However, his paintings in the flower and bird genre do not reflect such a psychological change, so the new style in his landscapes probably cannot be completely explained by events in his personal and public life.

What, then, can be said about Chen Shuren's mature landscape style? It is simpler, more direct, and more concrete than other Lingnan School landscape painting, including his own before the 1930s. Going a long way

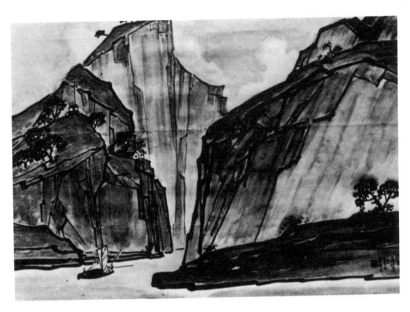

55. Chen Shuren, *Autumn in Guimen*, 1943.

back, the original Maruyama-Shijō style, which in its later developments so impressed the Lingnan painters, strove for the concreteness of a specific time and place. But from Maruyama Ōkyo on, many other techniques and demands had modified that concreteness. Especially in its later stages, painters of the Maruyama-Shijō School had striven just as hard for the dramatic or poetic effects obtainable through bravura brushwork and bold ink washes as they had for any realistic specificity. The early Lingnan painters, including Chen Shuren, had eagerly accepted and even exaggerated these devices in their eagerness to give their new painting more emotional impact. By the 1930s Chen was turning away from that rather flamboyant style. We have noted a somewhat similar development in both the Gaos by this time—less striving for the marvelous and heroic by Jianfu and less decorative exuberance by Qifeng. For the Gao brothers, it could be interpreted as a return to a more Chinese style and taste, but is this an adequate explanation for Chen's late landscape style? No doubt Chinese precedents could be found for the main features: heavily outlined forms (nothing boneless here), clear geometric design, flat washes, and plain colors (figure 55).[57] Yet beyond such generalities, nothing in traditional Chinese painting specifically resembles Chen's later landscape style, and he himself provides no clues about a Chinese lineage.

Furthermore, by Chinese standards these paintings are singularly lacking in brushwork. Some observers think they come closer to Western water-colors than Chinese landscapes. There is indeed the possibility that in Nan-jing or Shanghai at the beginning of the 1930s, Chen was influenced by Western art, for he was personally acquainted with some of the famous oil painters of the time. Still, neither in his work nor in the memories of survivors from that era is there any evidence of a direct connection. The obviously "Western" elements—fixed perspective and symmetrical composition—go back to his years in Japan. It is only the heavy outlining and generally geometric handling of forms that is strikingly new in this period. Although such features could come from traditional Chinese paint-ing, the overall effect is much more Western. It gives a sketch-like quality, a sense of specific place, and a *plein-air* realism that evokes nineteenth-century Europe more than Ming or Qing China.

That sketch-like quality is another feature important for understanding Chen's philosophy and his art. All the Lingnan School artists right back to Ju Lian emphasized close attention to nature as the basis for "painting from life" (*xiesheng*), and they all learned the importance of sketching in Japan. But they did not always have the opportunity to study and draw their more exotic subjects, such as mountain tigers or snow-swept peaks, from life. Chen, in his later landscapes, apparently did. He filled book after book with landscape sketches—simple ones in pencil, more detailed ones in color.[58] Their importance for his finished works can be seen by comparing a finished landscape with an entry in his sketchbook (figures 56 and 57). He also preached what he practiced, declaring that "*xiesheng* is the foundation of painting, to paint without experience in *xiesheng* is the equivalent of building a house without a foundation."[59]

This emphasis on *xiesheng* and verisimilitude with nature could lead further away from traditional Chinese art. For instance, Chen deliberately eschewed the texture strokes (*cun*) that most Chinese landscapists had emphasized since the Song dynasty, explaining that "if you use texture strokes heavily, you lose the real face of nature."[60] In other words, com-plicated or obtrusive brushwork detracted from naturalism and a sense of immediacy or realism in the picture.

Thus, these later works show a different side of Chen Shuren's artistic personality from what predominates in his flower and bird paintings. In the landscapes, poetic content and allegorical meaning are subordinated to a clearer view of nature. The touch of sweetness and evocative details of his earlier works disappear. His view of the Chinese landscape becomes starker, clearer, less picturesque, but in some ways more compelling. Whether it also becomes more somber and less optimistic is harder to decide.

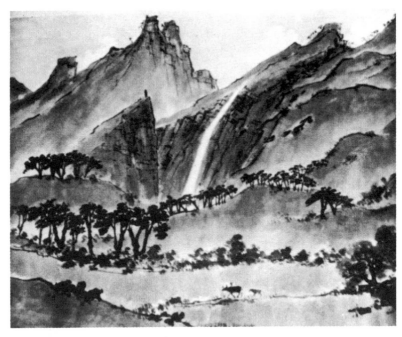

56. Chen Shuren, *Landscape*, n.d.

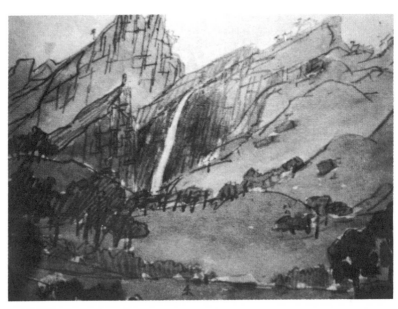

57. Chen Shuren, *Sketch for Landscape* (figure 56).

Suffice it to note that if Chen Shuren's later works lack the monumentality and vigor of Gao Jianfu's best landscapes, their *plein-air* realism shows a possible way of developing an art more directly in contact with contemporary life. But it still was not a socially conscious art. The subject matter is pure landscape, with the tiny, loosely drawn figures just incidentals in the rural scenery. Chen's realism is not social realism; his spirit is not militant or even very optimistic. Taking a different road from his friend Gao Jianfu, he was headed in the same general direction. It no longer paralleled the path of the Chinese revolution.

The Second Generation of Lingnan School Painters

Chen Shuren remained a solitary figure without a personal following, although his art may have had some influence on important artists in central China.[61] The Gao brothers had their university teaching positions and private teaching studios, which by the 1930s had produced a good number of students trained in their individual variations of the Lingnan style. Given the founders' flagging energies and tendencies toward withdrawal from social-political commitment, it was largely up to this second generation of the Lingnan School to push the revolution in art on to a new stage. By the mid-1930s, several of them had emerged as distinct individuals in what was now generally recognized as an important school in the Chinese art world.

Gao Qifeng had fewer close followers, but his small band of disciples from the Heavenly Wind Pavilion were intensely loyal to him and his memory. Soon after his death, they jointly painted a commemorative portrait of their teacher in two versions.[62] In both he appears in the traditional scholar's gown, not exactly the garb of a Tokyo-educated revolutionary but quite appropriate for the traditional painter-teacher and apparently faithful to the dress Qifeng actually wore in his last years (figures 58 and 59). The six "artists of the Heavenly Wind Pavilion" all contributed to the painting, filling it with standard symbols of scholarly purity and moral rectitude, such as the pine tree, plum blossom, bamboo, and orchid. Probably one should not expect innovation or individuality in this kind of conventional portrait, but it still is a rather curious way of commemorating an artist who started his career as a political and artistic revolutionary. The only possible Western element is the heavy shading in the face, although this too is a convention long established in Chinese portraiture. From the long robe and fan on Gao in a formal photograph with his disciples in 1931, we can infer that this was the way he wanted to be remembered. Are

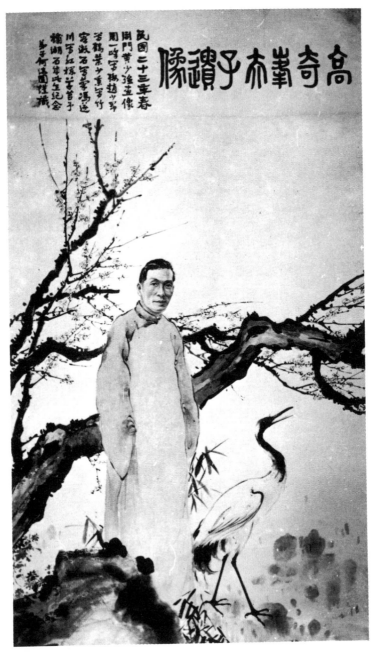

58. He Qiyuan and other disciples at the "Heavenly Wind Pavilion," *Portrait of Gao Qifeng*, 1934.

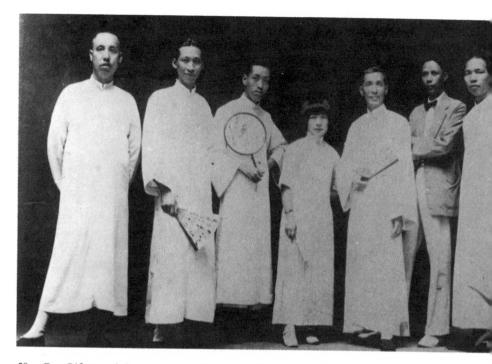

59. Gao Qifeng and disciples at the "Heavenly Wind Pavilion," 1931. *From left*: Zhou Yifeng, He Qiyuan, Zhao Shaoang, Zhang Kunyi, Gao Qifeng, Ye Shaohong, Huang Shaoqiang.

photographs and posthumous portraits further signs of a cooling off of the revolutionary ardor in the founders of the Lingnan School?

However, it is hardly fair to judge Gao Qifeng by this ritualistic act of disciples' devotion. His real legacy as a teacher had to be in the careers of those students. Initially, the publicity surrounding Qifeng's early death may have called some attention to them. In 1934 a three-man exhibition in Nanjing drew favorable comment from the critic Xu Shiqi writing in the art journal *Yi feng*. He was impressed by the spontaneity, liveliness, and spirit of Zhao Shaoang's plants and small animals but found the modern figure paintings done in Chinese style by Huang Shaoqiang to be even more remarkable.[63]

These two, Zhao Shaoang (b. 1904) and Huang Shaoqiang (1900–1942), were probably the most interesting of Qifeng's disciples. Zhao had studied with him early, at a very young age, and had shown an amazing aptitude for the wet washes and striking spontaneity of the Qifeng style. He ex-

60. Huang Shaoqiang, *Viewing Pictures*, n.d.

hibited abroad and became a teacher himself while still in his twenties.[64] He was the only representative of the second generation of the Lingnan School to be invited to teach at National Central University. After 1949 he became the foremost propagator of the Lingnan style in Hong Kong and abroad, but even in the 1930s he was a presence in the Chinese art world.[65]

Huang Shaoqiang did not have nearly so long or illustrious a career, and he could not match the all-round technical virtuosity of Zhao Shaoang, but he was the only disciple to concentrate on figure painting of contemporary people. Although little of his output survives, some extant pieces show considerable expressive powers in depicting the poor and downtrodden of society, combining a strong Chinese line with a distinctly modern handling of his figures. He also did more conventional figures, such as beautiful ladies, and sometimes even his pictures of the poor dissipated much of their social impact in excessive sentimentality. Still, some of his works show a direct honesty seldom found in Chinese ink painting at this time. In one of his more striking and innovative pictures, he painted common people viewing his scroll paintings of common people at an exhibition (figure 60). This was unusually elaborate for Huang. Usually he did direct, simple pictures that have a sketch-like quality as if done from nature.

Thus, in many ways Huang Shaoqiang is like the Western-style woodcut artists from the 1930s who depicted the modern poor in a plain unvar-

61. Huang Shaoqiang, *Coolies*, n.d.

nished light, with sympathy but not romanticization (figure 61). Although somewhat crude in execution, such works show vigor and promise. His premature death during the war must be counted another misfortune for the Lingnan School. In the early 1930s, it seemed to critics like Xu Shiqi that he was opening a promising new direction for Chinese painting. No other member of the school followed him in it.

Gao Jianfu had many more followers than did his brother, some of them personal disciples who lived at the Spring Slumber Studio, and others, more casual students. By the 1930s, a second wave of Lingnan School painters, all of them Jianfu's disciples, had gone to Japan.[66] In 1935, four of them returned to Canton, occasioning a joint exhibition of their new works and some paintings by Gao's other students. The critic from *Yi feng* who traveled south to review the exhibition waxed enthusiastic about their innovative new art and mused about the "fierceness" of southerners who had started the political revolution and now were pushing an artistic revolution.[67]

The most noteworthy of these newly returned artists, both in productivity and boldness of experimentation, was Fang Rending (1903–1975), who had over a hundred paintings in this exhibition alone. From six years in Japan, he had acquired a radically new approach to figure painting, not

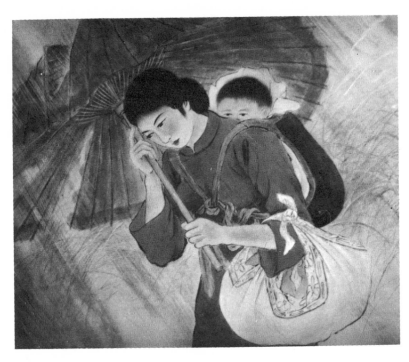

62. Fang Rending, *Wind and Rain*, 1932.

only turning to unusually common subjects but placing them in unusual compositions. Huang Shaoqiang's figure paintings had preserved the Chinese emphasis on a strong defining outline. In these years, Fang often used a more restrained line, without the calligraphic quality usually associated with Chinese drawing, and the atmospheric effects are pure Lingnan School (figure 62). But the strong Japanese flavor is also unmistakable. As for his subjects, they are both "realistic"—ordinary people in everyday situations—and "romantic"—sweet-faced Japanese farm girls, langourous nudes, and mythological scenes. The critic Wu Zhao was much taken with his work: "Fang Rending's works have a distinctive style, innovative color system, elegant line, pure harmony, principled composition, decorative interest and are fully expressive of the present time." [68] Others were less enthusiastic, but he did attract attention and stimulate controversy.

In the next two years, his works were seen in several individual and joint exhibitions in China and abroad. Modernist critics generally liked his work and praised him for reviving Chinese figure painting to serve present-day needs.[69] Cultural conservatives naturally did not approve, and its "foreign-

ness" worried some nationalists. One, Lu Jie, in the art section of *Hua-Mei wanbao* (Sino-American evening news), approved of Fang's intention to bring new subjects into Chinese painting but thought that the Japanese character to his work made it worse than the traditional painting, which may have stagnated but still retained a Chinese national flavor.

In the increasingly anti-Japanese atmosphere of the times, this freshly-made-in-Japan appearance was a liability much heavier than the first generation of Lingnan painters had had to bear twenty years earlier. Defenders of the school argued that the "Japanese elements" had originally been learned from China as far back as the Song dynasty or that art was international in scope, but neither argument was wholly successful. As early as the Manchurian Incident of 1931 Gao Jianfu, in a published "Appeal to Japanese Art Circles and Announcement to the World," had gone on record as stating "everyone in the world knows our country is your honorable country's cultural mother," while calling on Japanese artists to pressure their government to stop this matricide.[70] After the outbreak of full-scale war in 1937, such appeals to cultural conscience were useless and the Japanese background even more damaging to the Lingnan School. Jen Yu-wen, the school's most consistent defender, tried two gambits against the charge of Japaneseness. First, like Gao Jianfu five years earlier, he brought up the Chinese origins of Japanese art, trying to counter anti-Japanese nationalism with more anti-Japanese nationalism: "It must be remembered that the Japanese have no art of their own. Whatever they have has been learned from the Chinese." Then he fell back on a plea for artistic universalism: "After all, art should transcend all national and racial boundaries."[71] But with Japanese armies transcending China's borders, a cosmopolitanism that included the national enemy was not in style. And Fang's version of the Lingnan style still smacked of its Japanese origins.

Anti-Japanese feeling aside, there was also the basic problem of innovation and a harmonious blending of foreign and Chinese elements. Even Jen Yu-wen had to admit that some of Fang's mixtures of East and West gave the viewer a slightly queer feeling.[72] Another modernist critic, Wen Yuanning, was less equivocal: "They [Fang's paintings] are neither Chinese nor Western, ancient nor modern in manner; they are just what they are— a pathetic witness to the danger of grappling with modern subjects without sufficient mastering of an appropriate technique."[73]

Thus, Fang's efforts were not universally a critical success. Fang himself wrote about the need for a new art in touch with the scientific temper of the times.[74] Jen Yu-wen posited that figure painting had been the strong point of Chinese painting until the Song and Yuan periods, and it was up to artists like Fang to recover this lost heritage and make it relevant to modern

times.[75] In fact, it was remarkable how often modernist critics harkened back to the famous semi-legendary figure painter of the Tang dynasty Wu Daozi (d. 792) as justification for emphasizing figure painting, perhaps betraying a defensive national pride behind their exhortations to innovation and modernity. Unfortunately, despite the general agreement on the need for revitalized figure painting, Fang Rending's figures did not often satisfy Chinese tastes. He remained more innovative than influential.

None of Gao Jianfu's other proteges seems to have attracted as much attention or such violent criticism in the years before the Sino-Japanese War. Su Wonong returned from Japan at the same time, but his more conventional flowers, birds, and small animals stirred little controversy.[76] He did not become a national figure. A female student, Wu Peihui, specialized in *plein-air* landscapes of common rural life, such as *Busily Drying Rice in a Farm Village*. She drew enough attention to be included in the Brussels International Exposition and the Second National Art Exhibition but without raising much furor over her new subject matter. A third disciple, Yong Dagui, also did some contemporary landscape scenes. Though a student of Jianfu, he was stronger in his use of Qifeng-like light and atmospheric effects achieved through bold ink washes.[77] He also followed Gao Jianfu's recommendation to travel widely and see at firsthand the scenes you are painting.

All of these disciples, and others, were useful troops in the campaign for a new national painting, but up to 1937 none seemed likely to lead the charge. On the polemical front, Gao Jianfu found a useful ally and follower when the Western-style Cantonese artist Setoo Ki (Situ Qi) leapt to Gao's defense in the "pen war" between advocates of a new national painting and its conservative critics in Canton.[78] Converted to Gao Jianfu's theory of a rejuvenated Chinese ink painting for a time in the late 1930s, Setoo became one of the most successful adapters of Lingnan School realism to scenes of war and national resistance.

There were also younger second generation painters who were not yet visible as distinct artistic personalities. They included a young Cantonese schoolteacher, Guan Shanyue, who, like Jianfu some thirty years earlier, wanted to leave the classroom for an artist's life and saw art as intimately involved with contemporary political issues. Later, Guan Shanyue would become the most famous of Gao Jianfu's former students. Similarly, Yang Shanshen, the closest and most successful follower of Gao Jianfu in Hong Kong after 1949 was then a largely unpublicized talent studying in Japan during the pivotal years from 1935 to 1938. Many more of Gao's disciples were only locally recognized before 1937.

But one of Gao's subsequently famous proteges had already begun to

make his mark. This was Li Xiongcai, in some ways the most talented and favorite of Gao's disciples. Gao Jianfu had discovered Li as a poor country boy when the famous painter was on one of his rustic retreats at the Cloud Greeting Monastery in Guangxi.[79] Recognizing his native talent, Gao brought him back to Canton where Li lived at the Spring Slumber Studio until 1933. Gao then sent him to Kyoto for further training. Upon his return in 1935 he again lived at his master's studio. Even in the early 1930s, Li could produce landscapes of astonishing freshness and beauty which combined the lyricism of the early Chen Shuren, Gao Qifeng's sensitivity to light and atmosphere, and Gao Jianfu's strength and vigor of execution. The same modern-minded Shanghai critic who had dismissed Fang Rending's efforts as a hopeless mishmash of conflicting styles praised the beauty and spirit of Li Xiongcai's landscapes, although he found Li's attempts at modern subjects, airplanes and battleships, "not always convincing."[80] Apparently, others had the same opinion, because in a few years such subjects disappeared from his repertoire. But, as a landscapist pure and simple—portraying traditional subject matter in a lively new style that further harmonized the Gao brothers' modern techniques of perspective, light, shading, and color with traditional painting values—the critic Wen Yuanning found Li Xiongcai to be "easily the most promising and brilliant of Mr. Gao's pupils."[81]

But was there enough promise in the second generation to carry the Lingnan School forward to national relevance in a social, political, and cultural milieu that had changed so much since the basic ideas and style of the school had been formed early in the twentieth century? The tensions and contradictions inherent in their syncretism have been noted, but logical contradictions need not prevent a relevant answer from satisfying a pressing historical need. The Lingnan School's problem by the mid-1930s was that, once they had finally got a fair hearing on the national scene for their answer, new questions about social relevance, popular appeal, and newer Western styles were cropping up. It is not surprising that men already in their fifties found it difficult to adjust. The political party they supported and served for so long had similar problems in understanding what the new questions were.

The Lingnan School succeeded in transcending provincial boundaries—succeeded in getting a hearing (or a viewing) at the national level—and the initial critical reaction was not at all adverse. There was cause for hope in the last relatively peaceful years of the Chinese Republic. Then came the deluge—invasion, renewed civil war, and social revolution. It would put the Lingnan School, like the Nationalist government, to the severest of historical tests.

Contemporary Chinese painting cannot be separated from
the needs of contemporary China's revolution.

Gao Jianfu, 1936

War and Revolution:
Demise of the Lingnan School, 1937–1949

The outbreak of the war with Japan in August 1937 was as untimely for the
Lingnan School as it was for the Nationalist government and, once the
initial outburst of patriotic fervor subsided, equally disastrous for the long-
term prospects of both the painters and the politicians. The government's
hold on the economic heartland of the lower Yangtze Valley was shattered;
the Lingnan painters' recently won national prominence and influence at
the center of China's artistic and political circles was ended. The Nationalist
party retreated into its wartime exile in the remote western regions; the
Cantonese artists withdrew to their southern homeland and then beyond it
to even more provincial refuge in Hong Kong and Macao. From the center
of Chinese national life, they were pushed to the periphery, from the main-
stream to a backwater. For an artistic movement so closely tied to con-
temporary cultural and political developments, it was a fatal exile.

The first challenge posed by the war was how to produce an art of even more contemporary relevance, painting alive with the spirit of patriotic resistance and social content. Since the Lingnan School artists had preached such ideas for thirty years (most recently in a late 1936 article by Gao Jianfu on "Painting and National Defense"),[1] they would appear to have been in a position to ride the new wave of nationalism as they had the patriotic tide of 1911. But the political and artistic theories that had been radical in 1911 were no longer so revolutionary nor so relevant by 1937. Like the Nationalist party itself, the Lingnan School still traded on the title "revolutionary," while reconciling itself with many traditional values. For some years, the surviving founders of the school had been moving away from the kind of rough-edged realism and contemporary relevance associated with wartime art. It remained to be seen whether the second generation disciples could rejuvenate the school. One basic objective of the Lingnan School, to produce an art contemporary in spirit and subject matter, but still strongly Chinese in character, remained just as relevant. But the syncretic formula originally learned in late Meiji Japan was now even more vulnerable to charges of not going far enough in breaking with tradition and, at the same time, acquiring too strong a foreign flavor.

The charge of foreign flavor was all the more damaging now that Japan was the detested enemy in the "War of National Resistance." The only real defense against the accusation of Japanese origins was to play down the more obvious Japanese-derived elements in their art. But here, as Lu Xun and other radicals of the May Fourth era had noted twenty years earlier, lay the danger of nationalism pushing toward conservatism. When a good part of the technique for their "revolution in art" still bore traces of its Japanese origin, could they continue to pursue it in the face of the universal detestation of things Japanese? But, if they submerged those techniques in traditional Chinese styles, could their art continue to be revolutionary? They had not drunk directly at the springs of Western art as had leading painters of the era since the 1920s, such as Xu Beihong and Lin Fengmian. Therefore, they were caught squarely in a dilemma between modern being unpopularly foreign and national (Chinese) being mainly conservative. The turn toward conservatism was not the right solution. Not only was the current of social and political change demanding more radicalism or social commitment, but by becoming more conservative the Lingnan School gave up much of what had made it unique while still being at a disadvantage in competing for leadership of traditional-style painting against the older, more established schools and artists of China's main cultural centers.

Gao Jianfu was at the center, Nanjing, when war broke out in 1937. Initially he followed the Nationalist government to Hankou and then Chongqing (Chungking) with one futile trip behind Japanese lines back to Nanjing in an effort to recover the bulk of his painting collection. The paintings were irretrievably lost, not the first or last time that the vicissitudes of China's turbulent twentieth century robbed the artist and posterity of important works. In 1938 he returned home to his students and studio in Canton. It was a fateful decision, although perfectly natural at a time when Canton was the last major coastal city still in Chinese hands, while Chongqing was a remote and provincial place that happened to be the temporary location of the national government. This temporary location would remain the political capital of China for seven years, whereas Canton fell to the Japanese within six months. Whatever intellectual and cultural life China was able to sustain during the long war years went on in the transplanted universities and art schools of the Western provinces; Guangdong and Gao Jianfu's eventual refuge, Macao, remained cut off by the Japanese occupation. Twenty years earlier, Jianfu had gone home to Guangdong and seen it become the generating point for the next stage of the Chinese revolution. This time he went home to relative obscurity and exile. Guangdong was no longer where the political and artistic future of China was being made.

In October 1938 Jianfu was forced to flee Canton before the the advancing Japanese army. Again, some of his important works were lost in the flight. After briefly stopping in Saiwu, the hometown of his disciple and colleague Setoo Ki (Situ Qi), Gao continued on to Macao where he reestablished the Spring Slumber Studio with most of his close disciples from Canton. For the next three years, he moved back and forth between Macao and Hong Kong, showing his continued concern for the national war effort by holding war relief fund exhibitions together with his students in both cities. He also joined with his students in sending works to the loan exhibition that the Nationalist government sent to the Soviet Union in 1939.[2] But even these tenuous connections with the national cause were stretched further when, in December 1941, the Japanese took Hong Kong, forcing Gao to retreat further to the small and isolated refuge of Macao.

The next few years were not easy ones for Jianfu or for China. He was a nationally famous artist, but there was no national art market or government school in Macao. The economics of supporting himself, a new family (he had remarried after his first wife's death in 1939), and a band of less famous disciples were onerous. He spurned offers of high salary and official position with the Japanese puppet government in Nanjing, even though his old Alliance Society comrade Wang Jingwei headed the regime. Less subtle

inducements, threats of physical violence, were used to try to get him to abandon his self-chosen exile and lend his political and artistic prestige to the puppet regime by coming back to Nanjing or Canton. These too he contemptuously refused, citing a Buddhist retirement from the world in public,[3] but privately telling his disciples that honor and patriotism forbade such opportunism.[4] The newspaper obituary for Gao quotes his remark on this occasion, which rings with the traditional rhetoric of the loyal scholar-official of old: "My death is a small thing; to lose honor is a big thing."[5] Still, in failing health and deepening poverty, the last years of the war were increasingly difficult for him; by 1945 he was able to keep going only with the help of emergency funds from the Nationalist government in Chongqing.

This raises the question why he did not go to Chongqing where his old revolutionary connections would have ensured him a comfortable position. Chen Shuren urged him to do so, but Gao demurred on the grounds of ill health.[6] Certainly his health was not good but disciples from his Macao years do not remember him as being at all invalided.[7] The reasons may have been more political or philosophical. The complete demise of the old heavily Cantonese "left Guomindang" with Wang Jingwei's defection to the Japanese left Gao with few close friends in the Nationalist government. He also may have disapproved of the trends toward conservatism and corruption within the Guomindang as the war dragged on.[8] In any event, he cited bad health and a Buddhist-tinged weariness with the world as reasons for maintaining the exile in Macao. There his honor and personal integrity could be preserved, but not his influence in the world of art and politics.

The hardships, vicissitudes, and disappointments of these years are reflected, directly or indirectly, in his wartime painting. His early wartime exhibitions, such as the one held by the Chinese Society of Hong Kong University in July 1939, contained some works that depicted the horrors and suffering of war, including one of Shanghai in ruins after the Japanese bombardment of Chapei district (figure 63). Apparently it resembled his earlier painting of the Shanghai library in ruins. Moreover, in his 1936 article on "Painting and National Defense" he referred to two other works, *New Battlefield* and *Air Defense*, which he had painted during the 1935 crisis with Japan. Unfortunately, these do not seem to be extant, and the 1937 painting is only available through a photograph.[9] It was the model for similar works by his disciples, showing them how to use the Lingnan School's realistic techniques—fixed perspective, shading, light and shadows—to produce contemporary scenes in the Chinese ink medium. But Gao Jianfu himself did not practice this genre after 1937. His war

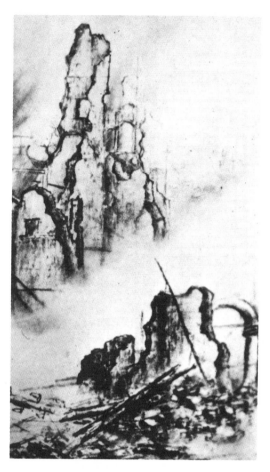

63. Gao Jianfu, *A Disaster for Civilization*, 1937.

commentaries are more often indirect or allegorical, such as the painting of a fox carrying a dead chicken originally done in 1914 and reworked in the 1920s (figure 24). Titled *The Strong Devour the Weak*, it was brought out again for the 1939 exhibition, its original social-Darwinian message somewhat modified into a protest against war and aggression.

More contemporary and more powerful was a small painting with a long inscription done in the autumn of 1938, presumably just after the fall of Canton, which showed four moldering skulls in a field of grass (figure 64). It reads: "The gentry's tables are loaded with food and wine. In the wilderness there are cold dead bones. . . . Alas, the richer become richer, the

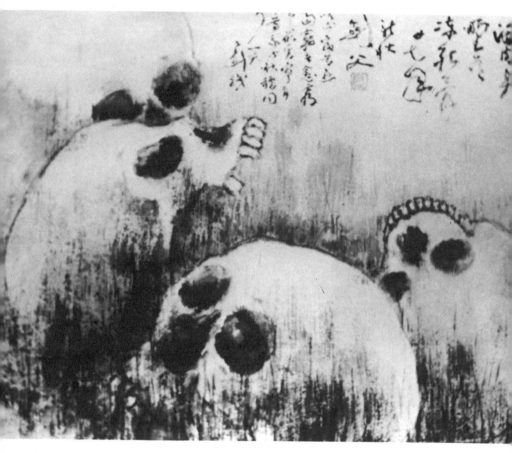

64. Gao Jianfu, *Skulls Crying over the Nation's Fate*, 1938.

poorer become poorer. People of every sort would be better equal. I and the skeletons cry together." Not one of his major works, it is a strong statement of those times and echoes a theme that left-wing social protest artists, especially the woodcut artists, took up with increasing frequency and vehemence. But Jianfu did not directly return to it.

Instead, his occasional statements about the war were more allegorical as in a 1941 painting of a wooden cross bent and cracked in a driving windstorm, but still standing. The style recaptures the strong atmospheric effects, wind and rain, of his earlier works. The symbolism is rather unusual. Jen Yu-wen explains it as an allegory on the destruction of peace and

civilization by the storms of war, in particular the clash between Naziism and Communism.[10] There is no inscription to say exactly what the artist intended it to mean. Although his later works are full of Buddhist references, this is the only one to use a Christian symbol, possibly because he was commenting on the worldwide scope of the conflagration. It can be interpreted optimistically—the colors are light, the red-and-white lilies in the foreground bright and lively, and the cross still stands. Or it can be seen as an expression of his feeling of being caught in a cataclysm that would overturn all signs of culture and civilization. In either case, it is not so directly concerned with the Sino-Japanese War as some of his other works.

For example, in 1939 he produced another painting in a different style, drawing in a few bold brush strokes, a wicker chair with an open oil lamp sitting on it. Around the flame flutter a few moths (figure 65). The effect is not unlike some of the straw basket, fruit, and insect pictures made popular by the Shanghai School and occasionally painted by Qi Baishi. In this case, a lengthy inscription makes clear that the moths are the Japanese, and the oil lamp, in the center of which shines the eight-point star of the Nationalist party, is China, whose inextinguishable flame will consume the foolhardy moths. It is a clever allegory, in a completely Chinese idiom, but it does not at all attempt to apply the distinctive features of the Lingnan style to depicting the national crisis.[11]

In fact, his paintings from these years are less imbued with the spirit of patriotic resistance than with feeling for the sorrows of the world—sadness, resignation, and the solace of Buddhism. A more representative landscape from 1939 shows a quaintly rustic fishsweep on the banks of an autumn river (figure 66). It is a scene from real life and an unusual subject, but the style and spirit are sad, dreamy, and relaxed. The whole picture is done with loose, soft washes showing the mist along the river and the half-hidden bushes and rocks along the shore. The large fishsweep with its high tower for drawing the net out of the water is loosely sketched; more *xieyi* (painting the idea or spirit) than *gongbi* (meticulously detailed work). The soft washes and muted evening colors together with the absence of any human figures evoke rather chilly, desolate, and slightly melancholy feelings, which the inscription reinforces with references to coming winter and leaving the world of men.

A painting of the previous year, 1938, shows a Buddhist monk with his alms bowl staring up at a dragon in the clouds. Again the style is soft, the colors muted, even more use made of empty space. It is a Zen-like picture with a Zen message in the inscription's references to the enlightened laughing at the changes in the world for he realizes truth is not to be found there.[12] Something of the same philosophical message can be found in Gao

65. Gao Jianfu, *Lamp and Moths*, 1940.

66. Gao Jianfu, *Fishsweep*, 1939.

67. Gao Jianfu, *Poet of the South*, n.d.

Jianfu's much more famous painting *Poet of the South*, probably done about the same time (figure 67). It is one of his larger and more ambitious figure paintings, showing a Zen or Daoist-like scholar smiling at a crescent moon. The reference to the Chan-inspired painting by the Southern Song painter Liang Kai, showing the famous poet Li Bo looking at the moon, seems unmistakable, especially when Gao uses Liang Kai's "rough hemp" drawing for the poet's robes.[13] This painting does not have the same melancholy atmosphere, but the Zen references and the escapist message seem to have

affinities with the other works from this period. None of them shows the current war scene or suggests any active commitment to social and political concerns. Other paintings, especially landscapes, from the war years reinforce this impression of withdrawal and resignation. Some, such as *Dusk on the Ganges River* (1939), hark back to his Indian travels.[14] In Macao he painted the ruins of the seventeenth-century cathedral as an appropriate subject for such feelings about the passing of worldly symbols.[15]

However, there are many other paintings of small birds, insects, fish, flowers, and tree branches that retain the lively freshness of his earlier period. He also could still come up with new and unusual subjects in conformity with the Lingnan School dictum that painters should go to real life for inspiration rather than repeating established styles and subjects. As tropical subjects, perhaps from his Indian Ocean travels, he painted flying fish, coconuts, and jackfruit. In 1939 he painted a very real and vivid cactus, which showed him still able to use the old Shijō School techniques of the unevenly loaded brush to get a rounded naturalistic effect.

Still, only a minority of his later paintings emphasize this *xiesheng* (drawing from life) naturalism. Far more of the small life scenes, which came to dominate his production, were less detailed and less naturalistic, relying more on a traditional Chinese painter's control of brush and ink for their esthetic interest. Few large landscapes appeared after 1941, and none of them had the dash or power of his earlier works. The spirited horses, fierce birds, and menacing tigers of his younger days were also gone. He showed earlier paintings in his wartime exhibitions, but he did not try to revive these subjects as symbols for Chinese nationalism in its current travails. Similarly, the style of his later works continued the trend toward more reliance on ink values and a dry scratchy line, with less display of the imported techniques of perspective, light and dark, and atmosphere.

Gao Jianfu was not the only foreign-influenced Chinese painter who became more Chinese and more conservative during the war years. The switch to Chinese styles by such Western-trained artists as Wu Zuoren and Lin Fengmian is even more marked, but in Jianfu's case it meant a decline in his relevance and his influence as well as some loss of vigor in his work. There are several possible causes for this change. He was in poor health, in exile, and plagued by personal and national misfortunes. The fact that he persevered and survived the war was a testimony to his spirit. But somehow he no longer had the vigor or the optimism to challenge the times or the position from which to influence the emerging art of those times. In an exile that must have been more cruel because it was so close to his native land and his native city, Gao Jianfu, like the Nationalist government in distant Chongqing, endured and waited out the war.

Up to 1937 there was an overall identity to the Lingnan School, even though the followers of Gao Jianfu and Gao Qifeng differed in their emphases. The war eclipsed the small band of Qifeng disciples with only one of them, Zhao Shaoang, emerging as a significant figure after it and that more outside of China than within it. Many of Jianfu's more numerous band of disciples followed him in his flight from Canton to Macao, some staying with him throughout the war. They revived and preserved the Spring Slumber group of the Lingnan School and, at least in the early years of the war, they attempted to continue the new national painting movement from their place of exile.

In the July 1939 Lingnan School exhibition at the Macao Chamber of Commerce, Jianfu and his students exhibited over two hundred works. Large crowds, reportedly over ten thousand people in five days, flocked to what must have been one of the biggest cultural events in the history of the tiny Portuguese colony.[16] The paintings shown give a good idea of what Gao's disciples were doing in the early years of the war. Many of them were concentrating on an art of national reistance by producing paintings that used the distinctive Lingnan style to show the horrors of war and lives of the common people. One of the most notable of these was Guan Shanyue's *Observed at San Tsao Island*, a vivid depiction of Chinese junks being bombed by Japanese aircraft.[17] The fire and smoke gave him a chance to use the Lingnan atmospherics in a different context from that of misty rivers or moonlit landscapes. The prototype, of course, was Gao Jianfu's 1933 picture of the Shanghai library after bombing. The difference was that Guan Shanyue was attempting to catch an action scene, not the mournful quiet after the attack. It is difficult to judge from the photographic reproduction (all that remains) how well he succeeded. At the time, with patriotic spirit running strong, it was highly acclaimed at both the Hong Kong and Macao exhibitions.

A few of Guan Shanyue's other war studies still survive in Canton. One, a long horizontal scroll, *Fleeing the City*, is a narrative of urban refugees fleeing from the bombed and burning metropolis (Shanghai or Canton) to a peaceful but rather forlorn countryside (figure 68).[18] It is an ingenious effort at adapting the traditional hand scroll format to new purposes and using the Lingnan School's realistic techniques (fixed perspective, shading, atmospherics) to set a contemporary social scene. But here too there is still a question of whether the atmosphere or mood conveyed by the characteristic Lingnan School devices is not too sentimental or too romantic for the intended message of the picture. For instance, the fire and

68. Guan Shanyue, *Fleeing the City*, 1940.

smoke over the bombed-out city skyscrapers and the tiny, swallow-like airplanes wheeling overhead still remind one more of Gao Jianfu's ruined towers or sunset pagodas than of the holocaust of modern war. Another refugee painting, from 1940, shows a huddled mass of refugees in a shanty-town on the outskirts of a bombed city. It is less picturesque than the hand scroll, but for this reason perhaps more convincing as a social documentary. Well before 1949 Guan had started his journey toward social realism.

The other Lingnan School painter who most successfully practiced this genre in the early years of the war was Guan's close friend and colleague Setoo Ki. His original training had been in Western art before he fell under the influence of Gao Jianfu's syncretic modernist style. Two pictures by Setoo of urban scenes after Japanese bombing draw on his Western art experience and the dramatic atmospheric effects of the Lingnan School. One, titled *Mother* in Chinese, but given the English subtitle *Even Innocents Suffer*, shows a dead baby and mother in front of a pile of bomb rubble. The other, *Homeless and Destitute*, has a mother breastfeeding her baby as she turns her head to gaze at her destroyed house (figure 69).[19] Both transform the familiar mists into smoke and the romantic ruins into contemporary devastation. Again, it recalls Gao Jianfu's Shanghai library picture, but in this case the message is more obvious, even melodramatic. Still the picture must be placed in its historical context: Japan had introduced the world to the first large-scale bombing of civilians. As patriotic art, it probably was

69. Setoo Ki, *Homeless and Destitute,* 1939.

effective, again showing how the Lingnan School's realistic and dramatic effects could be used for contemporary purposes.

Guan Shanyue and Setoo Ki became the best-known proponents of this kind of art, but others among Gao Jianfu's students practiced it too. Li Xiongcai, the talented protégé with a flair for lyrical landscapes, reportedly did battlefield scenes before and after the outset of the war.[20] Huang Dufeng, another Gao student who went to Japan in the mid-1930s, turned from his bird and flower specialty to war and farm scenes when he returned to China at the beginning of the war. Wu Peihui, at the time Jianfu's best-known female student, had a penchant for *plein-air* country scenes with a common touch. The title of one of her works in the Macao exhibition, *Busily Drying Rice in a Farm Village at the Close of the Year*, gives some idea of what she was painting. Even Gao's more esthetically inclined student, Li Fuhong, who at that time was specializing in pictures of beautiful women, worked patriotism and everyday life into some of his works. His painting *Black Peony* in the Macao exhibition showed a beautiful young woman drawing seawater to boil out salt. The critic Jen Yu-wen thought this simple, patriotic act justified retitling the painting *A Patriotic Woman*.[21] Regardless of the title, many of their works in this period were intended to carry a patriotic message.

Not all their art was of this kind. Gao Jianfu rarely touched on such subjects, and some of his students, such as the flower and bird painter Su Wonong, also stuck to more traditional genres. Moreover, as the war dragged on, the band of Spring Slumber students in Macao dwindled. There was little market there for art of any kind, let alone innovative works on contemporary events. Gao Jianfu himself may have turned to more traditional genres partly out of the necessity of supporting his family in this small provincial town. His disciples gradually moved to the Chinese hinterland where perhaps there were better prospects for selling their art, or they drifted away from the kind of contemporary scene, social context art that marked the beginning of the war. The Spring Slumber Studio continued, and one of Gao's leading students, the Japanese-trained Yang Shanshen, returned from travels abroad to stay with the master through the 1940s. Nevertheless, for Gao and his students, Macao was no place in which to revivify Chinese painting.

The divided course taken by the second generation of the Lingnan School is best expressed in an incident that took place at the end of the war. Guan Shanyue and Setoo Ki had been close friends and the foremost pro-ducers of war scenes in Macao during the late 1930s. Afterwards Guan Shanyue had gone to the unoccupied areas in China's far west. Immediately after the war, Guan Shanyue returned to Guangdong and visited Setoo in

his home village. They talked all night with Guan saying, according to Setoo's recollection, "From now on we must use our flesh and blood to paint." His friend, who had moved away from scenes of war and suffering, repiled, "My car is in reverse gear. I am going back to ink."[22] He was going back to more traditional Chinese styles and, more importantly, to art as an expression of beauty and individual human emotion.

Guan Shanyue was already well down the other road—art with a social or political purpose. During the war he traveled widely in western China from Guilin to the northwestern borderlands, painting the peasants and the nomadic herdsmen of the northwest and identifying with the common people. In 1943 the doyen of leftist intellectuals Guo Moruo, then resident in Chongqing, added this inscription to Guan's painting *Camel Bells North of the Great Wall*:

> To renew art one must break with old ideas of the "sublime,"
> Truth is all important in folk forms,
> Through truth one enters a realm of fancy,
> Where the commonplace becomes sublime.[23]

Renewal and making the commonplace sublime—it sounded like echoes from Gao Jianfu's lectures at Nanjing in 1936. But by 1943 Guan Shanyue was one of the few Lingnan School artists still seeking the artistic sublime in the contemporary commonplace. Setoo Ki continued down the other path, as did most other Lingnan artists. In Setoo Ki's case, it led him to colorful, decorative experiments, especially with that Cantonese favorite, the brilliant red kapok.[24] But the times were not right for pure esthetics and decorative art in China, nor would they be again for some time. Setoo Ki became an emigre artist, first in Hong Kong and then in Vancouver, Canada; Guan Shanyue went on to become one of the most celebrated and most influential painters of the People's Republic.

Chen Shuren: The Lonely Road West

Chen Shuren naturally went with the Nationalist government in its retreat to the far west because he was still a government official. His crucial decision came in the second year of the war when his long-time friend and political associate Wang Jingwei defected to the Japanese and became president of their puppet government in Nanjing. Almost alone among Wang's close associates, Chen refused to join him and take high office in Nanjing. In Chongqing his position as head of the Commission on Overseas Chinese Affairs was essentially powerless, especially with most direct overseas con-

tacts cut after the loss of China's coastal ports. But, despite his friendship with Wang and long residence in Japan, the patriotic spirit that had infused the Lingnan School from its origins was evidently too strong to allow him to become a collaborator with the national enemy.[25] Several contemporaries speak of Chen Shuren as being a principled and incorruptible official while in office. That sense of principle kept him with the Chungqing government when collaboration seemed the more profitable course. It meant that he would never achieve real political power, but it also meant that he would not end up classified as a traitor along with Wang Jingwei and several other Cantonese colleagues. It left him without power, but with honor intact and with the leisure to engage in his cultural pursuits— poetry, painting, and the travels through China's vast western countryside from which many of his paintings arose.

Before the war he had begun the long sketching trips that markedly altered his landscape style; they continued and increased during the Chongqing years. Looking at his paintings in this period, it is not clear whether they show the same sense of resignation and loss of optimism that affected Gao Jianfu, but it must have been a lonely and somewhat bleak period for Chen too. Far from his home province and far from the lush lower Yangtze scenery that he had been fond of painting, abandoned by his closest political friends and associates, an eyewitness to the wartime sufferings of the Chinese people—his wartime poems do contain much sadness over the fate of his country and perhaps his own personal disappointments.[26] But he also had the means and leisure to pursue the artistic life of the semi-retired man of culture and he had his wife, a source of joy and comfort, as travel companion on his sketching trips.[27] The life probably was not too onerous. His paintings do not reflect any crushing psychological burden or any deepening pessimism about the world.

Chen's flowers and birds, still his most famous genre, continued to have the fresh, light, decorative touch he had acquired early. In his favorite composition, a tree trunk or hanging branches form the central diagonal with delicate blossoms or spring foliage brightening a picture, which is further animated by a small bird either about to take flight or already on the wing. In the 1940s he often modified this diagonal into a crossed branch or "X" composition, perhaps making the pictures compositionally more stable or solid (figure 70). Nevertheless, lightness and delicacy of touch were still his hallmarks. Therefore, when he painted trees, his pine trunks lacked the rugged strength of his colleague Gao Jianfu's pictures of this sort. Chen Shuren's brush was better suited to the flowering, graceful lines of willow branches or the bright, vivid blossoms of the flowering kapok tree.

In his last years, Chen became especially famous for his paintings of that

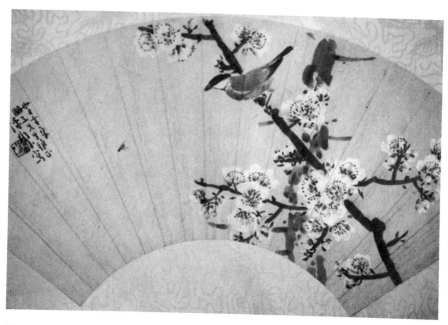

70. Chen Shuren, *Bird on Flowering Branch*, 1946.

uniquely Cantonese tree (figure 71; see also plate 3). A scholar in the People's Republic estimates that Chen did over a hundred paintings and more than ten poems on the kapok.[28] What was the source of its fascination for the artist? Obviously, it was a reference to the provincial homeland from which war and politics had separated him. But the popular nickname for this brilliantly blossomed tree, the "hero tree," suggests other meanings. Throughout the Chinese cultural world, the bright red blossoms of the flowering plum were an ancient and still-prevalent artistic symbol for moral rectitude and heroism in the face of adversity. The similarly colored "hero tree" could expropriate the symbolic significance of the plum, apply it to this distinctly Cantonese emblem, and enlarge it to a national symbol of China's unbroken spirit during the Japanese invasion. Or, in happier times, immediately after the war, like the plum blossom, it could serve as a symbolic harbinger of spring. The kapok was a good example of how the Lingnan School might use regional character to transcend regional significance. Unfortunately, by this time there were not enough appropriate symbols or techniques available for them to realize their goals for the new national painting.[29]

For example, although Chen brought some new techniques to kapok

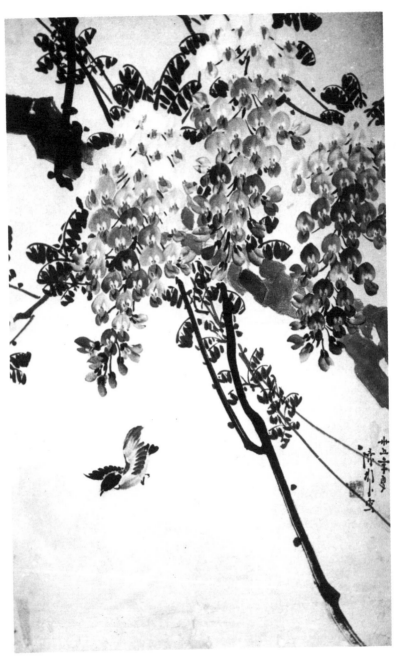

71. Chen Shuren, *Lingnan Spring Color*, 1946.

paintings in particular and flower and bird painting in general, these were not sufficient to revolutionize that genre as a whole or make it compellingly relevant to China's political or cultural needs by the 1940s. With some other symbols, such as rootless orchids representing the Chinese spirit deprived of the soil of the motherland, Chen was much less original. There is little of the "new" in this kind of national painting.

But in one other very traditional subject and symbol for Chinese painters, the bamboo, Chen Shuren's contributions to twentieth-century Chinese art may not have been adequately recognized. The conventional manner of painting bamboo demonstrated the artist's calligraphic skill and control of ink. Chen, on the other hand, adopted the closeup view of a section of bamboo trunk, a composition that all three of the Lingnan masters had originally learned in Japan. In contrast to the diagonal slant of a pine, cypress, or kapok trunk, the bamboo is a perfect vertical; Chen painted it with a single, broad, upward-moving brush stroke, the ink carefully modulated to give an appearance of roundness. He customarily added color—green for the leaves, light brown or green for the trunk, sometimes a few pink blossoms on the branch of another tree. But the main emphasis in these pictures is on the solid and upright bamboo trunk (figure 72). The naturalistic techniques, molding and color, give verisimilitude with nature; the strong vertical conveys the symbolic associations of strength, rectitude, and endurance already linked to the bamboo in Chinese culture.

However, it is difficult to claim that Chen made a major and influential innovation in Chinese painting at this time. It is possible that a much more influential painter on the Chinese national scene by the 1940s, Xu Beihong, was influenced by Chen when the Paris-trained Xu turned back to Chinese painting. Xu's bamboo paintings follow Chen's vertical bamboo trunk style, although they eschew color for plain black ink.[30] But, regardless of Xu's possible debt to his Lingnan School friends in this or in bird paintings, Xu Beihong's major impact on modern Chinese painting was not in those genres. Neither directly nor indirectly did Chen become the founder of a new style of bamboo painting.

Again, part of the reason why Chen did not make a greater impact with an art that seemed to be moving closer to the realism (even a symbolic realism) that the age demanded seems to come from the Lingnan School's penchant for mixing their realistic touches with a strong dose of decorative or romantic sensibility. Chen's bamboo in figure 72 has pink plum blossoms added to the background and two tiny bees darting toward the lower left-hand corner. The strength or solidity of the picture and its symbolic connotations are weakened by these decorative elements. This is not necessarily an esthetic defect. In other times, such fresh, light, colorful, and

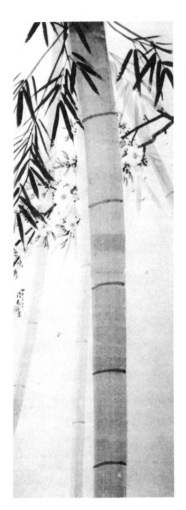
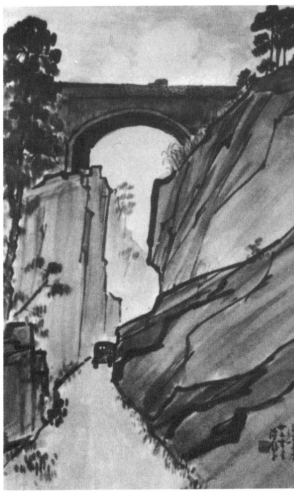

72. Chen Shuren, *Bamboo*, 1946. 73. Chen Shuren, *A Scene of Yu Zhou*, 1946.

attractive pictures might have had wider appeal as shown by the preference for Chen's work expressed by some Chinese critics during the post-Mao liberalization of the late 1970s. But in Chen's own era it required sterner stuff to make an impact on the national scene.

During these years, Guo Moruo, by no means a close associate of the Lingnan School, nevertheless admired Chen's paintings as "having a Zen flavor... pure and plain like drinking superior tea so the flavor lingers

on."[31] It was not an inappropriate metaphor, but in these years of war and revolution the subtle flavor of superior tea was overwhelmed by stronger tastes.

A similar situation obtained for the more realistic, but still subdued, landscapes that Chen produced in his later years. We have noted earlier how his landscape style changed in the 1930s from one displaying the light and shadow effects that all the Lingnan School founders picked up in Japan to a more simplified, more direct approach. We also noted a more somber quality, particularly a darkening of the colors, in his later landscapes. That darkening may have been related to his personal and political disappointments, and it continued in the war years but did not grow heavier. However, the change in style could also be seen as a method of getting away from the prettier, more decorative flavor in his early landscapes, a way of making them more direct and immediate by eliminating the bravura effects of early twentieth-century Japanese landscape painting. The two explanations are not, of course, mutually exclusive. A more somber view of life and close contact with the actual Chinese countryside may have worked together in moving him away from the dramatic and decorative aspects of his earlier landscape style.

There is something to admire in the simple honesty of his later works that surpasses the sometimes affected realism of most Lingnan School landscapes. In retrospect, it seems surprising that his late landscapes were not more influential, but that may be explained by Chen's position as a loner in the Chinese art world. Although firmly identified with the Lingnan School, he never was the leader of an artistic movement in the way that Gao Jianfu had been. He did not have any students, any desire to organize a movement, any freedom to devote his whole life to art. After the war, Chen resigned his official position and planned to settle into a gentleman's retirement near Canton. Perhaps then he could have cultivated successors, but he died in 1948 at the age of 65.

Chen's lack of serious influence on Chinese art in the 1930s and 1940s was due to more than just his not being a full-time professional painter and teacher. The realism the times demanded was not Chen's type of realism. He went directly to nature for his trees and flowers, but they were light, delicate, refreshing glimpses of nature, not the stern stuff of social realism. His landscapes caught the flavor of the real countryside, but they were neither heroic in spirit nor contemporary in the sense of portraying modern symbols and subjects. He has one small landscape, *A Scene of Yu Zhou*, which shows two automobiles and a concrete bridge on a country road (figure 73). That is the sum of his modern subject matter. He simply was not the kind of narrative scene and social realist painter that Guan Shanyue

had become in the war years. In different times under different circumstances, he might have had something to teach the next generation of Chinese artists; by the Sino-Japanese War, the time when his skills and experience could have been relevant was already past. Although less isolated then Gao Jianfu in his exile in Macao, Chen Shuren also moved outside the mainstream of China's cultural and artistic development.

The Postwar Years: End of an Era

When the war finally ended in August 1945, Chen Shuren could return to Nanjing with the Nationalist government, and Gao Jianfu could return to his Spring Slumber Studio in Canton, but neither the Nationalist government nor the Lingnan School could go back to the way things had been before the war.

Chen Shuren continued to paint privately while preparing to withdraw from official life. Gao Jianfu was less prolific as a painter in his final years, probably because of ill health and failing eyesight, but still enthusiastically active as a teacher. In addition to teaching his personal students at the Spring Slumber Studio, he undertook to organize a private South China art school. When the head of the Canton city school system approached the old master, with some trepidation, asking him to take the principalship of the poorly financed Canton City Art School, Gao surprised him with the alacrity with which he accepted, allegedly replying: "For the sake of cultivating artistic talent, I am willing to risk this old life." Obviously, he was still eager to transmit his vision of a new national painting to the next generation.[32]

In June 1948, the Lingnan School held its last joint exhibition. Gao Jianfu and Chen Shuren were joined by Zhao Shaoang (epigone of the Qifeng style), two of Gao's most famous students, Guan Shanyue and Yang Shanshen, and the artist-official Li Gemin (figure 74).[33] The exhibition, sponsored by the Guangdong Provincial Mass Education Institute, was a kind of last hurrah for the Lingnan School in mainland China. Before the year was out, Chen Shuren was dead. In 1949 the Communists' revolutionary armies rolled over Guangdong, sending Gao Jianfu into a second exile in Macao. Plans to establish a Lingnan School art institute and museum in Canton with support from the city government and private benefactors were finished.[34]

To the very end, Gao Jainfu clung to his mission of revolutionizing Chinese art and helping the Chinese revolution, his version of it, through art. In the second to last issue of the art school's magazine, Shi yi (City art)

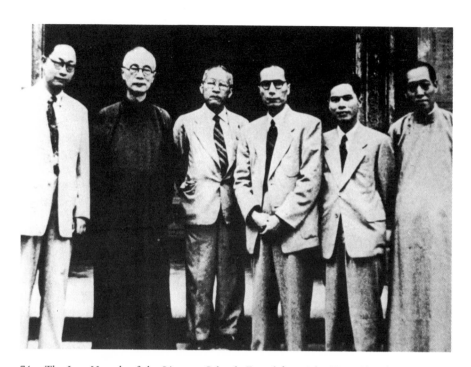

74. The Last Hurrah of the Lingnan School: *From left to right:* Yang Shanshen, Chen Shuren, Gao Jianfu, Li Gemin, Guan Shanyue, and Zhao Shaoang, posing before their joint exhibition at the Guangdong Provincial Mass Education Institute in Canton, June 1948.

for March 1949, he still called on the students to produce an art with social purpose involved in contemporary life. At the school's last art festival, he reemphasized the need for creativity: "Art is progressive change and creativity. It should create and create again—creation after creation—progress and progress again—progress and more progress without limit."[35] The spirit was still there, even if his own art could no longer express it. As the Communist armies closed in and Nationalist administration over the last major coastal city crumbled, he still urged the students to stay with the school, not to give up the "revolution in art" and their task of "saving the country through art."[36] But the old slogans from an earlier era could not stay the new turn of the Chinese revolution. Gao pleaded in vain for students to remain at the school in Canton but soon he himself went into his second and final exile.

Old friends, such as Liao Zhongkai's widow, the artist He Xiangning, tried to persuade Gao Jianfu to return from Macao and accept the new

order in China. His Guomindang affiliations had not been close enough with the dominant Chiang Kai-shek wing necessarily to classify him as an enemy of the revolution. Versions vary along political lines as to why he preferred a second exile in Macao. Zhu Xiuxia writing in the magazine *Free China* on Taiwan six years later quotes Gao as replying: "I never became an official with the Guomindang. At this stage you want to offer this mirage to entice me to jump into the sea of suffering."[37] It was an appropriately Buddhist answer about withdrawal from the world for his old comrades who had made the switch to the Communist side. But in the People's Republic, an old friend, Feng Boheng, remembers differently. Writing about thirty years after the event, he recalled that Gao was "happy with the Liberation of the Motherland and the glorious future that the nation looked forward to" and had expressed the intention of going to Peking shortly before his death.[38] As evidence, he cites a letter from Gao Jianfu postmarked December 30, 1950, from Macao, which pleaded ill health as the only reason for delaying that return.[39] Perhaps that was so, but his daughter Gao Lihua remembers her father as being angry at receiving a letter from his disciple Guan Shanyue which warned that failure to come back would make him "an enemy of the people."[40] It is not improbable that the old revolutionary wanted to keep his friends on the other side of the political fence. During the war he had already pleaded illness as a reason for not taking the Nationalist government's suggestion that he go to Chongqing. Whatever his feelings, he remained in Macao.

There, once again problems of economic sustenance for the artist in exile pressed down on him. The Nationalist government remembered him and sent some financial help.[41] He held exhibitions of his work at hotels and department stores in Macao and Hong Kong. But, as he lamented to his friends in the last year of his life, selling his paintings was like selling his children because his weak eyes no longer allowed him to paint the way he had done before. His last signed paintings are lesser works, loose, if not sloppy, in execution. In fact, a withered lotus, the painting uncolored and unfinished, is probably his very last work.[42] During his later years, autumn imagery and the sadness of decaying things loomed large in his paintings. It was an appropriately sad ending for an artist and a school that had started with so much spirit and such high ambitions. On May 22, 1951, Gao Jianfu died in Macao. For all practical purposes, the Lingnan School's forty-year effort to bring a revolution to Chinese art and to use art as a tool for national rejuvenation was over. The revolution that had brought a new political and social order to China and would soon reshape China's artistic world as well was not their revolution. Gao Jianfu's death only confirmed the end of an era.

The close parallel between the rise and fall of the Lingnan School and the fate of the Nationalist government is more than coincidental. It had never been an official school and never produced explicitly political art, but its founding members were closely linked to the Nationalist party right from its origins in the Alliance Society before 1911. They remained more or less connected with the Nationalist political cause for the next forty years, enjoying favors during its ascendancy and slipping into oblivion with the overthrow of the Nationalist government in mainland China.

Those political connections probably would have been closer if the Guangdong faction within the Nationalist party leadership had ultimately won out in the power struggle following Sun Yat-sen's death. As it was, the artists were fortunate that they did not follow Wang Jingwei into wartime collaboration with the Japanese. That would have discredited their nationalistic principles and led even more directly to the school's eclipse. Perhaps they can be identified politically with the "left Guomindang," but the label is not too useful, because they had little direct association with the Communists in the mid-1920s. Chen Shuren as acting governor of Guangdong was, in fact, a target of the Canton Commune uprising. Moreover, the crucial issue of social revolution in the 1920s does not seem to have been central in their thinking or ideology.

That ideology had been formed much earlier, in the pre-1911 Alliance Society period. It embraced nationalism, modernity, cultural rejuvenation without total rejection of tradition, and concern for the poor without espousing social revolution. The Lingnan artists' relationship to the May Fourth movement in the ensuing decade was ambivalent. They shared the prevalent romanticism, that is, the emphasis on personal feelings and sentiment as opposed to the social restraints of Confucian tradition, but they were not really cultural iconoclasts. They could never have applied to the world of painting the famous iconoclastic slogan of the philosopher Wu Zhihui—"Throw the classics into the cesspool." Their syncretic formula drew too heavily on Chinese identity and Chinese tradition. Nor did they pick up the rabid anti-imperialism of the later stages of the May Fourth movement. At least it did not directly impinge on their art. The matrix for their nationalism was more the anti-Manchu struggle before 1911 than the anti-imperialist struggle of the 1920s.

Why, then, was this early twentieth-century art and the ideas behind it ultimately unsuccessful in effecting the kind of revolution they wanted? Initially, the artistic ideas of 1911 were rejected by the cultural and political conservatives who were still strong enough to frustrate the hopes of the

early Republican revolutionaries. After 1927 when the Lingnan School artists were in a position to promulgate their new national painting, it was rejected by the succeeding generation of revolutionaries as being too conservative. The general parallel with the Nationalist party's political ideology and programs is obvious.

To pursue this parallel further raises the question of whether it was a growing conservatism within the party and the painters themselves that made them lag behind the times or whether they retained essentially the same position while historical circumstances changed around them. The rapid pace of modern Chinese history has turned many radicals, such as the Lingnan School's fellow Cantonese Kang Youwei, into conservatives without their changing their ideas at all. But there have also been revolutionary leaders and movements that became more conservative over the years. It is frequently charged that the Nationalist party turned to the right after 1927. Did the Lingnan School do the same? In its leader Gao Jianfu, there was a growing fascination with Buddhism and increasingly neo-literati tastes in painting. In Gao Qifeng, there was an estheticism in his art and a partial withdrawal from the world during the illness of his last years. As for Chen Shuren, despite elements of realism in his style, he never turned to social realism. The vigor and heroic spirit of their early years seemed to flag in all of them during the 1930s. True, the ideas about art expressed in Gao Jianfu's 1936 lectures still sounded revolutionary, and there were real efforts by some of the second generation Lingnan painters to realize them in practice. The tendency toward conservatism in the founders of the Lingnan School was less an abandonment of revolutionary principles than a flagging of revolutionary spirit. But in art, and perhaps in politics, spirit is crucial.

In any event, it was the war with Japan, starting in 1937, that made this conservative trend so fatal to both the Nationalist party and the Lingnan School. Like the government, the Lingnan School seemed to be enjoying a fair amount of success in the mid-1930s, achieving more national recognition, influence, and prestige than ever before. But at the pinnacle of its success there was still a somewhat dated or outmoded quality to its sentimental and vaguely Japanese romanticism. Some artists and critics were already calling for sterner, rougher stuff to force Chinese art into contact with contemporary reality. The war multiplied such voices but, with the exception of Guan Shanyue, neither the first nor second generation of the Lingnan School could satisfy the demands for a new social content in art.

There also is, of course, no little irony in the fact that the Japanese invasion substantially contributed to wiping out Japanese cultural influence in Chinese art. The same irony might be noted in the Nationalist party, with its origins in Japan, being fatally weakened by the Japanese. The

verdict on the Lingnan School as a revolutionary art movement seems to be that it was ahead of its times in 1911 and had fallen behind them by the late 1930s. The same may be said about the Nationalist party, but that verdict may be more debatable.

In the story of the Lingnan School the first important theme has been its relationship to modern China's revolution in politics as well as art. The other theme, also important for modern Chinese history, has been the relationship of the provinces to the nation, of the frontier or periphery to the center. Together these two themes, region and revolution, form the main threads in the history of the Lingnan School.

For these Cantonese artists, revolution presented a chance to overcome provincialism, to make the periphery central, not by going from the provinces to the center (Peking or the lower Yangtze) but by going outside the country to Japan for the new skills that could rejuvenate Chinese art and create a new national painting. This can be seen as part of a longer historical process through which Canton, China's gate to the sea, became a focal point for change once Western influence became the driving force in modern Chinese history. As long as China was mainly self-contained and self-sufficient, Canton was remote from the center and remote from the central processes of China's politics and culture. When that isolation ended by the mid-nineteenth century, Canton's position changed. Shanghai, located in the heart of the old cultural and economic centers of China, became the leading modern city, but Cantonese were perhaps even quicker to pick up on new ideas for changing China in politics and in art. Thus, Canton became the crucible in which the elements for China's nationalist revolution were fired and the Lingnan School artists were very much a part of Sun Yat-sen's first generation of revolutionaries.

After 1911 the Gao brothers' attempt to storm the center of the art and cultural world failed, but in the next decade the course of revolution brought Canton back to the center stage of Chinese politics. However, in the revolution of the 1920s the Cantonese wing of the party failed to capture national leadership, and so the Lingnan artists' connections with the new national government were not as close as they might have been. Still, it was in this period that they came closest to establishing their new national painting at the national level. Ultimately they failed. They remained recognized in "the north" as a regional school rather than as a new national movement in art; the Gao brothers had no non-Cantonese disciples to spread the school. The second generation artists were still regional, and, by trying to draw new inspiration from study in Japan, again, they identified themselves with an unpopular foreign source.

The war forced a retreat into provincial isolation. In Macao, Gao Jianfu

and his group were cut off from the nation as effectively as if they had been in more distant exile, where at least there might have been the stimulus of foreign ideas. There was little intellectual or artistic stimulation in Macao. It was a stifling isolation that only a few of the younger Lingnan painters, notably Guan Shanyue, could escape. After the war, the revolution had passed by both Canton and its artists.

In a longer perspective, the Lingnan School's failure to achieve its national goals was part of the failure of the southeastern coastal periphery to take and keep the leadership in the transformation of modern China. With the Communist revolution rising out of the villages of the hinterland and basing its new government in the northern capital of Peking, the southeastern littoral (Canton in particular) once again became a distant and provincial frontier. The revolutionaries of Sun Yat-sen's generation, including these Cantonese artists, had failed to make the southeastern periphery central to the new China that emerged by the second half of the twentieth century. In retrospect, it seems clear that the rise and fall of the Lingnan School as an important national art movement must be understood in the context of the revolutionary politics and regional dynamics of that pivotal transitional period between the last years of the Qing dynasty and the emergence of the People's Republic.

Epilogue: Contrasting Legacies of the Lingnan School

The frequent reference to "failure" in our assessment of the Lingnan School may be an excessively harsh judgment on its founders. In their time these men were successful artists and successful innovators. The only failure was in falling short of their lofty aspirations for reshaping all of Chinese art and culture. They failed to find a satisfactory synthesis of foreign innovations and native tradition that could form the basis for a new Chinese art. The Nationalist party also failed in its attempt to synthesize change and tradition. Chinese culture, including painting, still has not achieved any stable synthesis.

The Lingnan artists were forerunners in much that was new in Chinese art and the social organization of art. They introduced to China not only new techniques for painting, but a new concept of a national and public role for art with new institutions, such as art schools, public exhibitions, and government sponsorship of the arts. These were all legacies that the Lingnan School pioneers left behind, but with the disintegration of what was left of the school in 1949, remnants moved in three different directions—artistically, ideologically, and geographically.

Art and Politics in the People's Republic

The second-generation painters remaining in the People's Republic all settled in Canton, where they assumed important roles in the reorganized art life of the new order. Guan Shanyue, who was most like Gao Jianfu in his organizational and promotional abilities, became the most prominent.[1] He has had a long and successful career as one of the most honored painters in the People's Republic, living and teaching at the Guangdong Academy of Fine Arts most of the time, but with frequent national tours, exhibitions,

and political participation in the National People's Congress. However, for most of the past thirty-eight years, he has not usually been identified as a Lingnan School painter, perhaps partly because the school's close connections with the Nationalist party would have been embarrassing to an artist firmly committed to the People's Republic, but also because his style has evolved away from that of his teacher. Guan is best known for his landscapes. His most famous single painting is a vast panorama of northern China based on Mao's poem "Snow," which Guan did in 1959 in collaboration with the famous Nanjing artist Fu Baoshi. It hangs permanently in Peking's Great Hall of the People.[2]

After 1949 Guan's paintings simultaneously become more "Chinese" than those of the mainstream Lingnan School artists (drier, harder, less sentimental) and more "socialist realist." At times, Guan has applied this realism to modern subjects and political references far beyond anything attempted by his teacher. For instance, in 1961 he painted the open pit coal mine at Fushun from a bird's-eye view, carrying Gao Jianfu's injunction to expand the scope of what is considered esthetically sublime well beyond anything his teacher had attempted.[3] Then, in the early 1970s, the later stages of the Cultural Revolution period, he turned out even more buoyantly optimistic scenes of China's socialist construction, such as his *Southern Oil City* of 1971 (figure 75), or pictures with even heavier political symbolism, such as his exuberantly bountiful plum blossoms of 1974. Critics of the time praised such works for "vigour, prosperity and dogged militancy."[4] Subsequently, after the fall of the Gang of Four, his pictures have played down such political content and "dogged militancy" in favor of more traditional subjects and style. Nevertheless, over the past few decades, Guan Shanyue has been the artist who has furthest developed the realistic and socially concerned side of the Lingnan School.

His colleague and former fellow disciple of Gao Jianfu, Li Xiongcai, has also taught at the Guangdong Academy of Fine Arts. He too has traveled widely throughout China and achieved a national reputation as a landscape artist, but he has not generally been as celebrated at the national level as Guan Shanyue nor as politically active. During the Cultural Revolution, Li, along with many other artists, was in eclipse, possibly because he was never able to paint new socialist content with the same verve as Guan Shanyue. Li also tends to retain a little more of the special atmospheric effects popularized by the Lingnan School and what the critic Li Chu-tsing aptly calls "a sense of vibrant immediacy" that was one of the school's special strengths (figure 76).[5] However, he has also worked in other styles as well, including of late a modernized version of the antique monumental blue and green landscapes.[6] For both Li and Guan, color has remained an

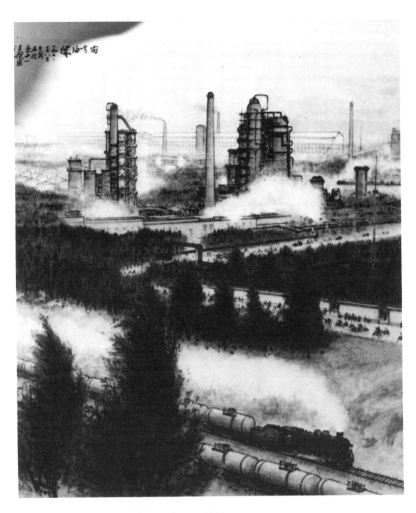

75. Guan Shanyue, *Southern Oil City*, 1971.

important element, and they generally use it more heavily or more force-
fully than was Gao Jianfu's practice. The wistful autumnal tints of many of
Gao's works have not, after all, been much in demand during most of the
history of the People's Republic.

The third prominent Gao Jian Fu disciple, the innovative figure painter
Fang Rending, also taught and was active in art administration in Canton.
Having already bent his talent for line drawing to the depiction of scenes

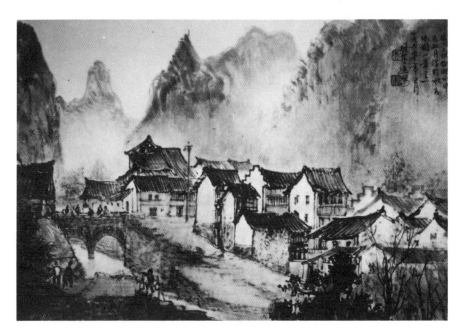

76. Li Xiongcai, *Double-Arched Bridge in Small Town*, 1960.

from common life during the war years, he was able to adapt to the demands for socialist-realist subject matter after 1949 (figure 77). He did not, however, become a major national figure as did Guan Shanyue, and his works from the politically relaxed years of the early 1960s show him much more fond of painting traditional scholars and beautiful ladies than new builders of socialism.[7] Neither his work nor that of other Lingnan School artists was particularly influential in creating a new style for Chinese socialist realism in figure painting. It appeared in exhibitions and publications during the 1950s, including some at the national level, but for the most part the Lingnan School remained a local tradition, confined to Canton and Guangdong.[8]

Moreover, whatever influence or direct continuity with the earlier Lingnan School did survive was almost entirely from the realist, not the romantic or decorative, side of the Lingnan tradition.

In the political-artistic atmosphere that prevailed for most of the first three decades of the People's Republic, this preference for realism over romanticism was not surprising. But, in the artistic liberalization of the post-Mao years this one-sided acceptance of the Lingnan School's legacy began to change. As interest in more purely esthetic aspects of art has

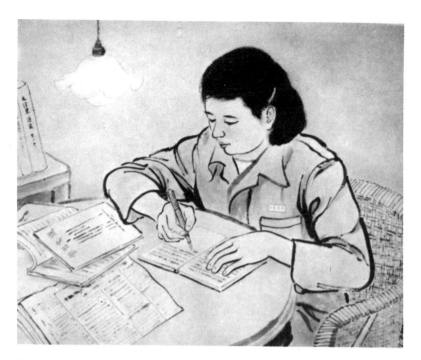

77. Fan Rending, *Organizing Notes*, 1952.

grown, something of the Lingnan School's more colorful and decorative side has reemerged in Canton and beyond. The best representative of this trend in Canton is Chen Ziyi (b. 1919), who has received increasing recognition for flower and bird paintings that seem to draw from the decorative finesse of Chen Shuren and the bold spirit of Gao Qifeng.[9] That familiar Cantonese symbol, the flowering red kapok, is one of his favorite subjects.

By the early 1980s, this revived interest in the romantic–decorative aspects of the Lingnan style was not entirely confined to Canton. In Shanghai, scene of Gao Jianfu's most ambitious efforts to establish a national school, the septuagenarian painter Huang Huanwu began to receive belated recognition for his characteristically Lingnan landscapes and flower and bird paintings. Although a member of the Shanghai National-Style Painting Academy since the 1950s, not until the 1980s was he honored by a one-man exhibition in Nanjing and a reproduction volume of his paintings.[10] Although not a direct student of the Gaos, he came from Canton and had studied art there before the Sino-Japanese War. He lived in Shanghai from 1949 to his death in 1985, maintaining the distinctive Lingnan style and, at

least in recent years, openly identifying himself with that southern tradition by signing his paintings "Lingnan Huanwu." Although he has not been a major influence in Shanghai painting circles, nevertheless this modest and belated recognition of his art was a clear sign of a changing attitude toward the Lingnan School and the kind of art it represented.

The spirit, if not the exact features of the Lingnan style, possibly reached as far as Peking. The post-1976 works of the now nationally famous artist Huang Yongyu (b. 1924), whose brilliantly decorative flower and bird paintings were one of the most widely publicized blossomings of the post-Mao Hundred Flowers campaign, may have absorbed a touch of Lingnan School influence. Huang is a native southerner and spent several years in Hong Kong around 1949 where he certainly could have been exposed to that style, although there is no known association with the school. Moreover, Huang's technical innovations, such as the mixing of oil and ink media, go beyond what the Lingnan masters attempted. Nevertheless, in some of his recent works there is a spirit and flavor reminiscent of the Gao Qifeng–Zhao Shaoang tradition.[11]

This raises the larger question of the extent to which many of the general features of Chinese painting in the second half of the twentieth century can be traced back to Lingnan School innovations. Realism, conscious syncretism, heightened emotional content, more vivid colors, selective use of perspective, light, and shading—all are commonplace in the national-style painting of the People's Republic. It is possible that more of this was borrowed from the Lingnan pioneers than has been acknowledged or recognized either by artists or art critics. But there were also other channels for most of these innovations, and it seems better to examine the specific contacts and contributions of the Lingnan School artists rather than make vague and unverifiable claims about their general influence. To take Huang Yongyu as a case in point, it is sufficient to say that his later works show an unrestrained emotional expressiveness that has an artistic and spiritual affinity with the Lingnan School artists at the period when they too had been trying to break out of constraints against individual expression.

Even if the resemblance to the work of Huang Yongyu is just coincidence, the more sympathetic attitude toward the Lingnan School after 1976 was unmistakable. Recognition came not just for artists directly or indirectly descended from the school, but also in increasing measure for the school as a historic movement. At first the recognition was local, an exhibition at the border town of Shenzhen in 1979, more for the convenience of Hong Kong compatriots than Canton art lovers. Soon after, as the pace of political and artistic relaxation quickened at the end of the 1970s, a major

exhibition of Chen Shuren's paintings was held at the City Art Gallery in Canton. This was followed by two other exhibitions in Canton that included works by the Gao brothers and Ju Lian. These Canton exhibitions came from the two major collections of Lingnan School paintings in South China, one at the City Art Gallery of Canton and the other at the Guangdong Provincial Art Museum also located in Canton. Then, late in 1981, there was a Lingnan School retrospective at the Shanghai Museum of Art, where important works from the Gao brothers' Shanghai years are still held.[12]

In a sense, that return to public exhibition space in the central metropolis of Shanghai, after an absence of forty-five years, marked a new stage of national recognition for the school. This was confirmed by the appearance of articles on its founders in several national art magazines. The first was "Gao Jianfu and the Lingnan School" in the important journal *Meishu yanjiu* (Art research) for April 1979, written by an old associate in Canton, Feng Boheng.[13] Then, in January 1982, the Peking art journal *Zhongguo meishu* (Chinese art) devoted more than half an issue to "The Works of the Lingnan Pai," with illustrations of hitherto unpublished works in the National Palace Museum Collection.[14] By far the most comprehensive survey of the movement to appear in the People's Republic, it contained works by and articles on Ju Chao, Ju Lian, Gao Jianfu, Gao Qifeng, Chen Shuren, Zhao Shaoang, Guan Shanyue, Li Xiongcai, Yang Shanshen, and Huang Shaoqiang. The tone was warmly appreciative and complimentary, praising both the esthetic and historical accomplishments of the school. In July 1982 this revalorization of the Lingnan School was extended to an international audience with the publication of Chi Ke's article in the popular English-language magazine *Chinese Literature*.[15]

The apex of this revival came in 1983 when *Zhongguo hua yanjiu*, journal of the newly founded Chinese Painting Research Academy published an article on the Lingnan School by one of Gao Jianfu's old students, Huang Dufeng.[16] And, then to honor the Gao Qifeng side of the Lingnan School tradition, his leading living disciple, the Hong Kong master Zhao Shaoang, was given a major exhibition, along with one of his students, She Miaozhi (Letty Shea), at the National Art Gallery in Peking.[17] Zhao sent his works and his student but, citing age and ill health, declined to attend in person. It did not seem to dampen the spirit of the occasion, as major figures from China's political, cultural, and artistic circles turned out for well-publicized attendance at the exhibition.

Nevertheless, a careful reading of the new critical literature on the Lingnan School shows that all this suddenly revived interest and the personal honors conferred on Zhao Shaoang did not signify a revival of the

Lingnan School's claims to found a new national painting. The three original masters of the Lingnan School were praised for their patriotism, their progressive thought, their modern spirit, and their daring innovations in art. Feng Boheng argued that Gao's progressive political thought, his active engagement with the issues of his times, was central to his art and that many of his paintings were direct commentaries on contemporary events. But he had to admit that, politically, Gao's vision was limited by his class background and that, artistically, he never really succeeded in his goal of popularizing Chinese painting.[18] Chi Ke concluded his sensibly balanced appraisal of the school's historical position: "These three painters instilled a new spirit and vitality into what was in many ways a declining tradition, and their legacy remains an inestimable contribution to modern Chinese art."[19]

This legacy is seen as a historical contribution, perhaps one whose importance has been overlooked, but not a model or formula for present-day Chinese art. The spirit of innovation and the desire to rejuvenate China's own artistic legacy without abandoning it is, of course, relevant to the current situation. In personal conversations, such prominent artists as Cheng Shifa in Shanghai and Ya Ming in Nanjing valued the Lingnan School mainly for the innovative example it had set for later Chinese artists.[20] Neither uses any of the Lingnan School's specific features in his own work.

In the early 1980s the People's Republic began a serious campaign for peaceful reunification with Taiwan. At a time when the People's Republic was making unprecedentedly generous overtures to Nationalist compatriots on Taiwan to let bygones by bygones and rejoin the Chinese "Motherland," it was not amiss to praise progressive artists who had been closely connected with the Nationalist cause. Overseas Chinese, the overwhelming majority of whom came from Guangdong, may also have derived some satisfaction from seeing their province's painters praised in national publications, and the high demand for economic investment in China's modernization program made appealing to capitalist fellow countrymen abroad a higher priority. But, as important as those factors have been, it would be an oversimplification to attribute the revived interest in the Lingnan School just to political and economic considerations. As already noted, the decorative and even the romantic aspects of the Lingnan School accorded well with the Chinese art public's thirst for art with a more expressive and emotional character after the long years of politically dictated stereotypes during the Cultural Revolution.

In short, political line and artistic taste have both contributed to the revival of interest in the Lingnan School within China. Yet, for the most

part, it concentrates on their past achievements. Elements of their syncretic formula (perspective, shading, color, etc.) are widespread in contemporary Chinese art, sometimes introduced from other sources, sometimes perhaps traceable back to their pioneer efforts. But their specific formula for a new national painting—the Lingnan style—is not often followed, even in Canton. The exhibitions and publications testify to the fact that in China the Lingnan School has been safely historicized, made part of the honored, but not living, past.

Buddhism and the Nationalist Cause in Taiwan

Meanwhile, in the other China across the Taiwan Straits, different remnants of the Lingnan School survive in a different cultural and political climate. It is not a cohesive organized art movement as it was in Canton before 1949, but both the Qifeng and Jianfu traditions survive in Taiwan. The former is upheld by Ou Haonian, a prize student of Zhao Shaoang from Hong Kong. Since 1970 Ou has been teaching art at the College of Chinese Culture at Yangmingshan near Taibei. This third generation Lingnan painter has fully preserved the colorful, dramatic, and highly emotional style of his teacher. More than that, his eagles, herons, and moonlit scenes are a distant but remarkably clear echo of the young Gao Qifeng but with the emotionally expressive or sentimental aspects carried even further.[21] An interesting example of this revived heroic spirit in the Lingnan School would be Ou's painting *White Horse in Autumn River* from 1978 (figure 78). Compared to Gao Qifeng's 1926 version, the painting is much more dynamic, even flashy. The autumn leaves are a brighter orange, and the brushwork is in the more abstract, less naturalistic Zhao Shaoang manner. The horse is also drawn with more emphasis on expressive line and active posture than naturalism giving, in total, a much more active and dynamic picture than Gao's wistful autumn scene.

Perhaps this represents a reinvigoration of the Lingnan School, the reassertion of powerful emotional effects and allegorical symbolism in the part of China still ruled by the party of the original 1911 revolution. But such signs of life in the later Lingnan School have to be seen in the context of the overall historical situation and the reception accorded these works. Ou Haonian and the other representatives of the Lingnan School on Taiwan all teach at the College of Chinese Culture in Yangmingshan, which is probably the most conservative institution of higher learning, culturally and politically, on Taiwan. Ou and his colleagues have not made their art the handmaiden of government policies any more than the

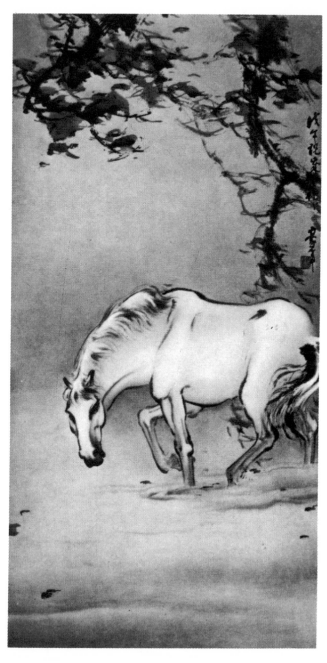

78. Ou Haonian, *White Horse in Autumn River*, 1978.

founders of the Lingnan School did. They are independent artists. But, to the foreign-influenced Western-style artists on Taiwan, they are traditionalists, lumped with the other conservatives who see Taiwan as a place to keep alive the old culture and values. Eighty years after the Gao brothers went to Japan, what was new in the Lingnan style does not look so new or so controversial. Politically, it becomes part of the defense against Communism; artistically, part of the resistance to more recent Western influences.

This is perhaps even more obvious in the work of the other leading exponent of the Lingnan style in Taiwan—the Venerable Xiao Yun, prioress of the Yongming temple near Yangmingshan and also a professor at the College of Chinese Culture. She too came from Hong Kong but represents a different style and tradition in the Lingnan School. Before the war, under her original name of You Yunshan, she was a student of Gao Jianfu in Canton. After extensive world travels in the late 1940s, including three years' study in India, she taught art in Hong Kong and later became a Buddhist nun. She came to Taiwan in the mid-1960s to help found the new Yongming temple. There she has has gathered a band of artistic and religious disciples around her, who in 1974 started a series of annual exhibitions originally held at the Taibei Provincial Museum but subsequently also shown elsewhere on the island. The Buddhist name given to these exhibitions was "Cool Purity" and the paintings, many by Xiao Yun herself, reflected a strong Buddhist influence in spirit and content.[22]

Xiao Yun represents the Buddhist side to Gao Jianfu's character and the Indian influence in his style. Thus, she is fond of the rich subdued browns and yellows that interested him on his visit to India, although she is also able to emulate his earlier stress on wind and rain effects in landscapes, which are her principal genre. The wind and rain she explains as metaphor for a world in storm and tumult, beyond which lies Buddhist tranquility. Though often devoted to Buddhist themes, her art is not disassociated from the present world and its political storms. A section of most of the "Cool Purity" exhibitions has been devoted to the "Storm and Rain" of the current times, and, to commemorate the anniversary of Chiang Kai-shek's death, she painted a windy landscape with the Chinese Nationalist flag flying from the mountaintop. This was reproduced as a cover for the popular picture magazine *Cosmorama Pictorial* (figure 79).

Since the late 1970s, she has extended the scope of her "Cool Purity" exhibitions to reach foreign and overseas Chinese audiences. In 1978 she held one in Brussels, which coincidentally was the site of the Lingnan School's earliest international recognition when Chen Shuren, Gao Jianfu, and Zhao Shaoang all exhibited there in the International Exposition of 1934. In 1983 "Cool Purity" exhibitions were sent to Singapore and

79. The Venerable Xiao Yun (You Yunshan), *Standing Through Wind and Rain*, 1977.

Kuching, Malaysia, carrying the Buddhist and Nationalist Chinese message to overseas Chinese communities through art.[23]

Hong Kong and the Esthetics of Exile

Although by the early 1980s the Lingnan School had once more achieved a certain amount of visibility and official favor in both of the two Chinas, its position obviously differed in Taiwan and the People's Republic. The place where it has shown the most continuity as a distinct, living school over a long period has been Hong Kong. After 1949 the colony was a natural refuge for non-Communist Cantonese artists where, supported by the local pride of a predominantly Cantonese population, the Lingnan style was perpetuated with surprisingly little change. The Gao brothers' two most famous and successful successors there have been Yang Shanshen, student of Gao Jianfu, and Zhao Shaoang, follower of Gao Qifeng.

Even before his exhibition at the National Gallery in Peking, Zhao Shaoang was probably the most famous of all the second generation paint-ers in the Lingnan School. His lively, colorful style and virtuoso effects in the Gao Qifeng manner made his works easily appreciated by Hong Kong patrons and foreign visitors (figure 80). Through his participation in inter-national exhibitions going back to the 1920s, and his travels abroad after 1949, he became one of the better-known Chinese painters in the West. The art historian and critic Li Chu-tsing expresses the central dichotomy in the later Lingnan School and the appeal of Zhao's works in these words: "While Gao Jianfu, in his last years, generally turned toward a greater use of ink and a stronger sense of antique quality, Chao Shaoang continues to portray the vitality of living beings as a reflection of the joy of life in the human world."[24]

Zhao's large group of Hong Kong art students formed the Today's Art Association in the 1960s, which held annual exhibitions for a number of years. The students' works are amazingly uniform and amazingly close to Zhao and through him back to Gao Qifeng. Few of these students were distinguished on their own. The association ceased holding its annual exhi-bitions in the mid-1970s after many of his best students left Hong Kong. Zhao continued teaching and his influence could still be seen in such con-temporary painters as Zhu Tiaowei, whose kingfisher over a lotus pond at the Hong Kong Museum of Art's "Contemporary Hong Kong Artists" exhibition in August 1978 still had all the moonlight, atmosphere, and romantic flavor that Gao Qifeng had brought back from Japan seventy years earlier. The most ironic aspect to this kind of painting in Hong Kong

80. Zhao Shaoang, *Withered Lotus in Moonlight*, n.d.

was that it became perceived as preserving Chinese tradition, whereas, when the Gaos introduced it to China, it was regarded as foreign and an attack on tradition.

Yang Shanshen is less well known abroad and has fewer students, but he too has had a successful career as an artist and teacher in Hong Kong. As a follower of Gao Jianfu, he maintained the Spring Slumber Studio's tradition of developing and departing more from their teacher's style than was the practice of Gao Qifeng's Heavenly Wind Pavilion students. Therefore, especially in recent years, much of Yang Shanshen's work does not show typical Lingnan School characteristics.[25] A large number of his paintings are in Gao Jianfu's drier ink style, but some of his animal paintings show a detail and realism reminiscent of Gao Qifeng (figure 81). Both he and Zhao Shaoang have been talented artists and worthy successors to the Lingnan tradition. But, for artists not drawing their inspiration from contemporary art developments in the West, Hong Kong too has been more a place of provincial exile, on the fringe of China, than a center for absorbing new ideas to develop a lively, contemporary art suited to China's new social and cultural realities. The original Lingnan School had been vitally connected with the living history of its times. The post-1949 survivors, whatever the advantages they gained from the artistic freedom and capitalist art patronage of Hong Kong, were living on the margin of China.

They have not been without honor, especially as such institutions as the

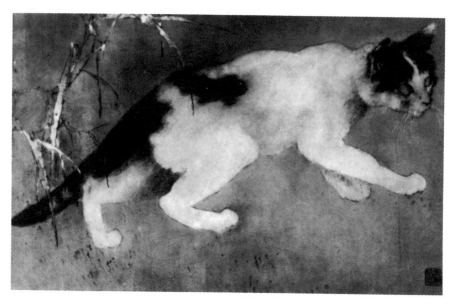

81. Yang Shanshen, *Cat*, n.d.

Hong Kong Museum of Art and the art galleries of the two Hong Kong universities developed public recognition for the Crown Colony's cultural life. The series of large-scale retrospective exhibitions on each of the three founders of the school held at the Hong Kong Museum of Art between 1978 and 1982, capped off by a joint exhibition on "Early Masters of the Lingnan School" in April 1983, were instrumental in publicizing the school's historical achievement.[26] Moreover, for the surviving second generation Lingnan masters, the growing cooperation between Hong Kong and Chinese authorities even permitted Zhao Shaoang and Yang Shanshen to enjoy an artistic reunion of sorts with their confreres in Canton, Guan Shanyue and Li Xiongcai. As a Hong Kong counterpart to the new recognition of the Lingnan School in Peking, the Guangdong authorities cooperated with the Fung Ping Shan Museum of Hong Kong University to hold a joint exhibition of the four veteran artists in the summer of 1983. Each of the forty paintings done expressly for this show was a joint production. But none of them was of the same character as the intimate group painting done by Gao Qifeng's disciples after his death in 1933. The new paintings, done separately in Canton and Hong Kong, were exchanged through the mail until each of the four had contributed his part. Understandably, they were for the most part rather standard Lingnan-type flower

and bird paintings, most of them carefully composed of one bird, one branch, one rock, one flower—a part for each painter involved. As paintings, they were as good as could be expected under the circumstances, but not any culmination of, or testimony to, the school's achievements.

Meanwhile, as younger artists in Hong Kong have been more influenced by contemporary Western art or have sought to find their own fusion of Chinese tradition with foreign inspiration, the Lingnan School has become more associated with preserving Chinese tradition than with stimulating new discoveries. By the 1970s, Western-style artists in Hong Kong clearly regarded it as old-fashioned and conservative—not without honor or respect, but, as successful Lingnan School students left Hong Kong for Taiwan or North America, not a creative force in the circumscribed Hong Kong environment.

Thus, the well-prepared exhibitions at the Hong Kong Museum of Art from 1978 to 1983 were occasions for polite approbation by critics and public with none of the outrage and controversy that had marked the school's original public exhibitions in Canton half a century earlier. Though still an ongoing tradition in its last Hong Kong resting place, here too the Lingnan School has nevertheless become safely historical, and local.

Perhaps the word "local" should be modified by acknowledgment that Zhao Shaoang's students have spread the Lingnan style overseas as they have left Hong Kong, mainly for North America. Huang Leisheng, for example, lived in San Francisco during the 1960s and 1970s where he taught and painted lyrically romantic landscapes.[27] In the early 1980s, however, he moved to Taiwan to teach at the center for Lingnan School art there, the College of Chinese Culture in Yangmingshan. Farther north in North America, Liu Yunheng (Stephen Lowe) founded a gallery in Victoria, British Columbia, and painted the whole range of Lingnan subjects from pert, lively little birds to evocatively misty landscapes.[28] But his premature death in 1975 cut short any further development of what was essentially the Gao Qifeng decorative style as developed by Zhao Shaoang. Of Zhao's later students, from the early 1980s, She Miaozhi moved to Vancouver after her successful joint exhibition in Peking, and He Fenglian, while remaining in Hong Kong, exhibited at Oxford University in 1986.[29] Both are young woman artists bold in their use of color and with a good technical command of the Lingnan style. It remains to be seen if they can develop this style in new directions.

On a more vulgar commercial level, distant and distorted reflections of the originally Japanese-inspired romantic Lingnan style (mists, moonlight, and monkeys) can still be found in many North American Chinatowns. But it would be manifestly unfair to hold either the Gao brothers or their

successors responsible for what has been done to their effort to combine realism and romanticism.

The main legacy of the Lingnan School remains in Chinese places—Canton, Taibei, and Hong Kong—not in North America. And so, in different times and in these different places, the scattered remnants of the movement that sought to revolutionize Chinese art linger on, pursuing their separate visions of what should constitute the proper synthesis of modernity and tradition. Hong Kong is probably home for the strongest continuing influences. That too is ironic in that a movement so passionately nationalistic in its origins should linger on in a foreign colony, but probably no more ironic or sadder than that a movement with such revolutionary national ambitions should end up preserved by local emigre nostalgia in Hong Kong and recalled to public attention for essentially political purposes in China itself.

However, the present remnants and extra-artistic uses of the Lingnan School are no measure of its historical significance. The founders of the school did not by themselves revolutionize Chinese painting and, through art, revolutionize China, but they did help bring changes in how painting was done and the role it played in society. And, of course, they were closely linked with the overall revolutionary process. They did not come up with a final solution to the problem of how to combine modernity and tradition into a living new Chinese art, but one could hardly expect that to happen in times of such sweeping and chaotic change. Moreover, no solutions to artistic or cultural problems are ever final for long.

As artists and revolutionaries the founders of the Lingnan School reached higher than most. Though they could not ultimately grasp their goals of remaking Chinese art and Chinese society, they contributed to both. In art, they started the longer process of accommodating the great tradition of Chinese painting to Western influence and modern needs. As revolutionaries, they participated in the rise of the Guomindang but were not involved in its downfall. Their "failure" came from striving for goals beyond the immediate reach of their generation. But there is considerable honor and important history in the attempt.

Notes

1. Rabb, "The Historian and the Art Historian," 107–17.
2. Rabb, "The Historian and the Art Historian Revisited," 655.
3. See, e.g., Murk, *Artists and Traditions: Uses of the Past in Chinese Culture.*
4. The literature available on twentieth-century Chinese art illustrates its general neglect in the West, and a glance at the syllabus for almost any university art history course confirms this. Even when leading art historians publish on modern China, it is not their most serious work. Thus, almost thirty years after its initial appearance, Michael Sullivan's *Chinese Art in the Twentieth Century* is still the most comprehensive study available in English. It is supplemented, but not superseded, by his more general work *The Meeting of East and West in Art.* Li Chu-tsing's *Trends in Modern Chinese Painting* has information on artists represented in the Drenowatz collection. James Cahill covers several leading "neo-literati" painters, but this book is only available in Japanese. For more recent and more political art, there is Arnold Chang, *Painting in the People's Republic of China,* shortly to be superseded by Ellen Johnston Laing, *The Winking Owl: Art in the People's Republic of China.*
5. The most ambitious cooperative effort between social scientists and literary historians is Goldman, ed., *Modern Chinese Literature in the May Fourth Era.*
6. The popularity of and critical acclaim for leading "individualists" of the Ming-Qing transition period—painters such as Shi Tao, Badashanren, Shi Qi, and the figure painter Chen Hongshou—is only matched by their influence on the work of twentieth-century Chinese artists. Some of these artists are discussed in Cahill, *The Compelling Image.*
7. This is still a controversial subject, but the work of Sullivan and Cahill have made a convincing case for a strong element of Western influence in some of the leading Chinese painters of the early and mid-seventeenth century. See Sullivan, *The Meeting of East and West in Art,* chap. 2; Cahill, *The Compelling Image,* chaps. 3 and 5; and both authors in *Proceedings of the International Symposium on Chinese Painting* (Taipei: National Palace Museum, 1972), pp. 593–698.

Chapter One

1. In three biographical lists cited in Ho Ping-ti, *The Ladder of Success in Imperial China*, p. 96, Guangdong ranks twelfth, ninth, and thirteenth out of nineteen provinces in the Qing dynasty with regard to the number of nationally prominent men it produced. In the series that Ho considers most comprehensive and most significant, Guangdong ranks thirteenth with 3.78 percent of the national total.

2. The population ranking is based on the 1787 Qing census. By the late nineteenth century, Guangdong ranked higher. The ranking in number of *jinshi* is for the length of the whole dynasty (Ho, *Ladder of Success*, pp. 223, 288).

3. Dou Zhen, *Qingchao shuhuajia bilu, juan* 2, p. 24.

4. Jen Yu-wen [Jian Youwen], "Ju Lian zhi huaxue," p. 24.

5. Statistics on the native places of important Guangdong painters during the Ming-Qing period compiled by Zhuang Shen show 67 percent of the province's total coming from just three districts—Shunde, Nanhai, and Panyu—all in the environs of Canton. The city itself, however, produced less than 2 percent of the total. Chuang Shen [Zhuang Shen], "Some Observations on Kwangtung Painting," p. 10.

6. Ibid., p. 13.

7. Ibid., p. 16.

8. See *Su Liupeng*.

9. Lawrence Tam, "An Introduction to the Development of Kwangtung Painting," pp. 32–33.

10. Ibid., p. 33.

11. Chuang Shen, "Some Observations," map (p. 25).

12. Ho Ping-ti has determined that the adjoining districts of Panyu and Nanhai in the larger metropolitan Canton prefecture produced 248 of the 1,012 *jinshi* from Guangdong in the Qing dynasty. This extraordinary performance placed these two districts eighth in a list of localities of outstanding academic success for the whole empire (*Ladder of Success*, pp. 228, 254).

13. There is some irony in this because considering that several of Ju Lian's students, including his most famous disciples, Gao Jianfu and Chen Shuren, became anti-Qing revolutionaries. It is worth noting, however, that they joined the revolutionary movement only after their master's death and after leaving Guangdong. Ju's dynastic loyalty is indicative of a conservative gentry background. Moreover, the issues of political and cultural loyalty had shifted considerably between the 1850s and the early 1900s.

14. Jen Yu-wen, "Ju Lian," pp. 25–26; Tam, "An Introduction," pp. 32–33.

15. Li Chu-tsing, "Landscape Painting in Kuangtung During the Ming and Qing," in *Landscape Paintings by Kwangtung Masters During the Ming and Ch'ing Dynasties* (Hong Kong, 1973), n.p.

16. The modern Cantonese scholar Jen Yu-wen considered this to be Ju's most creative genre ("Ju Lian," p. 27). His leading disciple, Gao Jianfu, retrospectively praised his teacher for leading his students to study and paint from nature so as to develop realism and their own creativity. See Gao Jianfu, "Ju Guquan [Ju Lian] xiansheng de huafa," p. 47.

17. Jen Yu-wen claims that Ju Lian was the first painter in Guangdong to open a studio where he regularly taught students ("Ju Lian," p. 23). There were professional painters before him who had disciples, but Ju Lian apparently taught more regularly, more openly, and on a larger scale.

18. Jen Yu-wen estimates the number of Ju's disciples as between thirty and forty, many of whom became professional artists or well-known amateurs ("Ju Lian," p. 23).

19. We are indebted to Jen Yu-wen's chronological biography of Gao Jianfu, entitled "Geming huajia Gao Jianfu," for the much more detailed information available about Gao Jianfu in particular and the Gao family in general. Feng Boheng, "Gao Jianfu xiao zhuan" [A short biography of Gao Jianfu], is based on some different sources and provides some additional information although generally agreeing with Jen on factual matters. For Chen Shuren there is Kong Jingzhi, "Chen Shuren xiao zhuan," the brief biography by Chen Danian as introduction to *Chen Shuren hua ji* (Shanghai, 1939), and the sometimes misleading article in Boorman and Howard, *Biographical Dictionary of Republican China*, vol. 1.

20. Chen Shuren married Ju Lian's grandniece, not, as erroneously claimed in Boorman and Howard, his daughter. Ju Lian had no children, only an adopted nephew Ju Cha, who became an accomplished painter in his own right, one of the six Ju masters of flower and bird painting (Jen Yu-wen, "Ju Lian," p. 49).

21. Most sources do not mention Gao Qifeng studying with Ju Lian. I believe the article in Boorman and Howard, *Biographical Dictionary* (p. 237), is wrong on this, as on a number of other points, when it asserts that "Kao Ch'i-feng [Gao Qifeng] went to Canton, where he studied under his brother's former teacher Chü Lien [Ju Lian]." First, Ju Lian was not in Canton; second, it would have had to be before Qifeng entered a Christian school at the age of fourteen.

22. Gao Jianfu, "Ju Lian," p. 28.

23. Jen Yu-wen, "Geming huajia Gao Jianfu," *Zhuanji wenxue*, vol. 22, no. 2; p. 85.

24. Liu Danian (preface to *Chen Shuren hua ji*) claims that Chen met Sun Yat-sen on a ship in Hong Kong harbor before going to Japan and was recruited to the revolutionary cause before the Alliance Society was formed. Li Jian'er concurs in this story in his *Guangdong xiandai huaren zhuan*, p. 13. But Boorman and Howard (*Biographical Dictionary* 1: 234) claim that Chen had not yet met Sun Yat-sen personally, and Kong Jingzhi (*Minguo renwu zhuanji* 6: 114) has him meeting Sun and joining the Alliance Society in Japan. In any event, he was an early member and personally knew fellow Cantonese in the inner circle of the revolutionary leadership.

Chapter Two

1. These figures are inexact because there is no comprehensive record of the students who were not supported by the Qing government. The estimates in Saneto Keishū, *Chūgokujin Nihon ryūgakushi* (p. 544) are accepted by Marius Jansen (*Japan and China*, p. 150).

2. Jen Yu-wen, "Gao Jianfu huashi ku xue cheng ming ji," 278–79. The freezing reception story was repeated in an interview with Gao Jianfu's daughter Diana Kao, New York, Aug. 1, 1978.

3. Jen Yu-wen, "Geming huajia Gao Jianfu," *Zhuanji wenxue*, vol. 22, no. 2, p. 86. Apparently, none of these paintings has survived. Shi Kefa was a seventeenth-century Chinese general who died a heroic death resisting the Manchu conquerors of China; Hua Mulan was the "Joan of Arc" of China, also fighting foreign invaders. *Flood Disasters* and *Refugees* seem to anticipate the kind of contemporary

national disaster subjects that Gao and some of his students would paint in the 1930s, but there is no evidence that Gao carried on with this genre in the intervening decades, and, even in the 1930s, he only painted a few such scenes.

4. Jen Yu-wen's chronological biography (*nianbiao*) of Gao Jianfu, "Geming huajia Gao Jianfu," is the most detailed and reliable account of the Gao brothers' early career; but one can also consult Li Jian'er, *Guangdong xiandai huaren zhuan*, pp. 8–13; Feng Boheng, "Gao Jianfu xiao zhuan," pp. 107–14; and Boorman and Howard, *A Biographical Dictionary of Republican China* 2: 235–38. For Chen Shuren, there is nothing comparable to Jen Yu-wen's biography of Gao, but Kong Jingzhi, "Chen Shuren xiao zhuan," pp. 114–18, is useful. Also see the biographical introduction by Chen Danian to *Chen Shuren hua ji* (2: 235–36), and the entry in Boorman and Howard, *Biographical Dictionary* 1: 235–36).

5. Li Jian'er, *Guangdong xiandai huaren zhuan*, p. 13, and Kong Jingzhi, "Chen Shuren," p. 114.

6. Paula Harrell characterized their attitude to the traditional culture in these terms: "China's heritage is stressed as a factor for strength in national development and the Chinese are taken to task for—unlike the Japanese—failing to pay it sufficient heed" ("The Years of the Young Radicals," p. 211).

7. Jen Yu-wen, "Geming huajia Gao Jianfu," vol. 22, no. 2, p. 86.

8. The most scholarly appraisal of Fenollosa's extraordinary career and role as cultural intermediary between Japan and the United States is Chisholm, *Fenollosa*. For Fenollosa's own ideas see his *Epochs of Chinese and Japanese Art*.

9. The revivalist character of the school can be seen in Okakura's insistence that teachers and students wear a school uniform designed after the Nara period (710–783) court dress (Yasuko Horioka, *The Life of Kakuzo*, p. 30). The archaic costume and dedication to moral rejuvenation of society through art have something in common with nineteenth-century European revivalist art movements, such as the Nazarenes and the Pre-Raphaelite Brotherhood. But in the Japanese case, their art was not nearly so consciously atavistic, and their purposes were not so far removed from the predominantly nationalistic values of their society.

10. Perhaps the best summary of these ideas is by Okakura himself in *The Ideals of the East*, pp. 227–30.

11. Quoted in Chisholm, *Fenollosa*, pp. 50–51.

12. Okakura, *Ideals of the East*, p. 227.

13. Jen Yu-wen, "Geming huajia," vol. 22, no. 2, p. 86; Li Jian'er, *Guangdong xiandai huaren zhuan*, p. 10.

14. The school later became the Fine Arts University (Bijutsu Daigaku) and still exists in Ueno Park. I am grateful to Tsuruta Tsueyoshi of the National Cultural Properties Research Institute in Tokyo and Kao Mei-ching of the Chinese University of Hong Kong for calling my attention to these records.

15. The device, known as *nozoki karakuri* in Japanese, was similar to the twin picture stereoscope popular in Victorian England or the View Master made possible by the development of color transparencies in photography after World War II. It was a toy that had an important impact on high art. It is described in Sasaki Johei, "Ōkyo and the Maruyama-Shijō School," in *Ōkyo and the Maruyama-Shijō School of Japanese Painting*, pp. 26–27.

16. For Ōkyo's early experiments with "eyeglass pictures," see ibid., illustrations 1–4 and color plate 1. For his realistic sketches, see ibid., illustrations 6–9 and color plate 8.

17. These members of the Dutch or Nagasaki School, oil painters such as Hiraga Gennai (1728–1779) and Shiba Kokan (1738–1818), were the forerunners of Western art in Japan, but in their own time their works were merely curiosities in Japan. For illustrations, see illustrations 5 and 9 in Sullivan, *The Meeting of East and West in Art*.

18. The use of terms that have strong associations with Western art history when discussing Japanese or Chinese art is fraught with the peril of misunderstanding. But to do without them impoverishes our vocabulary and diminishes the possibilities for comparative insights. The author of the best English-language study of the Shijō School, Jack Hillier, prefers "suggestivism" over "impressionism" for Goshun's emphasis on light and atmosphere, and "naturalism" over "realism" for Ōkyo's concern with solidity and specificity (*The Uninhibited Brush*, pp. 9, 12). Impressionism probably is too firmly linked to a specific European art movement to bear transferring to a Japanese context. In my opinion, neither realism nor romanticism need have such specific Western connotations. In this book I use realism, ranging from eighteenth-century Kyoto to twentieth-century Canton, in a general sense. It refers not to a completely worked out style or philosophy of art, but to the general approach of East Asian artists who reacted against the formalism and idealism prevalent in the art traditions of their day by drawing closer to nature and perhaps closer to the new social reality of growing urban bourgeois patronage. Similarly, romanticism in this book does not indicate a specific style, even if it would be possible to define precisely the elements of a romantic style in nineteenth-century Europe. Rather, the term here refers to a temperamental affinity that leans toward the emotional, dramatic, and sentimental instead of the rational, reserved, and classical. If cross-cultural comparative history is to be possible, some general terms and categories have to be freed from their specific Western contexts, providing that emancipation is explained.

19. Hillier, *Uninhibited Brush*, p. 46.

20. By Meiji times, the Maruyama-Shijō School was often referred to as "the sketch school" (Baekelund, *Imperial Japan*, p. 47).

21. Sasaki, "Ōkyo and the Maruyama-Shijō School," p. 33. Ju Lian, the Cantonese mentor of the founders of the Lingnan School, was also an exponent of the boneless technique, but he used it in a more restrictive way for more limited purposes.

22. Miyagawa Torao, *Modern Japanese Painting*, p. 13.

23. Hillier, *Uninhibited Brush*, p. 359. Despite this accolade, Hillier is not enthusiastic about the results. On Seihō's famous later animal study, *A Speckled Cat*, Hillier comments, "a half-caste version of a style already, at the time it was painted, long discredited in Europe" (p. 363). This would be a problem for many of the Chinese East-West syncretists throughout the twentieth century, including the Lingnan School. Rapidly changing styles and fashions in the West would soon make the Western component of their syncretism seem out of date.

24. Seihō taught there from its founding in 1895 and was made a professor when it changed to the Kyoto Painting Specialty School in 1909.

25. Gyokushō even studied with an English illustrator and casual painter, Charles Wirgman, who happened to be in Tokyo in the 1870s and attracted several adventuresome young artists to him before the government opened an official school for the study of Western art in 1876. See examples of Gyokushō and Kogyo's later works in Baekelund, *Imperial Japan*, pp. 44–47, 72.

26. See Mitchell, *The Illustrated Books of the Nanga, Maruyama, Shijo and Other Related Schools of Japan*; and Brown, *Block Printing and Book Illustration in Japan*, esp. chaps. 5 and 10.

27. The most important of these cultured traders was Shen Nanpin. His "meticulous detail and realistic coloring" influenced Ōkyo and other important eighteenth-century Japanese artists (Sasaki, "Ōkyo and the Maruyama-Shijō School," p. 25). It is not impossible that the young Cantonese painters imbibed a little indirect and long-deferred influence from this source. In particular, see Gao Qifeng's picture of a pheasant with tree and flowers, dated 1907 (figure 12). Nevertheless, this was not what caught their main attention in Japan. The taproot of their flower and bird painting was in Guangdong.

28. *Mombushō bijutsu tenrankai zuroku*, 1908, p. 90.

29. Screen paintings of lions done by Takeuchi Seihō are reproduced in *Takeuchi Seihō ten*, unpaged. The Mochizuki Seihō lions are in the catalog to the third Bun Ten (*Mombushō bijutsu tenrankai zuroku*, 1909, p. 107).

30. There is an undated Gao Qifeng painting of two deer reproduced on a color slide by the Centre for Asian Studies at Hong Kong University (Wong Shiu-hon, *Lingnan huapai zuopin huandeng pian mulu tiyao*, p. 24, slide no. 23). Most of the Jen Yu-wen collection is now at the Art Gallery of the Chinese University of Hong Kong, Shatin, New Territories, Hong Kong.

31. The animal painter Mochizuki Seihō had a monkeyscape in the second Bun Ten; it combines moonlight, snow, and a tribe of monkeys. Evidence from other paintings proves almost conclusively that at least one of the Gao brothers saw this exhibition (*Mombushō bijutsu tenrankai*, 1908, p. 99). It is possible that they copied these Japanese compositions from reproductions, but the poor quality of the illustrations in the Bun Ten catalogs makes it unlikely that they could have learned enough from such a source.

32. Reproduced in *Ming bao yuekan* (Hong Kong) 13, no. 8 (Aug. 1978): 52.

33. Gao Qifeng's *Monkeys on Snowy Pines* is reproduced in *The Art of Gao Qifeng*, illust. 18.

34. Chen Shuren also did a fox among the reeds in a similarly misty setting; see *Xin hua xuan*. Evidently, they all liked Kyoto foxes.

35. Kano Hōgai eagles are reproduced in Hosono Masenobu, *Edo Kano to Hogai*, pp. 64–65. Wong Shiu-hon, *Lingnan huapai zuopin*, p. 20, slide no. 1.

36. Wong Shiu-hon, *Lingnan huapai zuopin*, p. 20, slide no. 1.

37. There is an undated owl and moon in the Shanghai Museum, which has recently been duplicated as an inexpensive reproduction scroll by the Du Wen Xuan Art Store in Shanghai. Also see *Owl Calls to the Moon*, in *Gao Qifeng xiansheng yi hua ji*.

38. Reproduced in *Xin hua xuan*.

39. *Mombushō bijutsu tenrankai* 1907, pp. 30–31.

40. The Goshun screen appears in *Ōkyo and the Maruyama-Shijō School* (pp. 82–83).

41. The Qifeng sparrows appear in *Xin hua xuan*; the Jianfu painting is in the Jen Yu-wen collection. It is published in *Gao Jianfu de yishu* (illust. 60, p. 76).

42. *Mombushō bijutsu tenrankai* 1908, p. 64. The Qifeng painting is reproduced in *Gao Qifeng de yishu* (p. 34).

43. Kimura Buzan's painting is reproduced in color in *Nihon Meiji* (Japan Painting Gallery, Meiji Period), vol. 9, pp. 44–45. For Gao Jianfu's near-copy, see Wong Shiu-hon, *Lingnan huapai zuopin*, p. 19.

44. Reproduced in Wang Lipu, *Lingnan hua pai*, p. 40.

45. Interview with the Venerable Xiao Yun (You Yunshan), Yangmingshan, Taiwan, Aug. 1, 1978.

46. Leo Lee, *The Romantic Generation of Chinese Writers*.

47. This account of Zheng Jin's career is based on Li Jian'er, *Guangdong xiandai huaren zhuan* (pp. 57–58), and interviews with the Zheng family in San Francisco, July 1980. Unfortunately, none of his paintings seems to be available in published form.

Chapter Three

1. Jen, "Geming huajia Gao Jianfu," in *Zhuanji wenxue*, vol. 22, no. 2, p. 87.

2. Ibid.

3. Wang Jingwei, "Memorial Tablet for Mr. Gao Qifeng," in *Gao Qifeng xiansheng rongai lu* [A record of the glories and sorrows of Mr. Gao Qifeng] (Shanghai, 1935).

4. Jen, "Geming huajia Gao Jianfu," vol. 22, no. 2, p. 87.

5. Feng Boheng ("Gao Jianfu he Lingnan pai," p. 108) claims that when Gao visited Tokyo in 1913, he worked actively with Sun's new revolutionary party in exile, but Jen Yu-wen states that the main purpose of the trip was to promote Gao's new porcelain business. In any event, he supported the revolutionary cause during these years.

6. Gao Jianfu's successor as governor of Guangdong, Hu Hanmin, appointed him special commissioner to "investigate the applied arts in Italy, Holland, Germany, France, America, and Japan." Unfortunately, Yuan Shikai's usurpation canceled this world tour (Jen, "Geming huajia Gao Jianfu," vol. 22, no. 2, p. 88).

7. There is a good example of Gao Jianfu's handpainted porcelain reproduced in color in *The Art of Kao Chien-fu* (p. 25).

8. Jen Yu-wen stresses the public purposes behind his venture in the porcelain business ("Geming huajia Gao Jianfu," vol. 22, no. 2, p. 89). Gao's daughter Diana Kao recalls it as more of a business enterprise (interview, New York, Aug. 1, 1978).

9. Feng, "Gao Jianfu he Lingnan pai," p. 109.

10. *Zhen xiang huabao*, no. 3 (May 30, 1912).

11. Ibid., no. 14 (June 14, 1912).

12. Ibid., nos. 12, 13, and 14: drawings of a junk, an owl, and a peach.

13. Ibid., nos. 1–16.

14. Ibid., no. 14, pp. 7–8.

15. John Canady, *Mainstreams of Modern Art*, p. 141.

16. Interview with Liu Haisu, Shanghai, Feb. 1983.

17. Jen, "Geming huajia Gao Jianfu," vol. 22, no. 2, p. 88.

18. Feng, "Gao Jianfu he Lingnan pai," p. 73; Jen, ibid.

19. Jen, ibid.

20. Feng, "Gao Jianfu he Lingnan pai," p. 74.

21. Good published illustrations of works from this period are rare. Two good sample landscapes are *Winter Landscape*, undated, reproduced in Wu Tung, *Painting in China*; and *Cock's Crow over Thatched Hut* in Wang Lipu, *Lingnan hua pai*, p. 45.

22. The bear, which appeared in *Zhen xiang huabao* (no. 6), was unsigned, but its posture, expression, and the composition of the picture are so close to some of Gao Qifeng's other animal pictures that the attribution is fairly safe.

23. In addition to the 1917 peacock, two undated peacock paintings and one dated 1909 appear in *The Art of Gao Qifeng*, pp. 52 and 79. For comparison with a late Meiji Japanese peacock painting, see *Peacock and Peahen* by Araki Kampo, 1890 (*Nihon Meiji*, p. 15).

24. The most readily accessible reproductions are those in *The Art of Gao Qifeng*, pp. 38, 76, 78, 83, 91.

25. Now in the private collection of Li Xiongcai, Canton.

26. See *The Art of Kao Chien-fu*, pp. 37–39. The Venerable Xiao Yun mentioned Xia Gui and Mu Qi of the Song dynasty and Wang Hui, Shi Tao, and Shi Qi of the Qing dynasty as ancient masters whom Gao particularly admired (interview, Yangmingshan, Taiwan, Aug. 3, 1978).

27. The flutist is reproduced in *San Gao yi hua heji* (p. 6). The Daoist sage is in the collection of slides photographed from the Jen Yu-wen collection by the Centre for Asian Studies, University of Hong Kong (slide 29).

28. Some appeared in the Esthetic Publishing House reproduction volumes, *Xin guohua*, but these books are hard to find. *San Gao yi hua heji* has three Gao Jianzeng paintings, but they are early works that do not show his Japanese-derived style. Two of his later paintings, one in the Shanghai Museum collection, the other in the Canton City Art Gallery, were published in the 1986 calendar *Lingnan huaniao hua xuan* [Flower and bird paintings by the Lingnan School] (Shanghai renmin meishu chubanshe). These are paintings of deer and of a crane. There is also one Jianzeng landscape in the Art Gallery of the Chinese University of Hong Kong that is almost identical to Gao Jianfu's in style.

29. Feng, "Gao Jianfu he Lingnan pai," pp. 77–79.

30. Ibid., p. 77. The specific painting Feng refers to is undated, with a colophon from 1922 referring to it as an "old work."

31. Reproduced in *The Art of Gao Qifeng*, p. 35.

32. Jen Yu-wen, "Geming huajia Gao Jianfu," vol. 22, no. 2, p. 88.

33. Ibid.

34. Interview with the Venerable Xiao Yun, Yangmingshan, Taiwan, Aug. 3, 1978.

35. Chen Daren, "Geming de yishu laoshi Gao Jianfu" [Revolutionary art teacher Gao Jianfu], *Huanqiu ribao* [Universe daily], reprinted in *Hua yi ying chen*, ed. You Yunshan, p. 7.

36. Kong Jingzhi, "Chen Shuren xiao zhuan," pp. 114–15.

37. Zhao Shaoang, "Yuanyuan: Lingnan san jia," p. 4.

38. It is not certain that these paintings have survived. Only the lion painting can be identified with certainty, because it bears an inscription saying that in 1927 Gao Qifeng did a copy of the Memorial Hall lion at the request of his students (figure 39). The sea eagle is alluded to in contemporary literature, as is the white horse, but identification with specific works is uncertain.

39. These, along with tigers and other paintings in the Lingnan School style, may be found in *He Xiangning hua ji* and *Shuang qing shi hua ji* [Collected poems and paintings of coupled emotion] (Hong Kong. 1982).

40. For a discussion of the traditional symbolism of horse paintings, see Jerome Silbergeld, "In Praise of Government: Chao Yung's Painting, Noble Steeds, and Late Yuan Politics."

41. The third Bun Ten of the Ministry of Education (*Mombushō bijutsu tenrankai* 3 [1909]).

42. "Lingnan zhuming huajia Gao Qifeng de mingzuo," *Liang you*, no. 3 (April 15, 1926), p. 14.

43. *Mombushō bijutsu tenrankai*, 2 (1908), p. 100.

44. Chen is reported to have done a horse painting for the First National Art Exhibition in Nanjing in 1931. Otherwise, I have seen only one unfinished sketch of a horse among over 300 extant paintings.

45. The inscription is transcribed with the reproduced painting in Wong Shiu-hon, *Gao Jianfu hualun shuping*, p. 31.

46. A particularly striking comparison may be found in Delacroix's *White Stallion Frightened by Lightning* where the rearing pose, windblown tail and mane, and stormy background all resemble Gao Jianfu's *The Steed Hualiu in Wind and Rain*. The Delacroix painting is reproduced in Kenneth Clark, *The Romantic Rebellion*.

47. See, e.g., Scott, *Literature and the Arts in Twentieth-Century China*, p. 93.

48. Jen Yu-wen, "Geming huajia Gao Qifeng," vol. 22, no. 3, p. 87.

49. There is an example of his coconut painting in *The Art of Kao Chien-fu* (p. 71). One of his later coconut paintings was reproduced in the 1970s in hanging scroll form by the Duo Yun Xun Art Studio, Shanghai.

50. See *The Art of Kao Chien-fu*, illust. 72, p. 86, and *Takeuchi Seihō* [A retrospective exhibition of Takeuchi Seihō] (Tokyo, n.d., unpaged). The Gao painting is undated, but the calligraphy is in his late-period style. Seihō's watering can picture is from 1931. This strongly suggests that Gao Jianfu occasionally used the Japanese painting style long after his student days in Japan were over.

51. This can be seen in the catalog, *The Art of Gao Qifeng*, if one compares the *Birds in Snow* of 1909 (p. 31) with later bird and branch paintings.

52. There are examples of this kind of figure painting in *San Gao yi hua heji* (pp. 6, 12, 34). See also *The Art of Kao Chien-fu* (p. 24) and *The Art of Gao Qifeng* (p. 39).

53. This kind of subject matter, picturesquely bizarre figures out of history and folklore, became quite popular by the late nineteenth century in Shanghai and elsewhere. Ju Lian himself occasionally did such subjects; Su Renshan and Su Liupeng, the two most innovative Guangdong figure painters of the nineteenth century, were famous for them. For Ju Lian's pictures of Bodhidharma and Zhong Kui see Wong Shiu-hon, *Lingnan huapai zuopin*, p. 7. For the others see Jen Yu-wen, "Su Renshan, Eccentric Genius of Kwangtung: His Life and Art" (Hong Kong: Hong Kong University, Centre for Asian Studies, 1971) and *Su Liupeng*.

54. See *Liang Dingming xiansheng hua ji*.

55. As mentioned before, Takeuchi Seihō's visit to Europe is a possible connecting point with early twentieth-century Cantonese romanticism. See particularly his paintings of Italian scenes in *Takeuchi Seihō ten*.

Chapter Four

1. See *Mei zhan tekan*. At the exhibition, Gao Jianfu had two paintings, one of a water buffalo, the other of a willow tree. Gao Qifeng had one of his tigers in the snow and a small bird painting. Chen Shuren had one of his usual flower paintings plus a horse painting, and their associate He Xiangning had a pine tree and a landscape. Works of their students Zhao Shaoang, Huang Shaoqiang, and Fang

Rending were shown. All in all, it was an impressive representation at the national level.

2. For a catalog of contemporary Chinese paintings in the Berlin Museum, see Liu Haisu, ed., *Bolin renwen bowuguan suo cang Zhongguo xiandai ming hua ji*.

3. Gao Qifeng was given a state funeral with the mayor of Shanghai leading the entourage of mourners and the funeral committee loaded with such central government dignitaries as Wang Jingwei, who wrote a eulogy for the commemorative volume of the artist's works (*Gao Qifeng xiansheng rongai lu*).

4. The guest list included such luminaries from Shanghai's art and cultural circles as Cai Yuanpei, Liu Haisu, and Feng Ziyou (Jen Yu-wen, "Geming huajia," in *Zhuanji wenxue*, vol. 22, no. 3, pp. 89–90).

5. Feng Boheng, "Gao Jianfu xiao zhuan," pp. 111–12.

6. Quoted in Huang Weiyu, ed., "Lingnan pai huajia lun hua," p. 11.

7. This contemporary debate, conducted in the intellectual journal *Wenhua jianshe* [Cultural construction], Jan.–July 1935, focused on the degree to which modern China should consciously retain the traditional culture. Excerpts, including statements by the leading "Westernizer," Hu Shi, are contained in Theodore de Bary, ed., *Sources of Chinese Tradition*, pp. 854–57.

8. Gao Jianfu, *Wo de xiandai guohua guan* (1955), p. 34.

9. Ibid., p. 32.

10. Ibid., pp. 13–15. In an ingenious, if forced, reinterpretation of the last of the classic six principles for painting laid down by the Tang dynasty theorist Xie He, Gao claimed that "to copy ancient masterpieces" originally referred to copying foreign works, i.e., paintings brought from India in the wave of cultural borrowing that accompanied the spread of Buddhism from India to China. Thus, the prestige of Xie He's name could be invoked to sanction learning from foreign sources, exactly what the Gaos were advocating for twentieth-century Chinese art.

11. Ibid., pp. 28, 32.

12. Ibid., p. 52.

13. Ibid., p. 35. *Qiyun* (spirit resonance), is the first of Xie He's six principles, the hardest to understand, and the one considered most important by later Chinese art critics. It is the feeling or spirit expressed by the brush and goes beyond formal elements, such as line, composition, or color. Gao, for all his criticism of literati painting's conservatism and mystification, never depreciated spirit resonance.

14. Ibid., p. 39.

15. An art historian in the People's Republic, Feng Boheng, sees Gao as fundamentally a *tiyong* (essence and utility) reformer in art: "But he took continuing the fine traditions of China's one thousand plus years of painting as the basis and absorbing the good techniques of Western painting as a means to support it. In other words, this was Chinese painting as essence, Eastern [Japanese] and Western painting as utility, taking the good points from others to supplement one's own shortcomings" ("Gao Jianfu he Lingnan pai," p. 74).

16. Gao, *Wo de xiandai guohua guan*, p. 26.

17. Jen Yu-wen, "Geming huajia," vol. 21, no. 6, p. 33.

18. Ibid. Also quoted in Feng, "Gao Jianfu," p. 75.

19. Feng, "Gao Jianfu," p. 76.

20. Ibid., pp. 76–77.

21. Gao, *Wo de xiandai guohua guan*, p. 2.

22. Ibid., pp. 24–25.

23. Ibid., p. 38.

24. These quotes are collected in Wu Zhao, "Chunshui huayuan huanying Fang, Su, Yang, Huang gui guo hua zhan," p. 140.

25. Ibid., p. 140.

26. Fu Baoshi, "Minguo yilai guohua zhi shi de guancha," p. 644.

27. Ibid., p. 645.

28. Ni Yide, "Xin de guohua."

29. Wen Yuanning, "Art Chronicle," *Tien Hsia Monthly* 1936, p. 163.

30. Ibid., p. 164. Wen has more comments on Gao Jianfu and the Lingnan School in *Tien Hsia Monthly*, May 1936, p. 418, and April 1937, p. 325.

31. Chen Yifan, "The Modern Trend in Contemporary Chinese Art," p. 42.

32. Li Baoquan, "Zhongguo huafa zhi yanbian," pp. 435–36.

33. *Gao Qifeng xiansheng rongai lu* (Shanghai, 1935).

34. *Chen Shuren jinzuo*; Chen Shuren, *Guilin shanshui xiesheng ji*. There is a review of a Shanghai exhibition of his works in *Liang you*, no. 69 (Sept. 1932), p. 25.

35. It is not clear to what extent Chinese culture shared the nineteenth-century European image of tuberculosis as a disease of the extremely refined and sensitive individual—the romantic personality (see Susan Sontag, *Illness as Metaphor*). The prevalence of fictional lovers spitting blood and dying after frustration in love, as in the hero of the popular opera and movie *Liang Shanbo and Zhu Yingtai*, suggests that tuberculosis was a romantic disease in China too. It certainly did not diminish Gao Qifeng's romantic appeal.

36. *Gao Qifeng xiansheng rongai lu* (unpaged).

37. See *The Art of Kao Ch'i-feng and Chang K'un-i*.

38. Quoted by Zhao Shaoang in "Yuanyuan: Lingnan san jia," p. 4. Zhao amplifies this rather cryptic statement by explaining that "Jianfu's style was extensively heroic and marvelous; Shuren's elegant and beautiful; Qifeng then combined their two strengths." If this seems to raise Qifeng above the other two, it should be remembered that Zhao Shaoang was a student of the younger Gao.

39. Christina Chu, in her thoughtful introduction to *The Art of Gao Qifeng* (pp. 6–12), sees his career as falling into three periods stylistically: the early years, the mature artist of the 1920s, and the last years of illness and semi-seclusion after 1929.

40. Zhao Shaoang, "Yuanyuan: Lingnan san jia," p. 6.

41. The incident is reported by Gao's disciple, Yang Shanshen, in his reminiscences about his teacher published in *Ming bao*, no. 152 (Aug. 1978), p. 93. The general is only identified as "Chen"; it could have been Chen Qitang or Chen Jiongming.

42. Diana Kao (Gao Lihua) interview, New York, Oct. 7, 1978; and Yang Shanshen in *Ming bao*, no. 152, p. 93.

43. A short biography of Yang Suying appears in Li Jian'er, *Guangdong xiandai huaren zhuan*, pp. 107–8.

44. Gao Jianfu had several exhibitions in India. One report, with photographs of his works on display, appeared in the *Ceylon Daily News*, Oct. 23, 1931.

45. Jen Yu-wen, "Gao Jianfu," p. 281.

46. Four of these, dated from spring 1931 to spring 1932, appeared in the Hong Kong Museum of Art exhibition of 1978. See *The Art of Kao Chien-fu*, illustrations 25–28, pp. 49–52.

47. See ibid., illustrations 32, 38, pp. 21, 58.

48. The details are from an interview with the Venerable Xiao Yun, Yang-mingshan, Taiwan, Aug. 3, 1978. His association with the monastery is confirmed in Yang Shanshen's preface to *San Gao yi hua heji*.

49. Jen Yu-wen, "Geming huajia," vol. 22, no. 3, p. 89.

50. Interview with Jen Yu-wen, Hong Kong, Aug. 12, 1978.

51. Jen Yu-wen, "Gao Jianfu," p. 281.

52. Feng Boheng cites a colophon from a Gao painting of 1934 that praises the doyen of Ming literati painting, Shen Zhou ("Gao Jianfu he Lingnan pai," p. 77).

53. Gao Jianfu, *Wo de xiandai guohua guan*, p. 41.

54. Both Jen Yu-wen ("Geming huajia," vol. 21, no. 6, p. 33) and Guan Shanyue (interview, Feb. 25, 1983, Canton) cite this affinity with Zheng Banqiao's calligraphy.

55. This information on the sources of his calligraphy styles comes from Yang Shanshen (*Ming bao*, no. 152, p. 93) and Diana Kao (interview, Oct. 7, 1978, New York). One other source (Wang Lipu, *Lingnan hua pai*, p. 36) claims that Gao's original calligraphy style was influenced by Kang Youwei, who was a much-admired calligrapher as well as a philosopher. By the 1930s, however, Gao's calligraphy was much more unorthodox, much "wilder" than Kang ever practiced.

56. Interview with Chen Shi, Toronto, March 23, 1979. This son, Chen Fu, went to Moscow during the period of Nationalist-Communist collaboration and became a member of the Chinese Communist party. He did underground work in Canton and Hong Kong before he was caught and executed by Guangdong governor Chen Qitang (Kong, "Chen Shuren," p. 115).

57. The Anhui School of the seventeenth century might provide some parallels, but not for everything in Chen's mature style (James Cahill, ed., *Shadows of Mt. Huang: Chinese Painting and Printing of the Anhui School*).

58. Chen Shuren's surviving son, Chen Shi, has five of these sketchbooks in his possession.

59. Quoted in Kong, "Chen Shuren," p. 117.

60. Quoted in Wang Lipu, *Lingnan hua pai*, p. 77.

61. In an interview in Peking, Dec. 28, 1981, the veteran artist Pang Xunqin recalled that in the 1930s Chen's works were more influential in Shanghai than the Gao brothers' paintings. This may have been so for Western-influenced artists, of whom Pang was one, because Chen was in some ways closer to their approach than were the Gaos, though with less emphasis on ink and brush. There is, for example, a certain similarity between Xu Beihong's bamboo and pine trees and those done by Chen Shuren.

62. One is in the Canton City Art Gallery collection, the other, formerly in the possession of Jen Yu-wen, is now in the Chinese University of Hong Kong collection.

63. Xu Shiqi, "Canguan Lingnan san zuojia zhanlan hou," pp. 119–20.

64. Interview with Zhao Shaoang, April 5, 1977, Hong Kong.

65. See notice of his one-man show in Shanghai in *Liang you*, no. 67 (July 1932), p. 9.

66. This second wave of Chinese student painters to Japan was not confined to Lingnan pai followers; painters from other parts of China also went. The one who subsequently became most famous was Fu Baoshi, whose philosophic, if not artistic, affinities with the Lingnan School have already been noted.

67. Wu Zhao, "Chunshui huayuan," p. 141.

68. Ibid., p. 136.

69. There are three favorable reviews of his late 1935 one-man Shanghai exhibition in *Yi feng*, vol. 3, no. 12 (Dec. 1935): 44–50.

70. Gao Jianfu, "Dui Riben yishu shijie xuanyan bing gao shijie."

71. Jen Yu-wen, "Art Chronicle," *Tien Hsia Monthly*, Feb. 1938, p. 145.

72. Ibid., p. 146.

73. Wen Yuanning, "Art Chronicle," *Tien Hsia Monthly*, Feb. 1936, p. 163.

74. Fang Rending, "Xiandai Zhongguo hua de fan shidai xing."

75. Jen Yu-wen, "Jieshao huajia Fang Rending," p. 396.

76. The paintings of the less-known Lingnan School artists are not widely reproduced. One Su Wonong painting, of cactus flowers, can be found in *Guangdong meishu xuanji* (p. 12); there is a poor small black-and-white reproduction of a moonlit landscape by Wu Peihui in Li Jian'er, *Guangdong xiandai huaren zhuan*.

77. His work is reviewed by Jen Yu-wen ("Art Chronicle," *Tien Hsia Monthly*, Feb. 1938, p. 146).

78. Interview with Setoo Ki, Vancouver, June 30, 1978. See also Jen Yu-wen, "Geming huajia," vol. 22.

79. Li Jian'er, *Guangdong xiandai huaren zhuan*, p. 70; Li Chu-tsing, *Trends in Modern Chinese Painting*, pp. 141–45.

80. Wen Yuanning, "Art Chronicle," *Tien Hsia Monthly*, Feb. 1936, p. 164.

81. Ibid.

Chapter Five

1. Gao Jianfu, "Guofang yishu zhi zhongdaxing."

2. Jen Yu-wen, "Geming huajia Gao Jianfu," in *Zhuanji wenxue*, vol. 22, no. 3 (1973), p. 91.

3. Ibid., p. 93.

4. Feng Boheng ("Gao Jianfu he Lingnan pai," p. 80) quotes Gao as telling his disciples: "This is an important issue of honor. Although I had close relations with Wang for a long time, when it comes to this I can only take up a knife and sever them."

5. *Xingdao ribao* (Xing Dao daily newspaper), Hong Kong, Jan. 27, 1951.

6. Feng Boheng, "Gao Jianfu xiao zhuan," p. 112.

7. Conversations with Yang Shanshen and the Venerable Xiao Yun.

8. Feng Boheng, his biographer in the People's Republic, certainly stresses this alienation from the leadership and policies of the Guomindang ("Gao Jianfu xiao zhuan," p. 112).

9. Reproduced in *Tien Hsia Monthly*, vol. 9 (1939), p. 82 ff.

10. Wong Shiu-hon, *Lingnan huapai zuopin*, p. 18.

11. Feng Boheng interprets this painting as referring to capitulationists within the Guomindang, but this is not obvious in the inscription and this interpretation seems forced ("Gao Jianfu xiao zhuan," p. 80).

12. See *The Art of Kao Chien-fu*, p. 57.

13. Gao Jianfu's art historical reference to Liang Kai is discussed by Christina Chu in her introduction to *The Art of Gao Qifeng*, p. 14.

14. See *The Art of Kao Chien-fu*, illust. 40, p. 60.

15. The painting is in the possession of his daughter, Diana Kao (Gao Lihua).

16. A description of the exhibition and some of the paintings in it may be found in Jen Yu-wen, "Hao jiang du hua ji."

17. The painting was reproduced in *Tien Hsia Monthly*, vol. 9 (1939).

18. *Guan Shanyue hua ji*, illust. 3.

19. Both are printed in *Tien Hsia Monthly*, vol. 9.

20. Li Jian'er, *Guangdong xiandai huaren zhuan*, p. 70; Gao Jianfu, "Guofang yishu," p. 3.

21. Jen Yu-wen, "Hao jiang du hua ji," p. 1299. The patriotic implications were that, in the face of the Japanese economic blockade, the people would rely on their own efforts for necessities.

22. Interview with Setoo Ki, Vancouver, Jan. 30, 1978.

23. Quoted in Chi Ke, "Kuan Shan-yueh's Paintings," p. 108.

24. The kapok and other subjects of Setoo Ki's mature years are shown in *Szeto Kei's Painting Collection* (Hong Kong, 1976).

25. When Chen learned of Wang's defection, he immediately recalled his wife and children from Hong Kong to Chongqing as a sign of his intention to stay with the Nationalist government. However, when it came to censuring Wang, Chen abstained on the party vote. The conflict of loyalties obviously was painful (Kong, "Chen Shuren," p. 116).

26. A volume of Chen's wartime poems (*Zhan chen ji*) was published in 1946.

27. Chen's wife appears, along with the artist, as one of two diminutive figures in a painting of a waterfall at the famous scenic resort of Lushan. The inscription, dated 1944, recalls a visit there seventeen years earlier (*Chen Shuren yizuo hua ji* vol. 1, p. 4).

28. Huang Weiyu, "Jin jian yu jie jingshen," p. 23.

29. On the question of his stylistic originality in painting the kapok, although Huang Weiyu claims that this flower had never been done this way before, there was a black ink and red flowering kapok by Ju Lian in the 1983 Hong Kong Museum of Art exhibition of early Lingnan School works that is an exact prototype for some of Chen Shuren's paintings of that tree.

30. See examples of Xu Beihong's paintings reproduced in *Hsu Pei-hung Selected Paintings*.

31. Quoted in Chi Ke et al., "Lingnan pai zuopin," p. 7.

32. Zhu Xiuxia, "Yi Gao Jianfu xiansheng." Feng Boheng suggests a somewhat different reason for Gao's enthusiasm to accept a public school position. He claims that the rampant inflation of postwar Nationalist China made it financially impossible to maintain the private South China Art School, so Gao had no choice but to join the Canton City Art School if he wanted to continue teaching ("Gao Jianfu xiao zhuan").

33. The 1948 exhibition is reviewed in *Xingdao ribao*, June 10, 1948.

34. Jen Yu-wen interview, Hong Kong, Aug. 1977. For details of Gao's own contribution of land for the academy, see *Shi yi* [City art], no. 2 (April 1949), p. 16.

35. Gao Jianful, "Fakanci" [Introduction], *Shi yi*, no. 1 (March 1949), p. 3.

36. Gao Jianfu, "Shuqi xunlianban gan yan," pp. 1–2.

37. Zhu Xiuxia, "Yi Gao Jianfu," p. 99.

38. Feng, "Gao Jianfu xiao zhuan," p. 114.

39. Ibid., p. 80.

40. Interview, May 1978, New York.

41. Zhu Xiuxia, "Yi Gao Jianfu," p. 99.

42. *The Art of Kao Chien-fu*, illust. 88, p. 97.

1. There are may reproductions of Guan Shanyue's post-1949 works in print. The best single reproduction volume is *Guan Shanyue hua ji* (Canton, 1981). Also see *Guan Shanyue huaxuan* (Canton, 1974). For brief accounts in English of his art and career, see Chi Ke, "Kuan Shanyueh's Paintings"; and Chang, *Painting in the People's Republic of China*, pp. 51–57.

2. Reproduced in *Fu Baoshi hua ji* [Collected Paintings of Fu Baoshi], p. 57. See also Fu Baoshi and Guan Shanyue, *Dongbei xiesheng xuan*.

3. Reproduced in Chi Ke, "Kuan Shanyueh's Paintings," p. 113.

4. New China News Agency, Peking, Dec. 10, 1973.

5. Li Chu-tsing, *Trends in Modern Chinese Painting*, p. 145.

6. There is a large example of this style measuring over thirty feet across in the Canton Foreign Visitors Reception Hall. It is one of the more ambitious efforts at expanding ink painting to mural size.

7. See *Fang Rending hua ji*.

8. Although Fang participated in several national exhibitions, his paintings were seldom published. *Guangdong meishu xuanji* contains one of his 1950s paintings (p. 2), but it was not until 1983, eight years after his death, that he was honored with an individual reproduction volume. Guan Shanyue wrote the introduction.

9. See *Chen Ziyi hua ji*.

10. Information gathered in interview with Huang Huanwu, Shanghai, Jan. 20, 1983. For his works, see *Huang Huanwu hua ji*.

11. See *Huang Yongyu hua ji*.

12. The Shanghai exhibition included paintings from Canton but also featured some early Gao brothers paintings from the Shanghai Museum collection.

13. Feng Boheng, "Gao Jianfu he Lingnan pai."

14. *Zhongguo meishu*, no. 1. (Jan. 1982), pp. 1–38.

15. Chi Ke, "The Three Founders of the Lingnan School."

16. Huang Dufeng, "Tan Lingnan hua pai."

17. For reviews see Huang Miaozi, "The Art of Zhao Shaoang," *Chinese Literature*, June 1983, pp. 77–81.

18. Feng Boheng, "Gao Jianfu he Lingnan pai," p. 79.

19. Chi Ke, "Three Founders," p. 84.

20. Interviews with the author, Dec. 1981.

21. See *Ou Haonian hua ji*; and Joan Stanley-Baker, "Tradition as Patterns in the Process of Change."

22. *Qingliang yi zhan te kan* [Special catalog for the "Cool Purity" art exhibition] (Taibei, 1974, 1976, 1977, 1978, and 1983); see also *Hua yi ying chen*. The thirteenth annual exhibition was announced in the Buddhist Society's newspaper *Yuanquan* (The source), no. 56 (May 15, 1986), pp. 2–3.

23. *Yuanquan*, no. 26 (Nov. 15, 1983): 2.

23. Wang Zhexing, *Si hai zhi yu* (Four seas friends), no. 67 (March 1, 1978), p. 40.

24. Li Chu-tsing, *Trends in Modern Chinese Painting*, p. 50.

25. Of several reproduction volumes of Yang Shanshen's work, perhaps the best introduction is through the catalog for his 1981 exhibition at the Hong Kong Museum of Art, *Yang Shanshen de yishu*.

26. *Lingnan pai zao qi ming jia zuopin*.

27. Wang Lipu, *Lingnan hua pai*, pp. 133–41.

28. See *Liu Yunheng hua ji.*

29. She Miaozhi (Letty Shea) has shown at the Asian Art Gallery, University of British Columbia, among other places. Her work is considerably more original than some other Hong Kong Lingnan School artists, such as Yan Xiaomei (Ngan Siu Mui in Cantonese), who have also shown abroad. He Fenglian (Susan Ho Fung Lin) began studying with Zhao Shaoang in 1979, but, unlike her teacher, landscape is probably her outstanding genre. There is a catalog of her Oxford exhibition: *He Fenglian hua ji* (Hong Kong, 1986).

Glossary

Badashanren　八大山人
Bao Shaoyou　包少游
Bun Ten　文展
Bunjin-ga　文人畫

Cai Yuanpei　蔡元培
Chan　禪
Changzhou　常州
Chen Baoyi　陳抱一
Chen Danian　陳大年
Chen Fu　陳復
Chen Hongshou　陳洪綬
Chen Jitang　陳濟堂
Chen Jiongming　陳炯明
Chen Shi　陳適
Chen Shuren　陳樹人
Chen Wuwo　陳無我
Chen Yifan　陳貽範
Chen Ziyi　陳子毅
Cheng Shifa　程十髮
Chi Ke　遲軻
Ching Liang (Qing Liang)　清涼
Chun shui huayuan　春睡畫院
cun　皴

Da Hua zazhi　大華雜誌
Daoguang　道光
dazhonghua　大衆化
Dianshi zhai　點石齋
Dong Qichang　董其昌
Dou Zhen　竇鎮

Fan Kuan　范寬
Fang Junbi　方君璧
Fang Rending　方人定
Feng Boheng　馮伯衡
Feng Ziyou　馮自由
Fu Baoshi　傅抱石

Gao Guantian　高冠天
Gao Jianfu　高劍父
Gao Jianzeng　高劍曾
Gao Lihua　高勵華
Gao Lijie　高勵節
Gao Lun　高倫
Gao Qifeng　高奇峰
Gao Weng　高翁
gongbi　工筆
Guan Shanyue　關山月

guo hua　國畫
Guo Moruo　郭沫若

Ha Tong　哈同
hake　刷毛
Hashimoto Gahō　橋本雅邦
Hashimoto Kansetsu　橋本關雪
He Fenglian　何風蓮
He Lei　何磊
He Qiyuan　何漆園
He Xiangning　何香凝
Hishida Shunsō　菱田春草
Hosono Masanobu　細野正信
Hu Hanmin　胡漢民
Hu Shi　胡適
Hua-Mei wanbao　華美晚報
Hua Yan　華嵒
Huang Binhong　黃賓虹
Huang Dufeng　黃獨峰
Huang Huanwu　黃幻吾
Huang Leisheng　黃磊生
Huang Shaoqiang　黃少强
Huang Shen　黃愼
Huang Weiyu　黃渭漁
Huang Xing　黃興
Huang Yongyu　黃永玉

Jian Youwen (Jen Yu-wen)　簡又文
Jin Nong　金農
Jingdezhen　景德鎮
jinshi　進士
Ju Cha　居槎
Ju Chao　居巢

Ju Guquan　居古泉
Ju Lian　居廉

Kachō　花鳥
Kang Youwei　康有爲
Kano　狩野
Kano Hōgai　狩野芳崖
Kawabata Gyokushō　川端玉章
Kawai Gyokudō　川合玉堂
Kimura Buzan　木村武山
Kishi Chikudō　岸竹堂
Kong Jingzhi　孔靜之
Kunlun　崑崙

Lan Ying　藍瑛
Lang Shining　郎世寧
Li Baoquan　李寶泉
Li Bo　李白
Li Fuhong　李撫虹
Li Gemin　黎葛民
Li Jian　黎簡
Li Jian'er　李健兒
Li Keran　李可染
Li Tang　李唐
Li Xiongcai　黎雄才
Liang Dingming　梁鼎銘
Liang Kai　梁楷
Liang Shuming　梁漱溟
Liang Xihong　梁錫鴻
Liao Zhongkai　廖仲凱
Lin Fengmian　林風眠
Lin Liang　林良
Lingnan pai　嶺南派

Lishan　离山

Liu Haisu　劉海粟

Liu Yunheng　劉允衡

Lu Xun　魯迅

Luo Jialun　羅家倫

Maruyama Ōkyo　丸山応挙

Matsumura Goshun　松村吳春

Meng Jinyi　孟覲乙

Min bao　民報

Mio Goseki　石吳尾三

Mochizuki Seihō　望月金鳳

Mombushō　文部省

Mu Qi　牧谿

muyou　幕友

Nanga　南畫

Nanhai　南海

Ngan Siumui (Yan Xiaomei)　顏小梅

Ni Yide　倪貽德

Nihon Bijutsu In　日本美術院

Nihon-ga　日本畫

Nishimura Goun　西村五雲

Okakura Kakuzō　岡倉覺三

Ou Haonian　歐豪年

Pang Xunqin　龐薰琹

Panyu　番禺

Qi Baishi　齊白石

Qingyou she　清游社

Qu Junwei　區鈞偉

Quanzhou　泉州

Ren Bonian　任伯年

Rikkyō University　立教大學

She Miaozhi　佘紗枝

Shen Nanpin　沈南蘋

Shen Zhou　沈周

Shenmei shuguan　審美書館

Shenzhen　深圳

Shi Qi　石溪

Shi Tao　石濤

Shi yi　市藝

Shijō　四條

Shunde　順德

Situ Qi　司徒奇

Song Guangbao　宋光寶

Song Minghuang　宋銘黃

Songjiang　松江

Su Liupeng　蘇六朋

Su Manshu　蘇曼殊

Su Renshan　蘇仁山

Su Wonong　蘇臥農

Sun Fuxi　孫福熙

Tai Xu　太虛

Takeuchi Seihō　竹內栖鳳

tiyong　體用

Tōkyō Bijutsu Gakkō　東京美術學校

Tongmeng hui　同盟會

Wang Jingwei　汪精衛

Wang Lipu　王禮溥

Wang Yiting　王一亭

Wenhua jianshe　文化建設

Wong Shiu-hon (Huang Zhaohan)
　黃兆漢

Wu Changshuo　吳昌碩

Wu Daozi　吳道子

Wu Deyi　伍德彝

Wu Haiquan　吳海泉

Wu Peihui　伍佩繪

Wu Zhao　午兆

Wu Zhihui　吳稚暉

Wu Zuoren　吳作人

Xia Gui　夏珪

Xiao Yun　曉雲

Xie He　謝赫

Xie Lansheng　謝蘭生

xiesheng　寫生

xieyi　寫意

Xin guohua　新國畫

Xingdao ribao　星島日報

Xinmin congbao　新民叢報

Xu Beihong　徐悲鴻

Xu Shiqi　許士騏

Xu Wei　徐渭

Yafeng hui　亞風會

Ya Ming　亞明

Yamamoto Baigai　山本梅涯

Yamamoto Shunkyo　山元春擧

Yang Shanshen (Yang Shansum)
　楊善深

Yang Suying　楊素影

Yangmingshan　陽明山

Yi feng　藝風

Yi jing　逸經

Yishujia　藝術家

Yokoyama Taikan　横山大觀

Yong Dagui　容大瑰

Yongming　永明

Yosa Buson　与謝蕪村

You Yunshan　游雲山

Yu Dafu　郁達夫

Yuexiu shan　越秀山

Yun Shouping　惲壽平

Zhang Daqian　張大千

Zhang Kunyi　張坤儀

Zhao Chongzheng　趙崇正

Zhao Shaoang　趙少昂

Zhao Zhiqian　趙之謙

zhezhong pai　折衷派

Zhen xiang huabao　眞相畫報

Zheng Banqiao　鄭板橋

Zheng Jin　鄭錦

Zhou Yifeng　周一峰

zhuangfen　撞分

Zhuang Shen　莊申

zhuangshui　撞水

Zhuanji Wenxue　傳記文學

Bibliography

Catalogs and Reproduction Volumes

The Art of Chen Shuren. Hong Kong: Hong Kong Museum of Art, 1980. Bilingual edition.

The Art of Gao Qifeng. Hong Kong: Hong Kong Museum of Art, 1981. Bilingual edition.

The Art of Kao Chien-fu. Hong Kong: Hong Kong Museum of Art, 1978. Bilingual edition.

The Art of Kao Ch'i-feng [Gao Qifeng] and Chang K'un-i [Zhang Kunyi]. New York: Metropolitan Museum of Art, 1943.

Baekeland, Frederick. *Imperial Japan: The Art of the Meiji Era (1868–1912).* Ithaca, N.Y.: Herbert F. Johnson Museum of Art, Cornell University, 1980.

Cahill, James, ed. *Shadows of Mt. Huang: Chinese Painting and Printing of the Anhui School.* Berkeley: University of California Art Museum, 1981.

Chan, Helen. *A Catalogue of Chinese Paintings in the Luis De Comoes Museum, Macau.* Macao: Imprensa Nacional, 1977.

Chen Shuren 陳樹人, *Guilin shanshui xiesheng ji* 桂林山水寫生集 [Collected landscapes from Guilin]. Shanghai, 1932.

Chen Shuren jin zuo 陳樹人近作 [Recent works of Chen Shuren]. Shanghai, 1937.

Chen Shuren yizuo hua ji 陳樹人遺作畫集 [Chen Shuren's posthumous Chinese paintings]. Hong Kong: Swindon Book Co., 1976.

Chen Ziyi hua ji 陳子毅畫集 [Collected paintings of Chen Ziyi]. Hong Kong: Jiguzhai, 1981.

Fan Tchun-Pi: Artiste chinoise contemporaine [Fang Junbi: A contemporary Chinese artist]. Paris: Musée Cernuschi, 1984.

Fang Junbi 方君璧. *Chinese Paintings by Fan Tchun Pi.* 2 vols. Hong Kong (?), n.d.

———. *Fang Junpi hua ji yi ce* 方君璧畫集一册 [Collected paintings by Fang Junbi]. Changsha: Commercial Press, 1938.

Fu Baoshi 傅抱石 and Guan Shanyue 關山月. *Dongbei xiesheng xuan* 東北寫生選 [Selected paintings from life in Manchuria]. Peking: Peoples' Art Publishing House, 1964.

Fu Baoshi hua ji 傅抱石畫集 [Collected paintings of Fu Baoshi]. Nanjing, 1981.

Gao Jianfu, Chen Shuren, Gao Qifeng zuopin zhanlan 高劍父、陳樹人、高奇峰作品展覽 [An exhibition of the works of Gao Jianfu, Chen Shuren, and Gao Qifeng]. Canton: Canton City Art Gallery, 1980.

Gao Jianfu Gao Qifeng yizuo jingxuan 高劍父高奇峰遺作精選 [English title: *Representative Paintings of the Late Kao Chien-Fu and Kao Ch'i-Feng*]. 4 vols. Hong Kong(?), n.d.

Gao Qifeng 高奇峰. *Qifeng hua ji* 奇峰畫集 [Collected paintings of (Gao) Qifeng]. 7 vols. Shanghai(?), 1931.

Gao Qifeng hua ji 高奇峰畫集 [Collected paintings of Gao Qifeng]. Shanghai: Shenmei shuguan, 1918.

Gao Qifeng xiansheng rongai lu 高奇峰先生榮哀錄 [A record of the glories and sorrows of Mr. Gao Qifeng]. Shanghai, 1935.

Gao Qifeng xiansheng yi hua ji 高奇峰先生遺畫集 [Paintings of the late Mr. Gao Qifeng]. Shanghai, 1935.

Grewer, T. *Chinese Paintings by Theo Grewer* (Zhao Shaoang's student). Hong Kong, ca. 1965.

Guan Shanyue hua ji 關山月畫集 [Collected paintings of Guan Shanyue]. Canton: Renmin chubanshe, 1981.

Guan Shanyue hua xuan 關山月畫選 [Selected paintings of Guan Shanyue]. Canton, 1974.

Guan Shanyue ten 關山月展 [Exhibition of Guan Shanyue]. Tokyo, 1982.

Guangdong lidai ming jia huihua 廣東歷代名家繪畫 [Guangdong famous historical paintings]. Hong Kong: City Museum and Art Gallery, 1973.

Guangdong meishu xuanji 廣東美術選集 [Selected art of Guangdong]. Canton: People's Art Publishing House, 1962.

Guangdong yishu zuopin xuanji 廣東藝術作品選集 [A collection of selected art works from Guangdong]. Canton, 1954.

He Fenglian hua ji 何風蓮畫集 [Collected paintings of He Fenglian]. Vol. 2. Hong Kong, 1986.

He Xiangning hua ji 何香凝畫集 [Collected paintings of He Xiangning]. Peking, 1963.

He Xiangning Zhongguo hua xuanji 何香凝中國畫選集 [He Xiangning's collected Chinese paintings]. Canton: Renmin chubanshe, 1979.

Hsu Pei-hung [Xu Beihong] Selected Paintings. Hong Kong, n.d.

Huang Huanwu hua ji 黃幻吾畫集 [Collected paintings of Huang Huanwu]. Changsha: Hunan Art Publishing House, 1983.

Jianfu hua bu 劍父畫簿 [Book of paintings by (Gao) Jianfu]. Shanghai: Shenmei shuju, 1920.

Kawakita, Michiaki *Modern Japanese Painting: The Force of Tradition*. Tokyo: Tuttle, 1957.

Landscape Paintings by Kwangtung Masters During the Ming and Ch'ing Dynasties. Hong Kong: Institute of Chinese Studies, Chinese University of Hong Kong, 1973.

Li Chu-tsing. *Trends in Modern Chinese Painting: The C. A. Drenowatz Collection*. Ascona, Switzerland, 1979.

Li Xiongcai shansui hua bu 黎雄才山水畫簿 [Li Xiongcai's landscape painting manual]. 3 vols. Canton: Lingnan Art Publishing Co., 1981.

Liang Dingming xiansheng huaji 梁鼎銘先生畫集 [Collected paintings of Mr. Liang Dingming]. Taibei, 1962.

Lingnan pai zao qi ming jia zuopin 嶺南派早期名家作品 [Works of early masters of the Lingnan School]. Hong Kong: Hong Kong Museum of Art, 1983.

Liu Haisu 劉海粟, ed. *Bolin renwen bowuguan suo cang Zhongguo xiandai ming hua ji*

伯林人文博物館所藏中國現代明畫集 [Famous contemporary Chinese paintings in the Berlin Museum]. Shanghai: Commercial Press, 1936; Taibei reprint, 1976.

Liu Qijun 劉奇俊, ed. *Takeuchi Seihō* 竹內栖鳳. Taibei: Art Book Co., 1983.

Liu Yunheng hua ji 劉允衡畫集 [Collected paintings of Liu Yunheng (Stephen Lowe)]. Hong Kong, n.d.

Mei zhan tekan 美展特刊 [Special catalog of the First National Fine Arts Exhibition of 1929]. Nanjing, n.d.

Miyagawa Torao. *Modern Japanese Painting: An Art in Transition*. Tokyo: Kodansha, 1967.

Mombushō bijutsu tenrankai zuroku 文部省美術展覽會圖錄 [Illustrated catalog of the annual art exhibition of the Ministry of Education]. Tokyo, 1907–.

Ōkyo and the Maruyama-Shijō School of Japanese Painting. St. Louis: St. Louis Art Museum, 1980.

Ou Haonian hua ji 區豪年畫集 [Collected paintings of Ou Haonian]. Taibei: Zhonghua minguo guoli lishi bowuguan, 1979.

Paintings by Kao Weng and Chang K'un-i. New York: Metropolitan Museum of Art, 1944.

Qifeng hua ji 奇峰畫集 [(Gao) Qi Feng collected paintings]. 5 vols. Shanghai(?), n.d.

Qingliang yi zhan tekan 清涼藝展特刊 [Special catalog for the "Cool Purity" art exhibition]. Yangmingshan, Taiwan: China Academy Institute for the Study of Buddhist Culture, 1974–1978.

San Gao yi hua ji 三高遺畫集 [A collection of extant paintings by the three Gaos]. Hong Kong, 1968.

Shaoang hua ji 少昂畫集 [Collected paintings of (Zhao) Shaoang]. 14 vols. Hong Kong, n.d.

Shaoang hua ji 少昂畫集 [(Zhao) Shaoang painting collection]. 20 vols. Hong Kong, 196?–1973.

She Miaozhi hua ji 佘紗枝畫集 [Chinese paintings by Miss Letty Shea Miu Chee]. Hong Kong, 1977.

She Miaozhi hua ji 佘紗枝畫輯 [Collected paintings of She Miaozhi]. Peking: People's Art Publishing House, 1982.

Situ Qi hua ji 司徒奇畫集 [Collected paintings of Situ Qi (Szeto Kei)]. Hong Kong, 1976.

Su Liupeng 蘇六朋. Hong Kong: City Art Museum and Art Gallery, 1965.

Takeuchi Seihō 竹內栖鳳. Tokyo, n.d.

Takeuchi Seihō ten 竹內栖鳳展 [Exhibition of Takeuchi Seihō]. Kyoto: Kyoto Art Museum, 1978.

Wang Lipu 王禮溥, ed. *Lingnan hua pai* 嶺南畫派 [The Lingnan School of painting]. Taibei: Art Book Company, 1983.

Wu Tung. *Painting in China Since the Opium Wars*. Boston: Museum of Fine Arts, 1980.

Xiandai Fojiao yishu tekan: Qingliang yizhan shi zhounianji zhuan ji 現代佛敎藝術特刊清涼藝展十周年紀專輯 [Cool Purity, an exhibition of Buddhist art: Tenth anniversary special edition]. Taibei: Institute for the Study of Buddhist Culture, 1983.

Xiao Yun shanshui ce 曉雲山水冊 [Landscape paintings of the Venerable Xiao Yun (You Yunshan)]. Taibei: Yuan Quan Press, 1974.

Xin hua xuan 新畫選 [Selection of new paintings]. Shanghai: Shenmei shuguan, ca. 1914.

Yang Shanshen de yishu 楊善深的藝術 [The art of Yang Shanshen (Shansum)]. Hong Kong: Hong Kong Museum of Art, 1981.

Yang Shanshen hua ji 楊善深畫集 [Collected paintings of Yang Shanshen]. Hong Kong, 1975.

Zhang Kunyi hua ji 張坤儀畫集 [Collected paintings of Zhang Kunyi]. Canton(?), n.d.

Zhao Shaoang hua ji 趙少昂畫集 [Collected paintings of Zhao Shaoang]. Hong Kong: Zhonghua shuju, 1940.

Zhao Shaoang hua ji 趙少昂畫集 [Collected paintings of Zhao Shaoang]. Taibei: Zhonghua minguo guoli lishi bowuguan, 1980.

Chinese and Japanese Language Sources

Chen Shuren 陳樹人. *Zhan chen ji* 戰塵集 [(Poems by) the dust of war]. Shanghai, 1946.

———. *Zhuan ai ji* 專愛集 [(Poems on) love alone]. Shanghai, 1947.

"Chen Shuren hua shi" 陳樹人畫詩 [Poems and paintings by Chen Shuren]. *Liang you* 良友 [Good friend], no. 25 (April 1928): 26–27.

Chen Wuwo 陳無我. "Guan Fang Rending hua zhan hou" 觀方人定畫展候 [After seeing Fang Rending's painting exhibition]. *Yi feng* 藝風, vol. 3, no. 12 (1935): 47–48.

Chi Ke 遲軻 et al. "Lingnan pai zuopin" 嶺南派作品 [Works of the Lingnan School]. *Zhonghua meishu* 中華美術 [Chinese art], no. 1 (1982): 1–38.

Dou Zhen 竇鎮. *Qingchao shuhuajia bilu* 清朝書畫家筆錄 [Record of painters and calligraphers of the Qing dynasty]. In *Yishu congbian* 藝術叢編 [Art collection], vol. 18. Taibei: World Book Company, 1962.

Fang Rending 方人定. "Xiandai Zhongguo hua de fan shidai xing" 現代中國畫的反時代性 [The-contrary-to-the-spirit-of-the-times nature of Chinese painting]. *Yi feng*, vol. 3, no. 7 (1935): 38–39.

Feng Boheng 馮伯衡. "Gao Jianfu xiao zhuan" 高劍父小傳 [A short biography of Gao Jianfu]. In *Minguo renwu zhuanji* 民國人物傳紀 [Biographies of the Republican period], vol. 6 (1979): 107–14. Peking.

———. "Gao Jianfu he Lingnan pai" 高劍父和嶺南派 [Gao Jianfu and the Lingnan School]. *Meishu yanjiu* 美術研究 [Art research], no. 4 (April 1979): 73–80.

Fu Baoshi 傅抱石. "Minguo yilai guohua zhi shi de guancha" 民國以來國畫之史的觀察 [An examination of the history of national painting since the beginning of the Republic]. *Yi jing* 逸經 [Ease and rest], vol. 2, no. 3 (1935): 641–45.

Gao Jianfu 高劍父. "Guofang yishu zhi zhongdaxing" 國防藝術之重大性 [The serious nature of art for national defense]. In He Yongren 何勇仁, ed., *Guofang wen yi lun* 國防文藝論 [On art and literature for national defense]. Shanghai, 1936.

———. "Dui Riben yishu shijie xuanyan bing gao shijie" 對日本藝術世界宣言並告世界 [An appeal to Japanese art circles and an announcement to the world]. *Yifeng*, vol. 1, no. 5 (1933): 20–23.

———. "Ju Guquan xiansheng de huafa" 居古泉先生的畫法 [The painting methods of Mr. Ju Guquan (Ju Lian)]. *Guangdong wenwu* 廣東文物 [Guangdong culture and archaeology], vol. 8 (1940): 46–49.

———. "Shuqi xunlianban gan yan" 暑期訓練班感言 [Emotional words to the summer session preparatory class]. *Shih yi* 市藝 [City art], no. 4 (Aug. 27, 1949): 1–2.

———. *Wo de xiandai guohua guan* 我的現代國畫觀 [My views on contemporary national painting]. Shanghai, 1936. Reprinted, Hong Kong, 1955; Taibei, 1975.

Guan Shanyue 關山月. "Chong du danqing yi wo shi" 重睹丹青憶我師 [Looking at paintings and recalling my teacher]. *Meishujia* 美術家 [The artist], no. 19 (April 1981): 38–40.

He Yongren 何勇仁. "Huashi Gao Qifeng" 畫師高奇峰 [Painting master Gao Qifeng]. *Guangdong wenwu* 廣東文物, 8: 711–12.

He Yufeng 何玉鳳. "Cong *Ying* kan Lingnan pai huihua" 從鷹看嶺南派繪畫 [From *Eagle* looking at the painting of the Lingnan School]. *Guangzhou ribao* 廣州日報 [Guangzhou daily], Feb. 22, 1980.

Hosono Masanobu 細野正信. *Edo Kanō to Hōgai* 江戶狩野と芳崖. Tokyo: Shogakukan, 1978.

Hua Qing 華青. "Yi Lingnan huajia" 憶嶺南畫家 [Recalling the Lingnan painters]. *Dahua zazhi* 大華雜誌 [Great China magazine], July 7, 1959, 27.

Hua yi ying chen 畫藝影塵 [Art reflecting the human world]. Ed. You Yunshan 游雲山. Taibei: Buddhist Studies Academy, 1977.

Huang Banro 黃般若. "Ju Chao de huafa" 居巢的畫法 [Ju Chao's method of painting]. *Zhilin conglu* 芝林叢錄 [Flowery forest collectanea], 3: 81–82. Hong Kong.

Huang Binhong 黃賓虹. "Mei zhan guo hua tan" 美展國畫談 [Discussing national painting at the art exhibition]. *Yi guan* 藝觀 [Art view], 3 (May 15, 1929): 33–35.

Huang Dufeng 黃獨峰. "Tan Lingnan hua pai" 談嶺南畫派 [Discussing the Lingnan School]. *Zhongguo hua yanjiu* 中國畫研究 [Chinese Painting Research], 3 (1983): 182–91.

Huang Ketian 黃刻田. "Lishan lao ren" 离山老人 [The old man of Lishan]. In *Tan yi lu* 談藝錄 [A record of art chats], 77–80. Hong Kong, 1973.

Huang Weiyu 黃渭漁. "Jin jian yu jie jingshen" 金堅玉潔精神 [A spirit hard as metal and pure as jade]. *Zhongguo meishu* 中國美術 [Chinese art], vol. 7, no. 1 (1982): 23–25.

Huang Weiyu 黃渭漁, ed. "Lingnan pai huajia lun hua" 嶺南派畫家論畫 [Lingnan School painters discuss painting]. *Zhongguo meishu* vol. 7, no. 1 (1982): 11–12.

Jen Yu-wen [Jian Youwen] 簡又文. "Gao Jianfu huashi ku xue cheng ming ji" 高劍父畫師苦學成名記 [A record of painting master Gao Jianfu's bitter struggle to achieve fame]. *Yi jing* 逸經 [Ease and rest], vol. 2, no. 6 (1936): 275–281.

———. "Geming huajia Gao Jianfu: Gailun ji nianbiao" 革命畫家高劍父概論及年表 [Revolutionary painter Gao Jianfu: Discussion and chronological biography]. *Zhuanji wenxue* 傳記文學 [Biographical studies], vol. 21, no. 6; vol. 22, nos. 2, 3 (1972–73).

———. "Hao jiang du hua ji" 濠江讀畫記 [Records of looking at paintings on the Hao River]. *Da feng* 大風 [Typhoon magazine], no. 41 (July 1939): 1299–304 and no. 43 (Aug. 1939): 1365–68. Hong Kong.

———. "Jieshao huajia Fang Rending jian tantan xin guohua" 介紹畫家方人定兼談談新國畫 [Introducing the painter Fang Rending together with chatting about new national painting]. *Yi jing* 逸經 [Ease and rest], no. 30 (May 1937): 1299–304, and no. 43 (Aug. 1939): 1365–68.

———. "Ju Lian zhi huaxue" 居廉之畫學 [Ju Lian's theory of painting]. *Guangdong wenxian* 廣東文獻 [Guangdong culture], vol. 4, no. 1 (1974): 22–28.

———. "Xin guohua de xinshang" 新國畫的欣賞 [Appreciating new national painting]. *Guangdong wenxian*, vol. 4, no. 3 (1974): 47–48.

"Jieshao Gao Jianfu xiansheng" 介紹高劍父先生 [Introducing Mr. Gao Jianfu]. *Liang you* 良友 [Good friend], no. 14 (April 30, 1927): 17–19.

Kong Jingzhi 孔靜之. "Chen Shuren xiao zhuan" 陳樹人小傳 [A short biography of Chen Shuren]. In *Minguo renwu zhuanji* 民國人物傳記 [Biographies of the Republican period], 114–18. Peking, 1979.

Li Baoquan 李寶泉. "Zhongguo huafa zhi yanbian" 中國畫法之演變 [Changes in the methods of Chinese painting]. *Yi jing* 逸經 [Ease and rest], no. 31 (1937): 433–36.

Li Jian'er 李建兒. *Guangdong xiandai huaren zhuan* 廣東現代畫人傳 [Biographies of contemporary Guangdong painters]. Canton(?), 1941.

Liang Xihong 梁錫鴻. "Huajia Fang Rending gezhan" 畫家方人定個展 [Painter Fang Rending's individual exhibition]. *Yi feng* 藝風, vol. 3, no. 12 (1935): 44–46.

"Lingnan zhuming huajia Gao Qifeng de mingzuo" 嶺南著名畫家高奇峰的名作 [Famous paintings of the renowned Lingnan painter Gao Qifeng]. *Liang you* 良友 [Good friend], no. 3 (April 15, 1926): 14.

Liu Jianwei 劉健威. "Yang Shanshen tan Gao Jianfu" 楊善深談高劍父 [Yang Shanshen chats about Gaio Jianfu]. *Ming bao yuekan* 明報月刊 [Brightness monthly], no. 152 (Aug. 1978): 92–93.

"Minzu zhengqitu" 民族正氣圖 [Paintings of racial righteousness]. *Zhong wai* 中外 ["Cosmorama pictorial"], March 1975, 23.

Mo Ruitian 莫瑞添. "Lüe tan Yang Shanshen de hua" 略談楊善深的畫 [A general chat about Yang Shanshen's paintings]. *Ming bao yuekan* 明報月刊, vol. 13, no. 6 (June 1978): 103–4.

Ni Yide 倪貽德. "Xin de guohua" 新的國畫 [New national painting]. In Yao Yuxiang 姚漁湘, ed., *Zhongguo hua taolun ji* 中國畫討論集 [Collected discussions of Chinese painting], 115–20. Peking, 1932.

Sanetō Keishū 實藤惠秀. *Chūgokujin Nihon ryūgakushi* 中国人日本留学史 [Chinese studying in Japan]. Tokyo, 1960.

Sun Fuxi 孫福熙. "Zhongguo yishu qiantu zhi tantao" 中國藝術前途之探討 [A discussion of the future of Chinese painting]. *Yi Feng*, vol. 3, no. 5 (1935): 31–34.

Tsuruta Takeyoshi 鶴田武良. *Kindai Chūgoku kaiga* 近代中国絵画 [Modern Chinese painting]. Tokyo, 1974.

Wang Deng 汪澄. "Lingnan hua pai de xin guohua" 嶺南畫派的新國畫 [The Lingnan School's style]. *Yishujia* 藝術家, no. 18 (Nov. 1976): 17–25.

Wen Yuanning 溫源甯. "Gao Jianfu de hua" 高劍父的畫 [Gao Jianfu's painting]. *Yi jing*, no. 21 (1936): 19–23.

Wong Shiu-hon [Huang Zhaohan] 黃兆漢. *Gao Jianfu hualun shuping* 高劍父畫論述評 [Gao Jianfu's theory of painting]. University of Hong Kong, Centre for Asian Studies, Occasional Papers and Monographs, No. 8. Hong Kong, 1972.

———. *Lingnan huapai zuopin huandeng pian mulu tiyao* 嶺南畫派作品幻燈片目錄提要 [Paintings of the Lingnan School: An annotated catalog of slides at the Centre for Asian Studies]. Hong Kong: University of Hong Kong, 1972.

Wu Zhao 午兆. "Chun shui huayuan huanying Fang, Su, Yang, Huang gui guo hua zhan" 春睡畫院歡迎方蘇楊黃歸國畫展 [The Spring Slumber studio

welcomes Fang, Su, Yang, and Huang's return home with an exhibition]. *Yi Feng* 藝風, vol. 3, no. 11 (1935): 136–41.

Xi Yuan 蔗園. "Xiandai mei yu gudian mei" 現代美與古典美 [Contemporary beauty and classical beauty]. *Yi feng*, vol. 3, no. 12 (1935): 49–50.

Xu Shiqi 許士騏. "Canguan Lingnan san zuojia zhanlan hou" 參觀嶺南三作家展覽後 [After viewing the exhibition of the three Lingnan artists]. *Yi feng*, vol. 3, no. 1 (1935): 118–20.

"Yang Shanshen guohua zuopin" 楊善深國畫作品 [The national style paintings of Yang Shansum]. *Meishujia* 美術家 [The artist], April 1981, 58–63.

Zhao Shaoang 趙少昂. "Yuanyuan: Lingnan san jia" 淵源：嶺南三家 [The source: Three Lingnan artists]. Unpublished essay.

"Zhao Shaoang geren huazhan chupin" 趙少昂個人畫展出品 [Products from Zhao Shaoang's one-man exhibition]. *Liang you*, no. 67 (July 1932): 9.

Zhao Shiguang 趙世光. "Lingnan pai de yuanyuan he zhanwang" 嶺南派的淵源和展望 [The original sources and future prospects of the Lingnan School]. *Xianggang Hanwen shifan tongxue hui huikan* 香港漢文師範同學會會刊 [Bulletin of the Hong Kong Study Society for Chinese Language Education]. Hong Kong, n.d.

Zhen xiang huabao 眞相畫報 [The true record]. Shanghai: Shenmei shuguan, 1912–1914.

Zhongguo renwu zhuanji 中國人物傳記 [Biographical dictionary of China]. Peking, 1979.

Zhu Xiuxia 祝秀俠. "Yi Gao Jianfu xiansheng" 憶高劍父先生 [Remembering Mr. Gao Jianfu]. *Ziyou Zhongguo* 自由中國 [Free China], vol. 5, no. 3 (1951): 99.

Western Language Sources

Boorman, Howard, and Richard Howard, eds. *Biographical Dictionary of Republican China*. New York: Columbia University Press, 1967–71.

Brown, Louise Norton. *Block Printing and Book Illustration in Japan*. London: Routledge and Sons, 1924.

Cahill, James. *The Compelling Image: Nature and Style in Seventeenth-Century Chinese Painting*. The Charles Elliot Norton Lectures, 1979. Cambridge, Mass: Harvard University Press, 1982.

Canaday, John. *Mainstreams of Modern Art*. New York: Holt, Rinehart, and Winston, 1959.

Chang, Arnold. *Painting in the People's Republic of China: The Politics of Style*. Boulder, Colo.: Westview Press, 1980.

Chen Yifan. "The Modern Trend in Contemporary Chinese Art." *Tien Hsia Monthly*, Jan. 1937, pp. 40–42.

Chi Ke. "Kuan Shanyueh's Paintings." *Chinese Literature*, Feb. 1964, pp. 108–14.

———. "The Three Founders of the Ling Nan School." *Chinese Literature*, July 7, 1982, pp. 75–84.

Chisholm, Lawrence W. *Fenollosa: The Far East and American Culture*. New Haven: Yale University Press, 1963.

Chuang Shen [Zhuang Shen]. "Some Observations on Kwangtung Painting." In *Kwangtung Painting*. Hong Kong: City Art Museum and Gallery, 1973.

Clark, Kenneth. *The Romantic Rebellion*. New York: Harper and Row, 1973.

de Bary, Theodore, ed. *Sources of Chinese Tradition*. New York: Columbia University Press, 1960.

Fenollosa, Ernest F. *Epochs of Chinese and Japanese Art*. Reprinted, New York: Denver Press, 1963.

Goldman, Merle, ed. *Modern Chinese Literature in the May Fourth Era*. Harvard East Asian Series 89. Cambridge, Mass.: Harvard University Press, 1977.

Harrell, Paula. "The Years of the Young Radicals: The Chinese Students in Japan." Ph.D. dissertation, Columbia University, 1970.

Hillier, J. *The Uninhibited Brush: Japanese Art in the Shijo Style*. London: Hugh M. Moss Ltd., 1974.

Ho Ping-ti. *The Ladder of Success in Imperial China*. New York: Columbia University Press, 1962.

Horioka, Yasuko. *The Life of Kakuzo*. Tokyo: Hokuseido Press, 1963.

Huang Miaozi. "The Art of Zhao Shaoang." *Chinese Literature*, June 1983, pp. 77–81.

Jansen, Marius B. *Japan and China: From War to Peace, 1894–1972*. Chicago: Rand McNally, 1975.

Jen Yu-wen. "Art Chronicle." *Tien Hsia Monthly*, Feb. 1938, 145–46.

Kawakita Michiaki. "Western Influence on Japanese Painting and Sculpture." In C. F. Yamada, ed., *Dialogue in Art: Japan and the West*, 71–112. Tokyo: Kodansha, 1976.

Keene, Donald. "The Sino-Japanese War of 1894–95 and Its Cultural Effects in Japan." In Donald Shively, ed., *Tradition and Modernization in Japanese Culture*, 121–75. Princeton, N.J.: Princeton University Press, 1971.

Lee, Leo. *The Romantic Generation of Chinese Writers*. Cambridge, Mass.: Harvard University Press, 1973.

Liu Wu-chi. *Su Man-Shu*. New York: Twayne Publishers, 1972.

Luard, Tim. "Kao Chien-fu, Southern Chinese Painter." *Arts of Asia*, vol. 8, no. 6 (1980): 2–8.

Mitchell, C. H. *The Illustrated Books of the Nanga, Maruyama, Shijo and Other Related Schools of Japan: A Bibliography*. Los Angeles: Dawson's Book Shop, 1972.

Murk, Christian. *Artists and Traditions: Uses of the Past in Chinese Culture*. Princeton, N.J.: Princeton University Press, 1976.

Okakura, Kakuzo. *The Ideals of the East*. London, 1905.

Proceedings of the International Symposium on Chinese Painting. Taibei: National Palace Museum, 1972.

Rabb, Theodore K. "The Historian and the Art Historian." *Journal of Interdisciplinary History*, vol. 4, no. 1 (Summer 1973): 107–17.

————. "The Historian and the Art Historian Revisited." *Journal Interdisciplinary History*, vol. 14, no. 3 (Winter 1984).

Rosenfield, John M. "Western-Style Painting in the Early Meiji Period and Its Critics." In Donald H. Shively, ed., *Tradition and Modernization in Japanese Culture*, 181–219. Princeton, N.J.: Princeton University Press, 1971.

Sasaki Johei. "Ōkyo and the Maruyama-Shijō School." In *Ōkyo and the Maruyama-Shijō School of Japanese Painting*, pp. 23–61. St. Louis Art Museum, 1980.

Scott, A. C. *Literature and the Arts in Twentieth Century China*. New York: Doubleday, 1963.

Shively, Donald H. "The Japanization of the Middle Meiji." In Donald Shively, ed., *Tradition and Modernization in Japanese Culture*, 77–119. Princeton, N.J.: Princeton University Press, 1971.

Silbergeld, Jerome. "In Praise of Government: Chao Yung's Painting, Noble Steeds, and Late Yuan Politics." *Artibus Asiae*, vol. 46, no. 3 (1985): 159–202.

Stanley-Baker, Joan. "Tradition as Patterns in the Process of Change." *Free China Review*, May 1984, 58–63.

Sullivan, Michael. *Chinese Art in the Twentieth Century*. London: Faber, 1959.

———. *The Meeting of East and West in Art*. London: Thames and Hudson, 1973.

Tam, Lawrence. "An Introduction to the Development of Kwantung Painting." In *Kwangtung Painting*. Hong Kong: City Art Museum and Gallery, 1973.

Uyeno Naoteru. *Japanese Arts and Crafts in the Meiji Era*. Trans. Richard Lane. Tokyo, 1958.

Yamada Chisaburoh, ed. *Dialogue in Art: Japan and the West*. Tokyo: Kodansha, 1976.

Index

Maruyama-Shijō School, 32–33, 34, 35, 130, 193nn.18, 20; influence on Chen Shuren, 36, 51, 53, 54, 127–28, 130; influence on Gao Jianfu, 36, 43, 45, 48, 53, 54, 152; influence on Gao Qifeng, 36, 41, 43, 45, 48–49, 51, 53, 54, 73, 76
Matsumura Goshun, 32, 34–35, 51, 193n.18
May Fourth movement, 67, 83, 84, 167
Meng Jinyi, 11, 13, 14, 18
Merchants: taste in paintings, 13, 35
Mio Goseki, 39, 40
Mochizuki Seihō, 40, 45, 46, 194n.31
Modernity, 73, 79, 110–11, 118–19, 167, 168
Mu Qi, 196n.26

Nagasaki School, 193n.17
Nationalism, 25–26, 28; and Chinese art, 40–41, 143, 158, 167
Nationalist party (Guomindang), 59; and Chen Shuren, 23, 27, 64, 87; and Gao Jianfu, 27, 62–63, 66, 85, 114, 145, 195n.5; and Lingnan School, 104–6, 169–71, 179
Naturalism, see Realism
New National Painting, 67, 72–73, 79, 84–85, 110–14. See also Lingnan School
Ni Yide, 115
Nishimura Goun, 40

Okamura Kakuzō, 29, 31, 192n.9
Ou Haonian, 179, 180

Pacific Painting Society, 29
Painting, Chinese: in Guangdong, 8–14, 190nn.1, 5; literati styles, 9, 12, 13; patronage of, 13, 67; and professional artists, 11, 15, 68; in Qing, 3, 9; realism in, 11; in Shanghai, 66–67; subjects, 12–13; tastes in, 67; Western influences on, 3–4, 67
People's Republic of China: and Lingnan School, 171–79
Perspective, 3, 33, 73, 96
Provincialism, 8–11

Qi Baishi, 87, 148

Realism: and Chen Shuren, 131, 133, 161, 163, 168; in Chinese painting, 11; and Gao Jianfu, 40, 48, 54, 110, 112, 152; and Gao Qifeng, 40, 41, 48, 77, 83, 89, 91, 93; in Japanese art, 33–34, 35, 36, 43;

193n.18; and Lingnan School, 56, 70, 83, 102, 161, 163, 168, 174; and modern Chinese literature, 60; socialist, 172, 174
Regionalism, 5, 11–12, 101, 159, 169–70
Ren Bonian, 66
"Reserved white" technique, 53, 74
Revolution: Gao Jianfu on, in Chinese painting, 113–14, 119, 125–26, 127, 164–65; vs. tradition in art, 4, 5, 143
Rocks, paintings of, 14, 17
Romanticism: and Gao Jianfu, 74, 96, 103, 122; and Gao Qifeng, 43, 45; in Japanese art, 34, 35, 36, 193n.18; and Lingnan School, 56, 70, 83, 96, 161, 167, 174–75, 197n.55; and modern Chinese literature, 59–60

Setoo Ki (Situ Qi), 140, 144, 154, 155, 156–57
Shanghai School, 4, 13, 66, 67, 79, 148
She Miaozhi (Letty Shen), 177, 186, 204n.29
Shen Nanpin, 194n.27
Shi Qi, 189n.6, 196n.26
Shi Tao, 79, 189n.6, 196n.26
Shiba Kokan, 34, 193n.17
Shijō School, see Maruyama-Shijō School
Song Guangbao, 11, 12, 13, 14, 18
Song Minghuang, 120
Southern School (of Chinese painting), 9
"Spirit resonance," 111–12, 198n.13
"Splashed water" technique, 12, 17
Spring Slumber Studio, 86, 120, 137, 144, 153, 156, 164
"Sprinkled powder" technique, 12, 17
Su Liupeng, 10, 13, 197n.53
Su Manshu, 60, 125
Su Renshan, 13, 197n.53
Su Wonong, 140, 156, 201n.76
Sun Yat-sen, 26, 28, 63, 84, 85; and Chen Shuren, 23, 87, 191n.24; and Gao Jianfu, 27, 85
Sun Yat-sen University Art Research Society, 109

Tai Xu, 125
Taiwan: legacy of Lingnan School in, 179–83, 186
Takeuchi Seihō, 35–36, 49, 193nn.23, 24, 197n.55; and Gao Jianfu, 40, 45, 48, 51, 54, 74, 101; and Gao Qifeng, 40, 41, 43, 48, 51
Terasaki Kogyo, 36
Tiger paintings, 38–40
Today's Art Association, 183

Designer: Mark Ong
Compositor: Asco Trade Typesetting Ltd.
Text: 10/12 Bembo
Display: Bembo
Printer: Braun–Brumfield, Inc.
Binder: Braun–Brumfield, Inc.